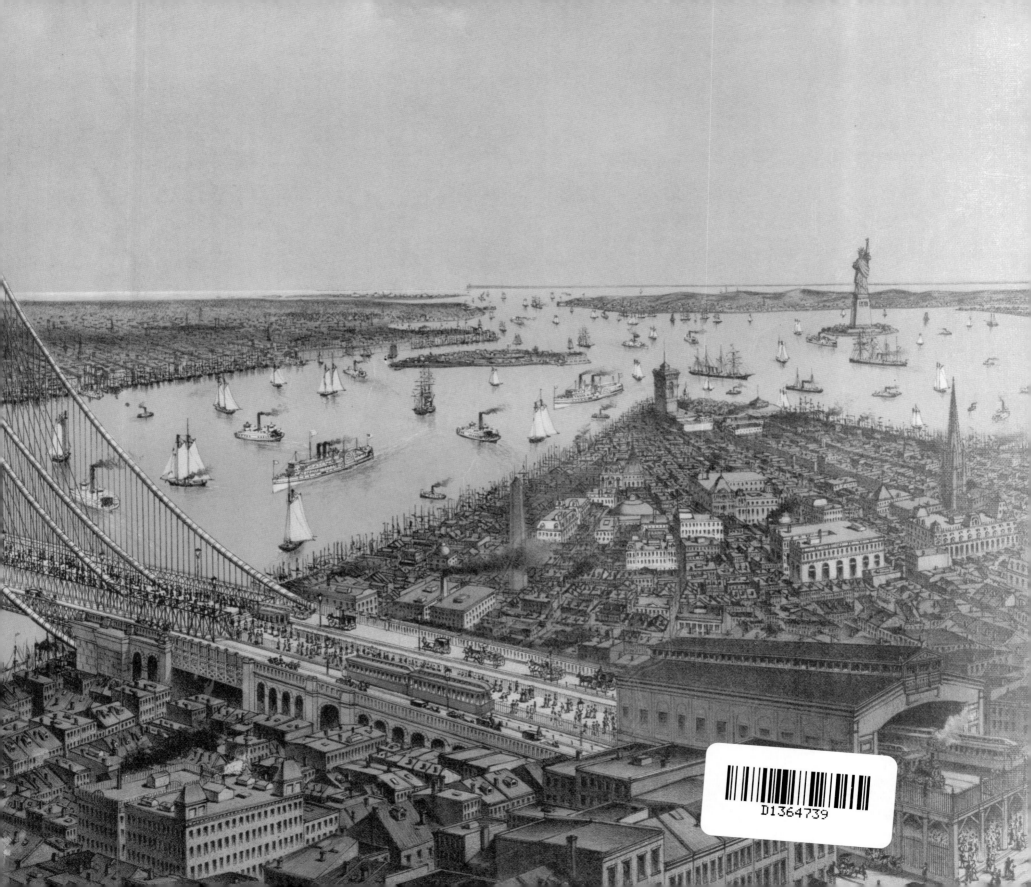

LOST NEW YORK

To Charlie, my unfailing source of knowledge and support.

Bibliography

Blackmar, Elizabeth, and Rosenzweig, Roy, *The Park and the Peop* [...]
(Cornell University Press, 1992)

Burrows, Edwin G., and Wallace, Mike, *Gotham: A History of New York City to 1898*
(Oxford University Press, 2001)

Bunker, John G., *Harbor & Haven: An Illustrated History of the Port of New York*
(Windsor Publications, 1979)

Caro, Robert A., *The Power Broker* (Vintage, 1975)

Goldberger, Paul, *The Skyscraper* (Alfred A. Knopf, 1989)

Hawes, Elizabeth, New York, New York: How the Apartment House Transformed the Life of the City
(Alfred A. Knopf, 1993)

Jackson, Kenneth T. (ed.), *The Encyclopedia of New York City* (Yale University Press, 1995)

Johnson, Harry, and Lightfoot, Frederick S., *Maritime New York in Nineteenth-Century Photographs*
(Dover Publications Inc., 1980)

Lopate, Phillip, *Waterfront: A Walk Around Manhattan* (Anchor Books, 2005)

Lowe, David Garard, *Stanford White's New York* (Watson-Guptill Publications, 1999)

McCullough, David, *The Great Bridge: The Epic Story of the Building of the Brooklyn Bridge*
(Simon & Schuster, 1972)

Miller, Sara Ceder, *Central Park, An American Masterpiece* (Harry N. Abrams, Inc., 2003)

Paterson, Jerry E., *Fifth Avenue: The Best Address* (Rizzoli International Publications, 1998)

Snyder-Grenier, Ellen M., *Brooklyn! An Illustrated History* (Temple University Press, 1996)

Snow, Richard, *Coney Island: A Postcard Journey to the City of Fire* (Brightwaters Press, 1984)

Stern, Robert A.M., Fishman, David, and Mellins, Thomas, New York 1880 (Monacelli Press, 1999);
and *New York 1960* (Monacelli Press, 1997)

Stern, Robert A.M., Gilmartin, Gregory, and Massengale, John, *New York 1900*
(Rizzoli International Publications, 1983)

Stern, Robert A.M., Gilmartin, Gregory, and Mellins, Thomas, *New York 1930*
(Rizzoli International Publications, 1987)

Stern, Robert A.M., Fishman, David, and Tilove, Jacob, *New York 2000* (Monacelli Press, 2000)

Wist, Ronda, *On Fifth Avenue: Then and Now* (Carol Publishing Corporation, 1992)

Endpapers

Front: Brooklyn Bridge, c. 1885 (Library of Congress)
Back: Bird's-eye view of New York, c. 1875 (Library of Congress)

First published in the United Kingdom in 2011 by
PAVILION BOOKS
10 Southcombe Street, London W14 0RA
An imprint of Anova Books Company Ltd

© Anova Books, 2011

ISBN: 978-1-86205-935-1

A CIP catalogue record for this book is available from the British Library.

10 9 8 7 6 5 4 3 2 1

Picture credits
Library of Congress: 6–7, 9, 12, 13, 14 (above), 16–21, 22 (right), 23, 26–28, 30 (above), 31, 32, 33 (right), 34–36, 38 (left), 39, 41, 42 (above), 43, 44, 46 (bottom), 47, 49 (top left), 50–51, 53 (bottom), 54 (right top and bottom), 58 (bottom), 59–61, 64–65, 66 (left), 67, 70 (left), 71–72, 73 (right), 76–81, 82 (right), 83, 85 (left and right), 86–88, 89 (bottom), 90 (left and right bottom), 94–96, 97 (left and center), 98 (center and right), 100–101, 102 (left and center top), 105 (left), 106 (above), 108–109, 110 (left and center), 111, 113, 114 (left), 118 (bottom), 119–120, 221 (left), 122–123, 126 (right), 137–139.

Corbis: 8, 10, 14 (right), 24, 29, 30 (below), 33 (left), 38 (right), 40, 42 (below and top right), 48, 49 (top right and bottom), 52, 53 (top left and right), 55, 57 (left), 58 (top left and right), 63, 66 (right), 68, 70 (right), 73 (left), 75, 82 (left), 89 (left and top), 90 (top), 91–92, 93 (left and right bottom), 97 (right), 98 (left), 99, 102 (right and center bottom), 103–104, 106 (bottom right), 107, 110 (right), 112, 116, 117 (left), 118 (top), 124–125, 127–128, 132, 133 (right), 135–136, 142–143.

Getty images: 15, 22 (left), 45, 54 (left), 56, 62 (right), 105 (right), 114 (right), 115, 117 (right), 126 (left), 129 (left), 130–131, 134, 140.

Anova Image Library: 46 (top), 57 (right), 62 (left), 69, 74, 93 (top), 106 (left), 121 (right), 129 (right), 133 (left and center), 141.

New York Historical Society: 11, 25, 37.

Museum of the City of New York: 14 (top right).

New York Public Library: 85 (center).

Repro by Rival Colour Ltd, UK
Printed by 1010 Printing International Ltd, China

www.anovabooks.com

LOST NEW YORK

Marcia Reiss

PAVILION

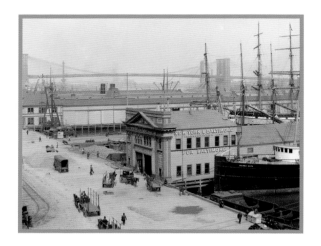

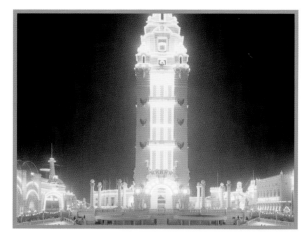

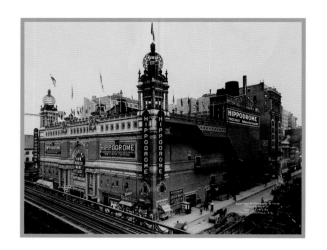

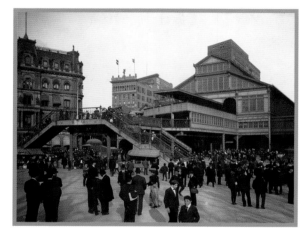

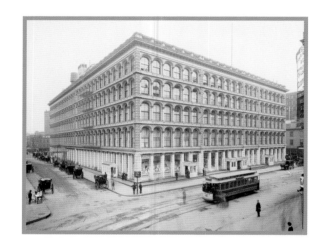

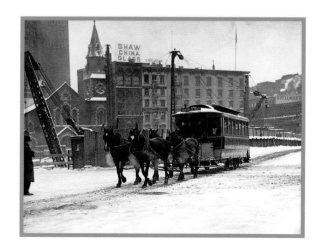

LOST IN THE...

First Metropolitan Museum of Art

ENGULFED BY ADDITIONS 1895

When it came to the subject of art museums, nineteenth-century New Yorkers had an inferiority complex. They desperately wanted their city to become a world-class metropolis with cultural institutions comparable to those many had seen in European capitals. But while the city was growing by leaps and bounds after the Civil War, it lacked an art museum to be proud of. It had a National Academy of Design that showcased the work of living artists and an art collection in the New York Historical Society, but not a grand museum. In 1869, John Jay, grandson of the famous jurist, called for "a museum of Art, which…shall be worthy of the great city of a great nation." His call resounded in the hearts and minds of the city's civic leaders. Within a few months, the Metropolitan Museum of Art Association was formed and plans were laid to build the museum in the city's new Central Park.

The association had big plans for the museum. From the start, it was to be a building with several wings that would hold the expanding collections of art being acquired by smaller institutions and private individuals. Calvert Vaux and Jacob Wrey Mould, two architects who had shaped Central Park, were hired to design the first building at the park's northern end at Fifth Avenue and 82nd Street.

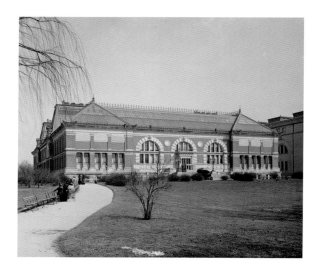

While the architects saw it as the central element in the group of buildings to come, it ended up being buried within the much larger, grander additions.

Completed in 1880, the first building was the target of immediate criticism by the press and public. The problem was a difference in taste, not only in style but also in what was appropriate for a building within a park. Vaux, together with his partner in creating Central Park, Frederick Law Olmsted, believed that grand buildings were an intrusion into its naturalistic setting. In the early years of building the park, they had fought off efforts by the classical architect Richard Morris Hunt to place huge, formal gates at one of the entrances. Hunt became a trustee and architectural advisor for the museum and would later have his artistic revenge.

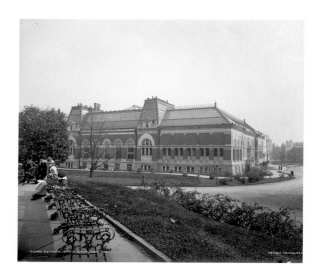

RIGHT *The Greco-Roman entrance to the museum was the first of many additions that blocked the original building, seen only in part on the far right behind the grand façade.*

LEFT AND ABOVE *Front and rear views of the original Arts and Crafts museum building, designed by the same architects who shaped Central Park.*

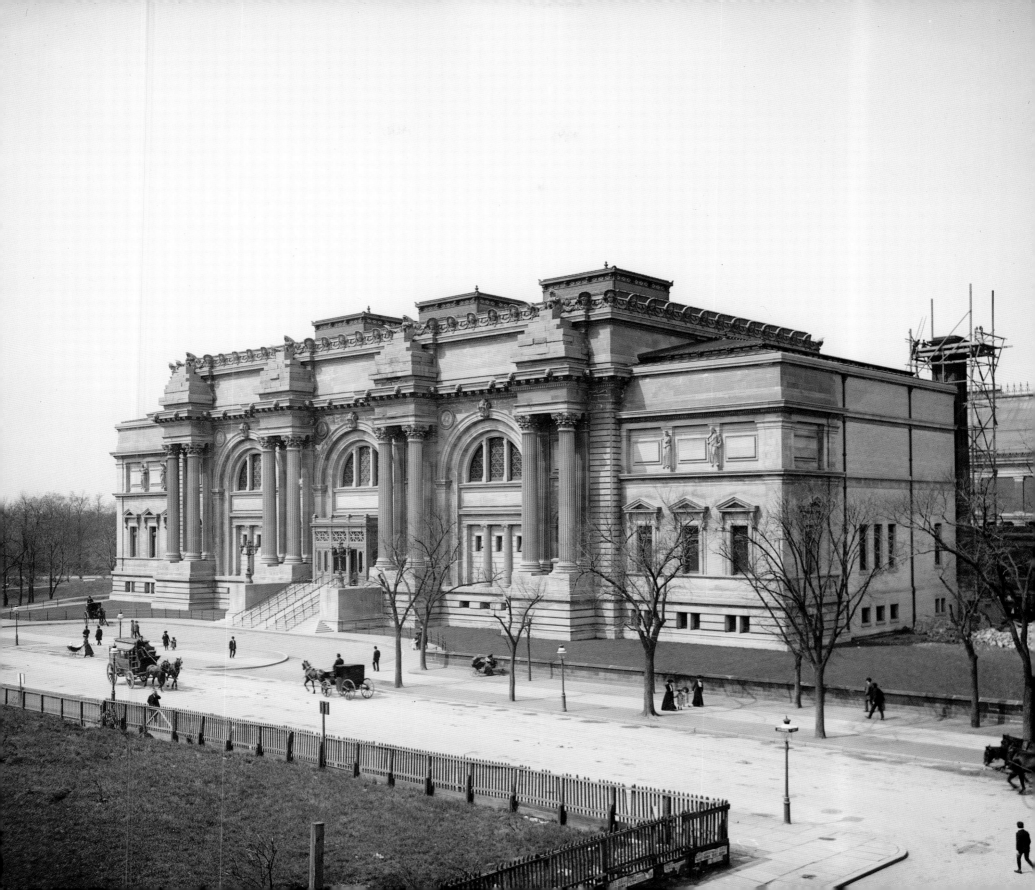

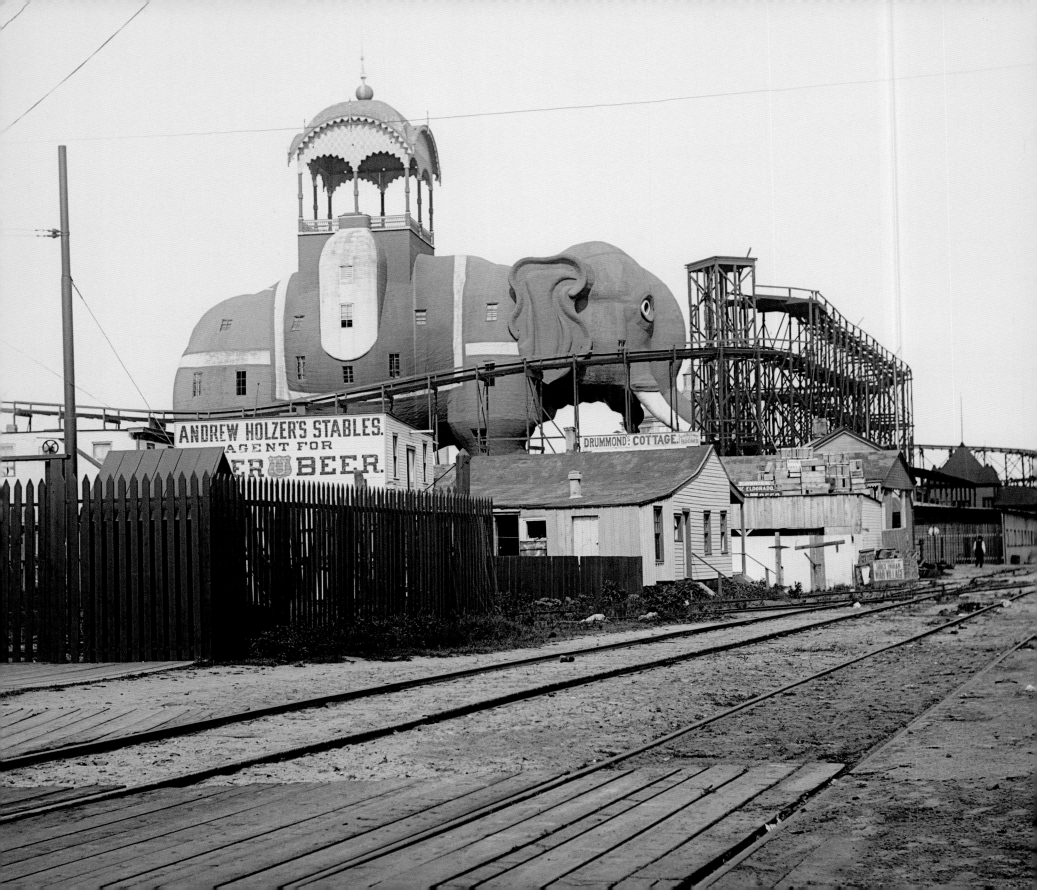

Coney Island's "Elephantine Colossus"

BURNED 1896

In the wild, carnival world of Coney Island's heyday, anything was possible—even a hotel shaped like an elephant. It was built in 1885, a time when more than five million people a year were coming to the narrow sandbar at the southern foot of Brooklyn, pouring in on railway lines, steamboats and roads that reached this remote location after the Civil War. In the 1860s, a few hotel entrepreneurs thought that it could become a summer haven for millionaires, like the one in Newport. While luxury resorts were built at the eastern end of the island in the 1870s and 1880s, the western section where the amusement parks took hold was anything but exclusive. It drew the full spectrum of New York City's working-class population, flooded with ethnic diversity in the waves of immigration that rose in the 1880s. Everyone wanted to see the sideshows and theatricals, take a spin on the rides or a dip in the ocean. And everyone wanted to see the Elephantine Colossus.

Twelve stories high, 150 feet to the top of its howdah or riding platform, it offered breathtaking views of the ocean and the surrounding amusements. From the observatory, one could also watch the horses running at the Sheepshead Bay (see pages 26–27) and Brighton Beach racetracks, and gaze at the splendid Manhattan and Brighton Beach hotels (see pages 22–23 and 28–29). Those resorts were off-limits to working-class New Yorkers, but affordable hotel rooms were available in the elephant itself, thirty-four in its head, stomach and feet. It also had a cigar store in one foreleg, a diorama in the other, and a dairy stand in its trunk. The builder, J. Mason Kirby boasted that it was the "eighth wonder of the world" and could hold 5,000 people. Unfortunately, some of them were pickpockets and prostitutes who gave the elephant a shady reputation.

OPPOSITE PAGE *Twelve stories high, the giant elephant towered over every other attraction in Coney Island.*

BELOW *The huge creature held thirty-four hotel rooms inside its head, stomach and feet, along with stores and attractions within its legs.*

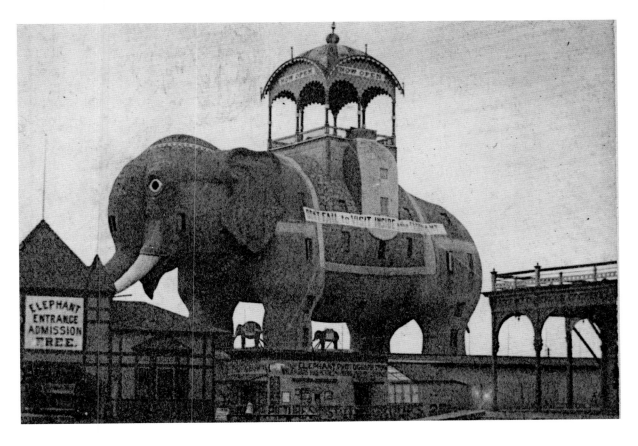

PATENT ELEPHANT BUILDINGS

Although it was not the first building shaped like an elephant, the colossus was the largest of its kind and the only one that operated as a hotel. The first one, sixty-five-feet tall, was built in 1881 as a house in Margate, New Jersey, near Atlantic City. Two floors of living space were in the body, with a staircase in a rear leg. The builder, James Lafferty, got a patent giving him the exclusive right to build elephant-shaped buildings for seventeen years. It is not clear if Kirby violated the patent with his Coney Island version, but in 1896 the wood and tin colossus was destroyed by fire, leaving little reason for a lawsuit. Lafferty's elephant, dubbed "Lucy," has enjoyed a long life despite a near brush with demolition in the 1960s. A "Save Lucy" campaign in 1970 raised enough money for repairs and led to her designation as a National Historic Landmark. While Lucy still stands in New Jersey, she does so at only half the height of the colossus, whose sheer size and amazing presence lives on in Coney Island history.

Fifth Avenue Reservoir

DEMOLISHED 1899

On a cold December night in 1835, a fire spread throughout Manhattan's financial district, destroying 674 buildings, including the New York Stock Exchange. Moving quickly in high winds, the fire could not be contained by the city's woefully inadequate water supply system. The disaster proved to be the spark for building the Croton water supply system, which included this reservoir. An engineering triumph, the system began pumping water in 1842.

Nothing is more critical to a city's growth than a source of clean water. Even before the American Revolution, New York City had grown to a point where it was struggling to maintain enough water for its residents. Before the Croton supply system was built, New Yorkers depended upon various unreliable sources. Fresh-water ponds, wells and rainwater cisterns often became polluted with urban refuse, airborne cinders and dust. Those who could afford to do so purchased water from private dealers who carted it into the city in casks hauled from rural locations or transported on ships. The limited supply led to outbreaks of disease, notably a cholera epidemic in 1832 that killed 3,500 people. The first arrival of pristine water flowing through the Croton system in 1842 was the occasion for parades, fireworks, music and fountains shooting plumes of water into the air.

OPPOSITE PAGE *The massive reservoir held twenty million gallons of water transported to Manhattan through pipes and tunnels from the Croton Watershed forty miles north of the city.*

BELOW *By the end of the nineteenth century, the reservoir, seen on the right, was surrounded by city buildings, including a women's college directly across Fifth Avenue.*

LIQUID ASSETS

The water came from the Croton watershed north of the city, traveling forty miles through aqueducts, tunnels and reservoirs to reach Manhattan. It flowed into a holding reservoir in what would become Central Park and then reached the distributing reservoir at Fifth Avenue and 40th Street, a monumental structure with granite walls, fifty feet high and twenty-five feet wide. They held twenty million gallons of water that were distributed through pipes to Manhattan buildings, providing clean drinking water and a plentiful supply for sewers and street cleaning. However, the system did not reach the worst slums whose inhabitants could not afford the water charges. Over time, the supply was not enough to keep pace with the city's tremendous growth and plans were made to expand the system with larger reservoirs in other locations.

Although the city had not expanded much beyond 42nd Street when the Fifth Avenue reservoir opened, over the years homes and even a college surrounded this four-acre, man-made lake and its site was increasingly in demand for other uses. In 1881, the state legislature approved a plan to replace the reservoir with a park. One was already in place next to the reservoir, called Reservoir Square (now Bryant Park). The state legislature also went on to approve plans for an expanded water supply system, which opened in 1890, carrying water to more reservoirs, including a much larger one in Central Park. Despite the plans to turn it into a park, the Fifth Avenue reservoir held its ground, continuing to be a public attraction for promenading on top of its wide walls. In 1895, a group of civic-minded New Yorkers secured the site for another public facility—the New York Public Library— a central research center for the entire city. The reservoir finally came down in 1899, but the library would take more than a decade to be completed. It opened in 1911, a classical temple of books that has held this once watery ground for a century.

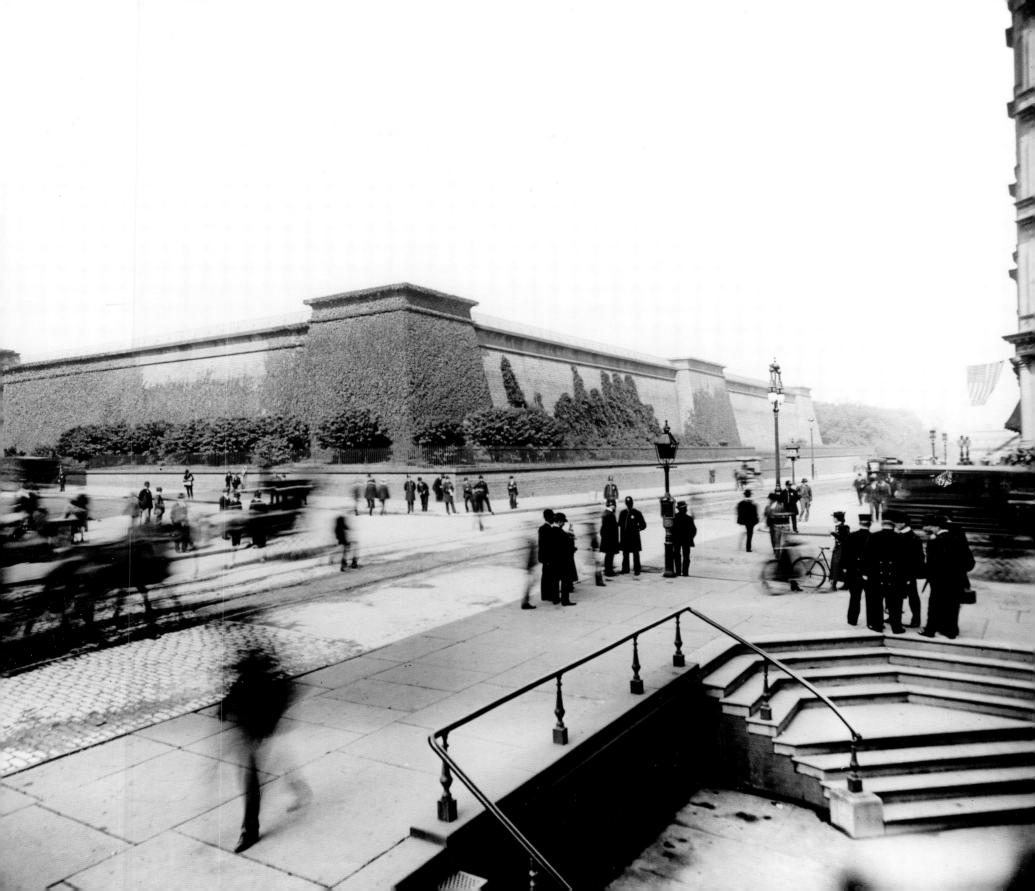

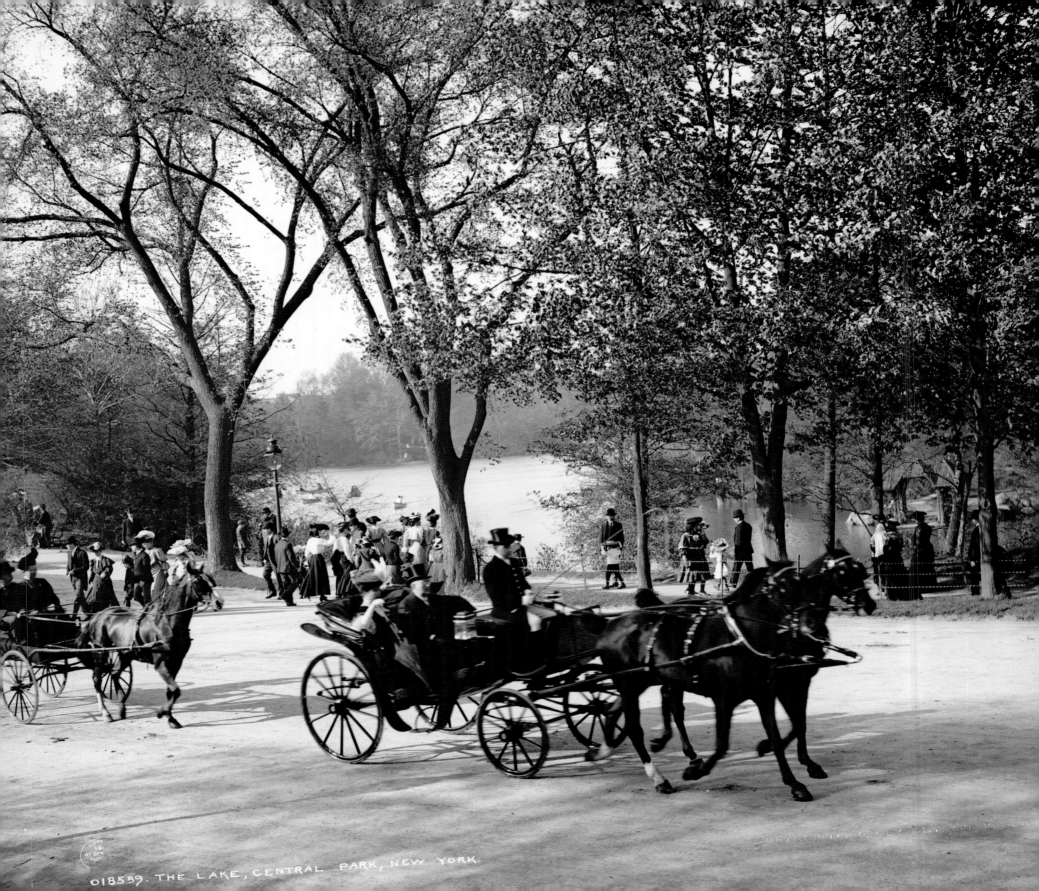

Horse-drawn carriages in Central Park

MONOPOLY ENDED 1899

While Detroit became the motor city in the twentieth century, New York City was the leading manufacturer of horse-drawn vehicles in the mid-nineteenth century. Among the many New York manufacturers of private carriages, Brewster and Company was internationally known for providing elegant carriages to wealthy patrons—and wealthy they were. An elegant carriage could cost as much as 1,200 dollars, a fortune compared to the average annual income for working-class New Yorkers of about 300 dollars at mid-century. The business got a big boost with the opening of carriage drives in Central Park in the early 1860s. Even before the park was finished, carriage owners turned out in droves to use the newly completed drives. The upper classes of New York were eager to escape crowded city streets and, just like their much-admired European counterparts, parade their carriages in a beautifully landscaped park.

To wealthy New Yorkers, one of the strongest arguments for building Central Park was to have a suitable place for carriage driving. For those who could afford horse-drawn carriages, a large park was a beautiful place to show them off, away from the noise, dirt and all-too-common companionship of commercial traffic. Commercial wagons were banned from the park drives, restricted to the transverse roads that ran beneath the park. The drives were curved rather than straight to prevent racing by "fast trotters." Frederick Law Olmsted, the park designer, knew the perils of carriage riding from a personal accident in 1860 that left him with a pronounced limp for the rest of his life. When cars first came on the scene, they were banned from the park, but the Automobile Club of America challenged that ruling in 1899 and won. Although park rules allowed only "pleasure carriages," the judge ruled that autos also fit the definition. As more cars entered the park, they clashed with horse carriages and tore up the gravel drives. Park police found it nearly impossible to enforce the eight-mile-an-hour speed limit. In 1912, the parks department began asphalting the carriage drives, and a few years later the park speed limit was increased to fifteen miles an hour. The age of the automobile had begun and soon expensive cars, not carriages, became the new status symbol.

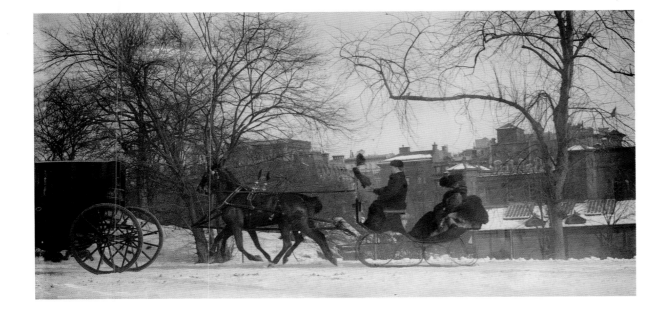

OPPOSITE PAGE *Wealthy New Yorkers paraded their horse-drawn carriages in Central Park, while the less affluent strolled along the lake.*

LEFT *Snowy weather brought horse-drawn sleighs and covered carriages to the park.*

Jay Gould's Mansion DEMOLISHED 1906

Jay Gould was a financier, but most people called him a robber baron, an unscrupulous speculator who made his fortune by manipulating stocks. His attempt to corner the gold market in 1869 caused a financial panic that ruined unwary investors and ensnared the presidency of Ulysses S. Grant in scandal. Gould walked away unharmed. He also had his hand in the biggest business transactions in nineteenth-century America, at various times owning railroads, telegraph companies, elevated rail lines, and New York newspapers. He lived in several mansions and in 1886 purchased this one on Fifth Avenue and 67th Street as a gift for his newly married son, George J. Gould and his wife, the actress Edith Kingdon. Jay Gould's dealings had made him an outcast in New York society. Although he owned a magnificent yacht, he was blackballed by the elite New York Yacht Club and never invited to Mrs. Astor's society balls. But things changed after his death in 1892. Although the senior Mrs. Gould had opposed her son's marriage to an actress, the charming Edith managed to maneuver her family into Mrs. Astor's good graces. She and her husband were invited to the balls at the new Astor mansion just two blocks away (see pages 48–49). Edith often appeared wearing a tiara of peacock feathers adorned with emeralds that had belonged to the Emperor of China.

Over time, this mansion became "too small" for George and Edith's family of seven children. Amply endowed with Jay Gould's fortune of more than seventy-three million dollars, they demolished this "unfashionable" Gothic building in 1906, acquired the lot next door, and built a "modern" French Renaissance-style home that filled out the corner site. Unfortunately for Edith, the new Parisian-style building proved to be French in more ways than one. During the couple's residence, George maintained a mistress elsewhere and fathered three illegitimate children. Edith died of a heart attack on the golf course of the Gould's country estate in New Jersey in 1921. George then married his mistress and sold the Fifth Avenue home to make way for an apartment tower that occupies the site today.

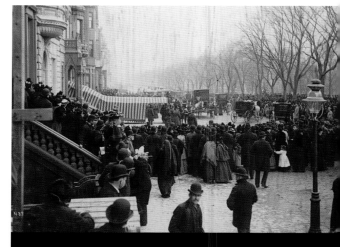

A WEDDING TO REMEMBER

Before George Gould demolished the mansion he had received from his father, he hosted a wedding there in 1895 for his sister, Anna Gould. It was one of the most talked about events of the day. Jay Gould had been dead for three years and the family's reputation was improving. Newspaper reports gushed over the lavish display of expensive wedding gifts and the number of fashionable guests. Anna married Count Boni de Castellane, the bearer of an old French title, but very little fortune. Fifth Avenue mansions provided a ready supply of American heiresses eager for European titles, particularly those looking to put a shine on a shady family name. But like the mansion, the marriage did not have a lasting future. The couple divorced in 1906, the same year the mansion was demolished. The Count had put a dent in the Gould fortune through gambling and various other entertainments. Two years later, Anna Gould married Boni's cousin, a French marquis, but eventually gave up living in mansions and spent her final days in 1961 as a widow surrounded by bodyguards and nurses in a grand suite at the Plaza Hotel.

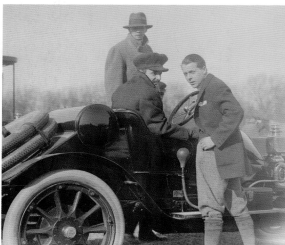

OPPOSITE PAGE *Jay Gould purchased this mansion for his son George and bride Edith. They eventually found it too small for their family of seven children.*

ABOVE *Jay's son George in the driving seat.*

RIGHT *The "robber baron," Jay Gould.*

TOP RIGHT *Crowds on Fifth Avenue watched guests arriving for the lavish wedding held at the mansion in 1895.*

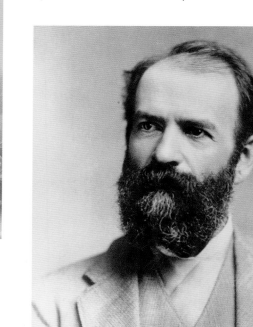

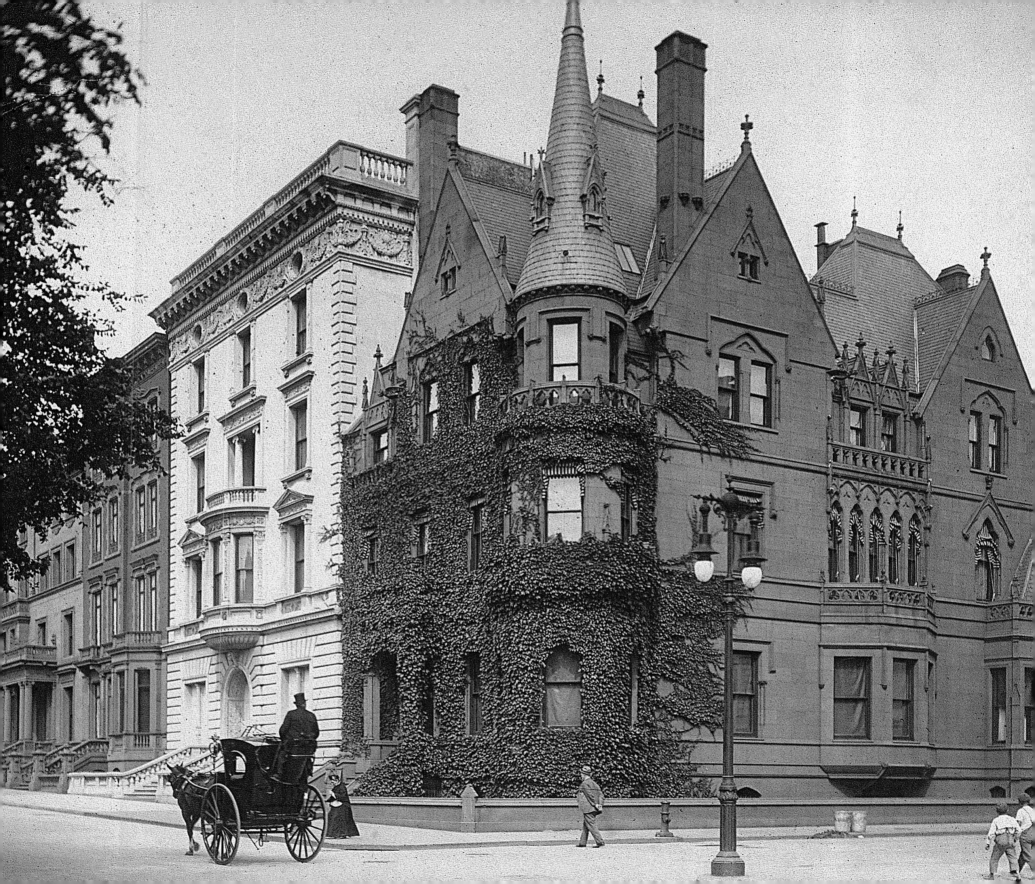

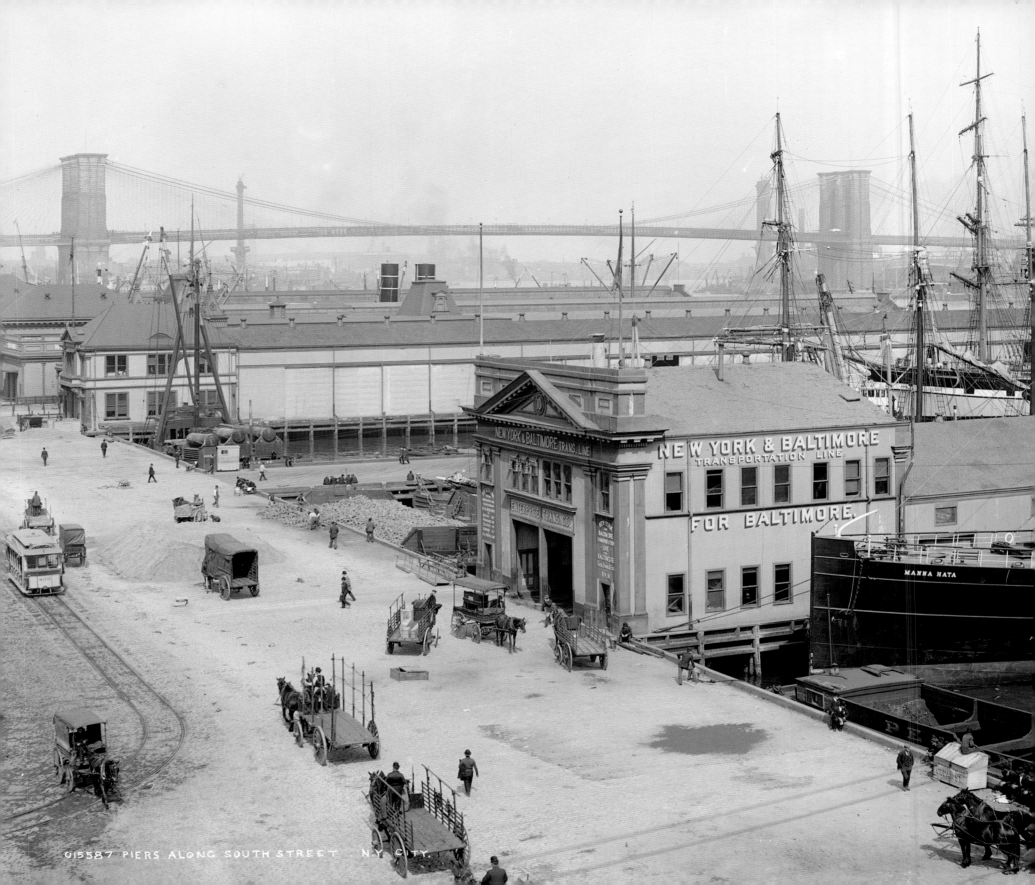

NEW YORK & BALTIMORE
TRANSPORTATION LINE

FOR BALTIMORE.

NEW YORK & BALTIMORE TRANS. LINE

ENTERPRISE TRANS CO

MANNA HATA

015587 PIERS ALONG SOUTH STREET N.Y. CITY.

South Street Seaport END OF AN ERA 1907

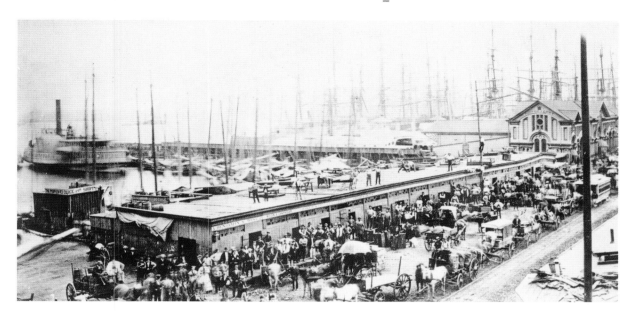

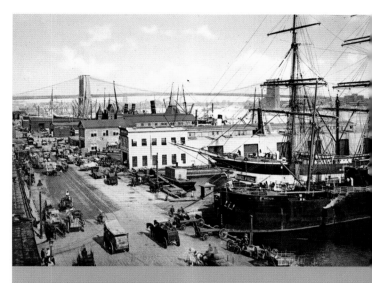

STEAM OVERTAKES SAIL

New York was also the cradle of American steam navigation that began with Robert Fulton's historic trip up the Hudson River in 1807. It took some time for oceangoing steamships to come of age, but when they did, they left South Street far behind. Too crowded and shallow to accommodate the larger steamships, the port began to decline after 1880. The steamship companies, many connected to rail yards on the West Side of Manhattan, moved to the Hudson River waterfront where the water was deeper and they could build large covered piers with better accommodations for cargoes and passengers. Ocean liners and freighters found it easier to maneuver in the Hudson's wider channels and slower tides. In 1907, docking records did not show a single sailing vessel at South Street. A few covered piers had been built, but the era of the great port on South Street was over. In the years ahead, it would become a backwater, rescued in the 1960s only as a museum and tourist attraction.

For most of the nineteenth century, the heart of New York's lucrative shipping trade was the South Street Seaport. From about 1815 to 1880, this strip of Lower Manhattan waterfront along the East River was a forest of tall-masted ships. They were New York's first skyscrapers and included every type of sailing vessel. Brigs, barks, schooners, packets and the fastest of them all, clipper ships, lined the waterfront from the Battery to Fulton Street, their bowsprits and booms jutting over South Street and nearly touching the buildings on the other side. They carried cargoes to and from places all over the world: London and Amsterdam, Calcutta and South America. The swift clippers also carried hoards of Easterners to California in 1849, hoping to get rich in the Gold Rush. The smaller vessels brought sugar and molasses from the Indies, cotton, tobacco and lumber from the South, and goods of all kinds manufactured in the mills and factories of New England. Bankers and shippers managed to route much of the South's cotton via New York to New England and Europe—the reason why New York City business interests resisted the North's fight in the Civil War and why Abraham Lincoln was elected president in 1861 with only a third of the city's votes.

Many of the Seaport's sailing ships were made in Manhattan's East River shipyards, which employed thousands of workers. The entire waterfront was a crowded, rowdy neighborhood of maritime shops, boarding houses, saloons, and brothels. Filled with the sounds and smells of the sea, it was packed with horses, wagons, and men of every trade, all jostling for space. The Fulton Ferry, which started running from Brooklyn to South Street in 1814, and the Fulton Market, operating here since 1822, also added to the hustle and bustle. But over the years, they would replace shipping as the major activity on this part of the waterfront.

OPPOSITE PAGE *Steamships, like the* Manna Hata *on the far right, displaced the sailing vessels that had made South Street New York's busiest port.*

ABOVE *Crowds of people and carriages are lined up for the arrival of the Fulton Ferry at the South Street terminal (far right). In the background is an uninterrupted line of tall masts from the sailing ships docked at the port.*

RIGHT *By the early 1900s, the forest of tall-masted ships that had once lined South Street had been pruned to only a few remaining sailing vessels.*

Coney Island's Dreamland BURNED 1911

In 1904, Dreamland's developers tried to outdo other attractions in Coney Island by trying something new. Along with rollicking rides and frightening freak shows, they wanted to build a grander and more sophisticated amusement park, an educational experience that would sanitize Coney Island's rowdier aspects and appeal to the genteel middle class—a Disneyland of its day. On the outside, it was tall, white and splendid, an architectural fantasy of a dream city with a 375-foot central tower surrounded by classical imitations of European landmarks, including the Doge's Palace and a *papier-mâché* version of Venice. But on the inside, Dreamland also had its share of the same blood and thunder acts that had always drawn people to Coney Island. As Richard Snow describes in *Coney Island: A Postcard Journey to the City of Fire*, the "Fighting the Flames" show had scores of firefighters armed with steam pumpers and hook-and-ladder trucks climbing over a six-story building to put out a sham fire while men and women leapt from the roof into nets. In the miniature city of Old Nuremburg a colony of midgets had a pint-sized fire department that rushed to put out false alarms at each show. Visitors also could take a Hell Gate ride and a Shoot-the-Chutes water slide or watch Captain Jack Bonavita try to tame wild lions and tigers. He lost an arm in a confrontation with one of the cats, which doubled his popularity when he returned to the ring.

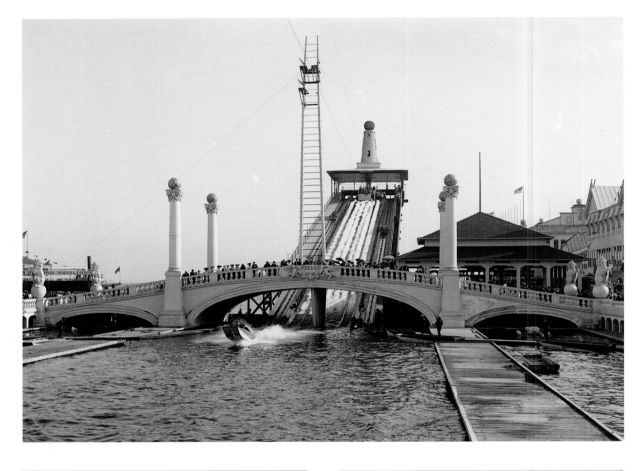

OPPOSITE PAGE *Every day in the Fighting the Flames pavilion, scores of firefighters squelched a sham fire in a six-story building while men and women jumped from the roof.*

ABOVE *The Shoot-the-Chutes ride plunged boat passengers down a steep water slide.*

RIGHT *A pagoda was the unlikely entrance to the Air Ship ride.*

FAR RIGHT *A 375-foot-tall tower was the focal point of Dreamland's fantasy world.*

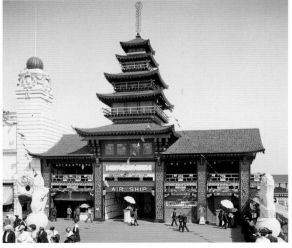

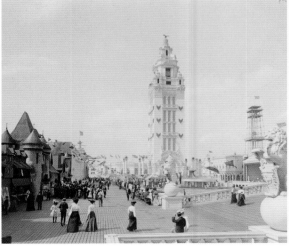

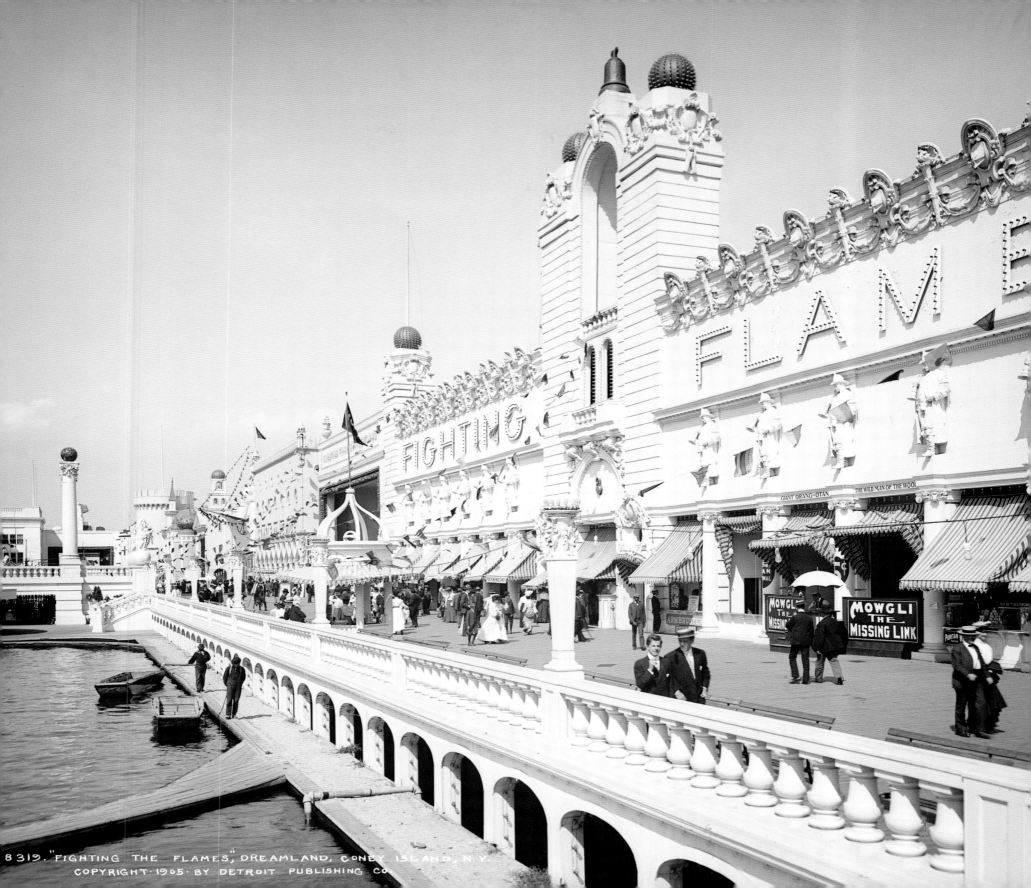

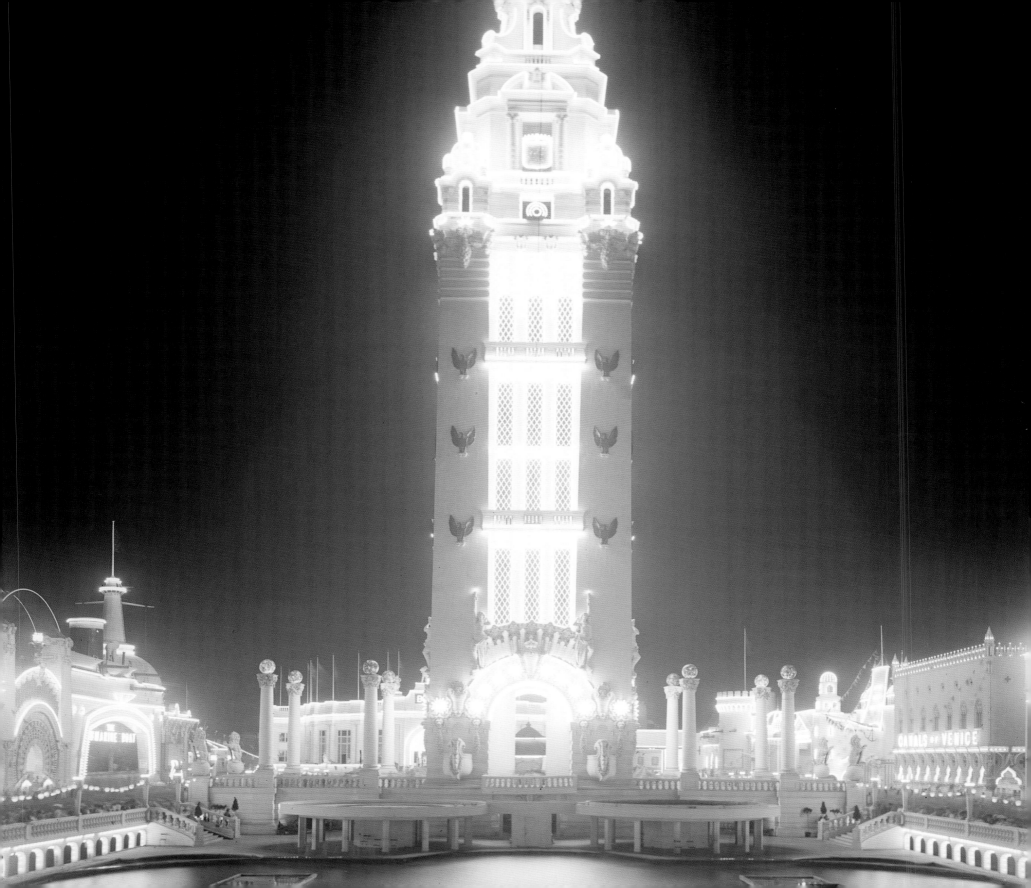

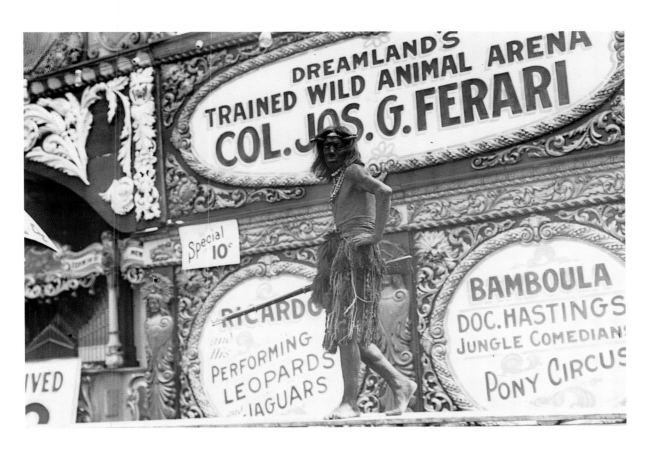

Thank you, Mr. Edison

Outlined with a million electric bulbs—four times more than its rival Luna Park, built just a year before (see pages 78–81)—Dreamland was a fantasy world at night. Years later, its leading developer, William Reynolds would try to create another fantasy in the New York skyline, the Chrysler building. He hired the architect but, short of funds, sold his interest to Walter Chrysler who got the vision built. Reynolds had a brief stint as a New York State senator and built Dreamland with methods that were hardly genteel—or new. The guiding principle was the time-proven practice of political favoritism. Along with a few other local politicians, he got the city government to turn over some of the land for free. They also managed to put down the foundations before the city took away its fire hydrants, leading to years of criticism that they used city water in their shows and rides. Nonetheless, Dreamland never met its expectations and was already experiencing financial losses when the park burned in 1911.

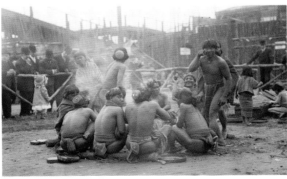

OPPOSITE PAGE *While many homes still lacked electric light, Dreamland was a nighttime vision.*

TOP *Wild animal acts and not-always-native tribesmen were among the attractions.*

ABOVE *Dreamland's manager also brought actual tribesmen from exotic lands.*

RIGHT *The fantasy world was reduced to rubble after the fire.*

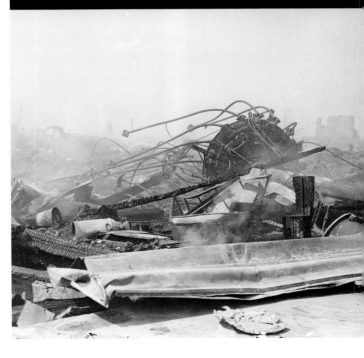

Manhattan Beach Hotel CLOSED 1911

Less than a mile from Coney Island's carnival atmosphere, Manhattan Beach, the eastern end of the Coney Island peninsula, offered a more exclusive setting. No place in Brooklyn was more exclusive than the grand hotels built here in the 1870s. The Manhattan Beach Hotel, built in 1877 attracted the leaders of the Coney Island Jockey Club. These rich horsemen built the nearby Sheepshead Bay Racetrack in 1880 (see pages 26–27), making this part of Brooklyn even more attractive to wealthy Manhattanites like themselves. The Oriental Hotel, built a few years later, brought visiting aristocrats, famous entertainers, powerful politicians, and more wealthy businessmen to this remote section of southern Brooklyn.

The hotels were part of a grand plan by Austin Corbin, the New York railroad magnate who formed the Long Island Railroad. During the depression of the early 1870s, he picked up more than 500 acres of the marshy Brooklyn shorefront at bargain prices. He named it Manhattan Beach to distinguish it from raucous Coney Island (and from Brooklyn in general) and built a railway that whisked Manhattanites from Brooklyn's Greenpoint ferry landing directly to the hotels in just an hour. The hotels charged the highest rates in the country. To keep everyone who could not afford these prices from venturing onto the vast lawns and private boardwalk, a high fence was built around the property. Pinkerton detectives were also stationed at the private railway station to meet arriving trains and screen out undesirables. And to insure even further exclusivity, Jews were banned from staying at the hotels.

The Manhattan Hotel was a summer palace, said to be the largest of its kind when built. It was 600 feet long and 225 feet deep, with 150 rooms, plus indoor and outdoor dining rooms. Guests arrived at the train station behind the hotel and comfortably reached their destination under a covered passageway. At the hotel opening on July 4, 1877, former President Ulysses S. Grant cut the ribbon. John Phillip Sousa wrote the "Manhattan Beach March," which was as popular at the hotel's large bandstand as Sousa's "Stars and Stripes Forever."

OPPOSITE PAGE *The spacious hotel and extensive grounds were a closely guarded retreat for the wealthy.*

BELOW LEFT *The hotel's front porch was an elite gathering place.*

BELOW RIGHT *The Oriental Hotel, another exclusive resort on Coney Island's eastern end.*

FALL FROM GRACE

Corbin enjoyed the glory of his beach empire throughout his lifetime. He died in 1896 after a fall from his horse carriage, more than a decade before the area's decline. While he and his wealthy patrons considered themselves above reproach, the reformers in the state legislature saw horse racing as an offense to public morality. In 1910, the legislature banned the bookmakers at the track, effectively shutting down horse racing. Without wealthy racing patrons, the hotels did not last much longer. The Manhattan Beach Hotel closed in 1911 and the Oriental a few years later. The area was sold for housing, originally in a gated community, but eventually opened to wider development. Today the only evidence of Corbin's legacy is a street sign, Corbin Place, in this predominantly Jewish neighborhood.

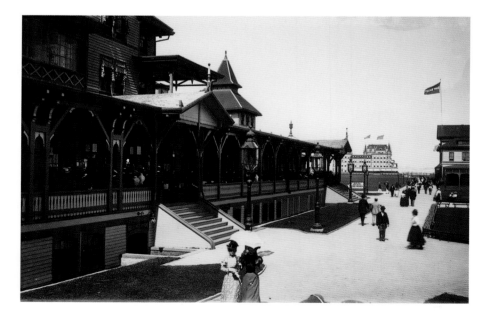

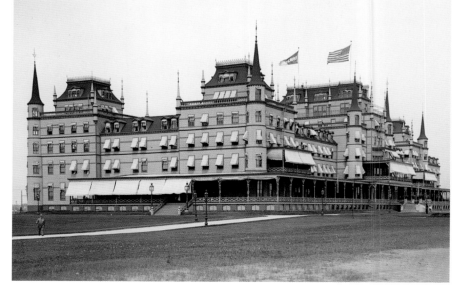

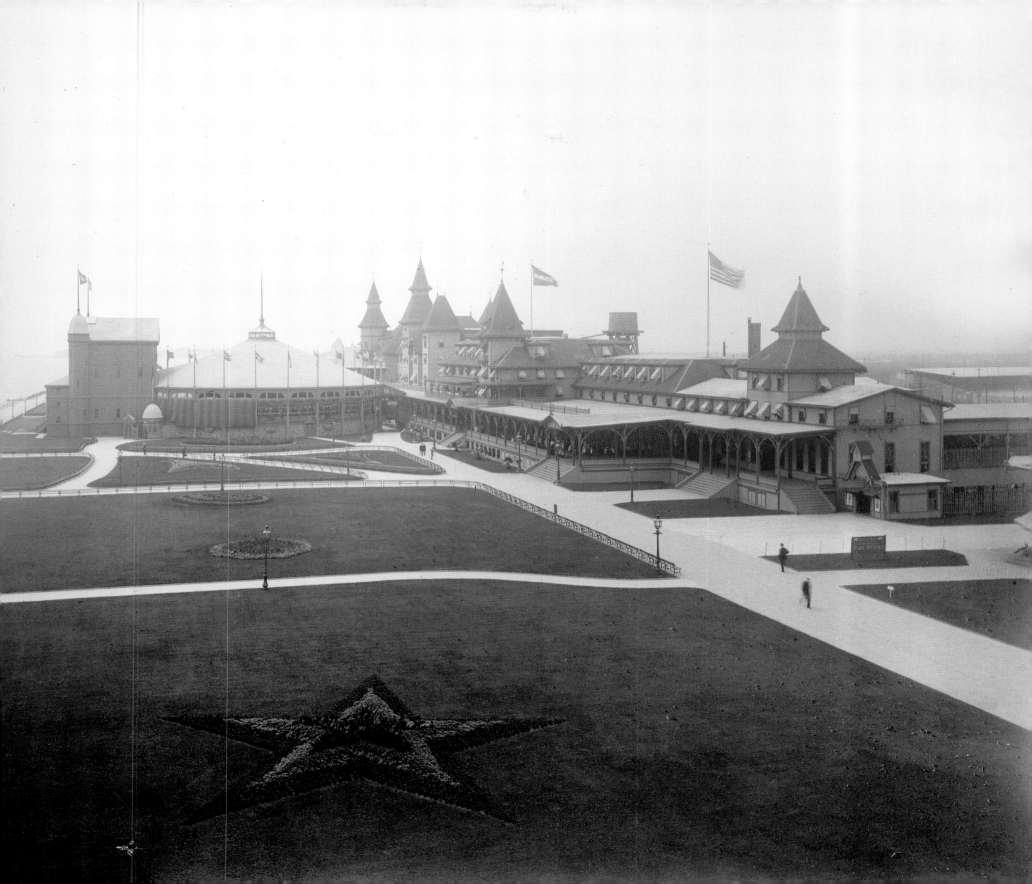

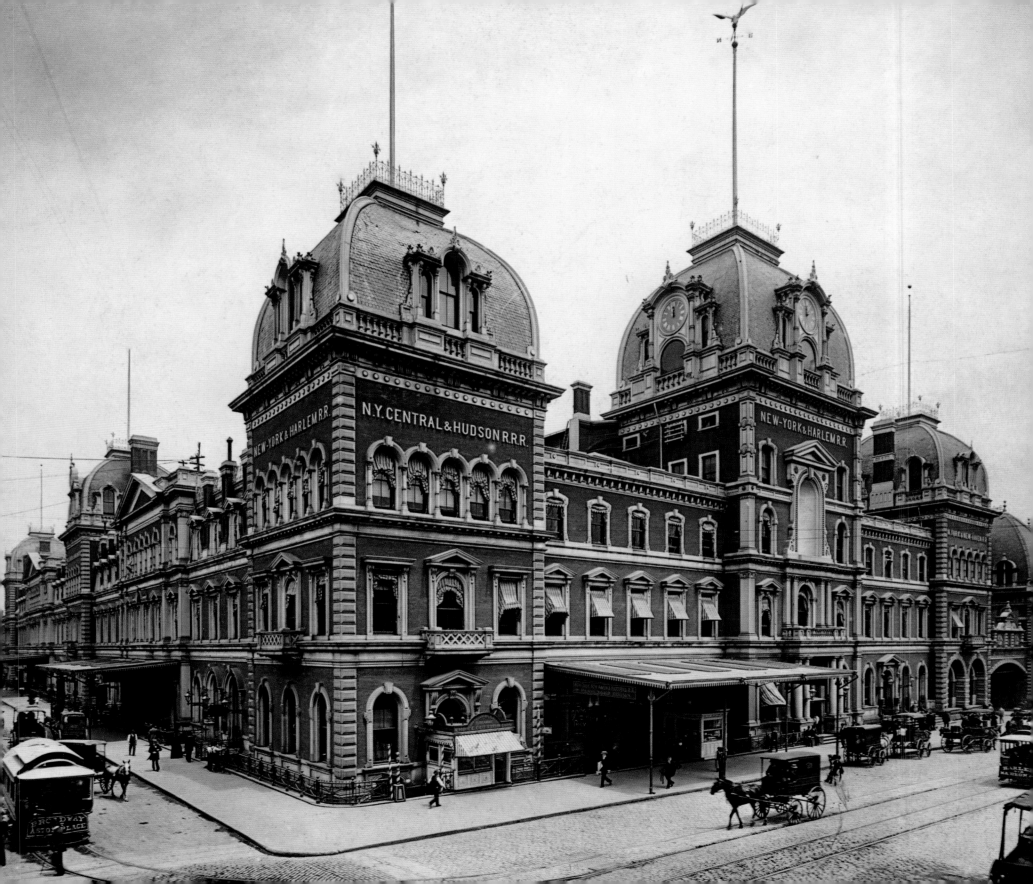

Grand Central Depot REPLACED 1913

If one man could be credited with shaping New York City in the nineteenth century, it would be Cornelius Vanderbilt, whose railroad empire connected America's western heartland to the heart of Manhattan. Born in 1794, this rough-around-the-edges, one-boat ferry operator from Staten Island became one of the richest men in America and patriarch of the Vanderbilt dynasty of multi-millionaires. He amassed his fortune in shipping and was always known as "the Commodore," but his greatest achievement was in consolidating railroad lines and bringing them together under one roof on 42nd Street in the center of Manhattan. His statue now stands in front of New York's famous Grand Central Terminal, surrounded by swirling lines of cars. But this was not the first passenger terminal at the site. Its predecessor was the Grand Central Depot, America's first great railroad station.

In 1865, after eight years of trying, the seventy-one-year-old Vanderbilt finally took control of the major railroads operating in the city. But ridership had doubled in the 1860s and each of the lines, entering the city from various directions, had an inadequate Manhattan terminal. Merging them

as the New York Central Railroad, he decided to build a central depot that could service them all. New tracks were laid, joining the lines on the east and west sides of the island so that they could all enter the new terminal. Construction began in 1869 and when the entire complex was completed in 1871, New Yorkers marveled at its tremendous size. Covering thirty-seven acres, it included a French Second Empire-style depot inspired by one in Paris and a train shed of heroic scale. More than 652 feet long and 100 feet high, the glass-and-wrought-iron shed was the largest enclosed space on the continent.

In 1871, 42nd Street was the northern edge of the city and at the depot's opening, goats could be seen in rural homesteads across the street. While some critics carped that the depot was "neither grand nor central," Vanderbilt could not have found a more central location at the time since steam locomotives were banned south of 42nd Street. But once the depot began operating, bringing thousands of people to the area, it propelled the city's expansion northward at a speed never before imagined.

DEATH TRAP

Unfortunately, the trains—as many as eighty-five a day—speeding on the open tracks that ran for blocks north of the depot soon became a death trap for people attempting to cross the area. Footbridges were built, but the noise and dirt of the steam locomotives made the area a chaotic, dangerous expanse. In 1902, after a deadly collision of two trains in a steam-filled tunnel, the city required all tracks to be electrified. In a daring plan, New York Central's chief engineer proposed sweeping away the old track system and building a new, massive complex on two levels underground. The tracks were covered by streets and buildings that became today's Park Avenue. This intricate system and a magnificent new terminal were built over the course of a decade while the old depot continued operating. The old building was torn down in phases between 1903 and 1913, when the new Grand Central Terminal that stands today was completed. The Commodore did not live to see it, having died in 1877. His heirs continued to control the railroad until the 1950s, when the company tried to tear down the terminal but were stopped by preservationists.

OPPOSITE PAGE *Completed in 1871, Grand Central Depot was America's first great railroad station.*

LEFT *At a time when horse-drawn carriages and trolleys were the major forms of transportation, the New York Central Railroad connected New York to America's heartland.*

Sheepshead Bay Racetrack and Speedway CLOSED 1919

Six New York racetracks were operating in the late nineteenth century in the Bronx, Brooklyn and Queens, but if you were part of the elite horseracing set, there was only one place to go—the new track in Sheepshead Bay, near Coney Island. It opened in 1880, sponsored by the Coney Island Jockey Club, formed by some of the city's richest horsemen: William K. Vanderbilt, August Belmont, William Travers, Leonard Jerome, and Pierre Lorillard. Their names comprised a roster of nineteenth-century wealth and social prominence derived from railroads (Vanderbilt), banking (Belmont), Wall Street (Jerome and Travers), and tobacco (Lorillard). Travers had founded the Saratoga Racetrack in 1864, now the oldest operating sporting venue in the country. Jerome, who also had built an earlier

racetrack in the Bronx, would later become known as the grandfather of Winston Churchill. Coney Island may seem an unlikely place for this powerful group, but they were drawn there by the opening of the exclusive Manhattan Beach Hotel in 1877 (see pages 22–23). The hotel provided an ample supply of well-heeled racing fans and, thanks to the Jockey Club's connections, the track had the best horses and highest-paying purses in New York.

Extending for 125 acres north of the bay, it established the first turf racecourse in the country, placed inside the main dirt track, the practice still followed today. It also inaugurated some of the highest paying stakes races in the country, including two still held at Belmont Park Racetrack in Long Island, named for August Belmont. While the

track was a great success with racing enthusiasts, opposition to gambling was mounting in the state legislature. It had outlawed the old form of auction pool betting in 1877, but the track, protected by its influential backers and local politicians, kept gambling going by allowing bookmakers to take bets at the track. In 1910, the reformers in the legislature struck back by banning the bookies and all other forms of betting, effectively putting all of the New York tracks out of business, at least for a time. It would start up again in 1913, but by then, the grand Manhattan Beach Hotel was closed and the Sheepshead Bay track would begin a new era of racing.

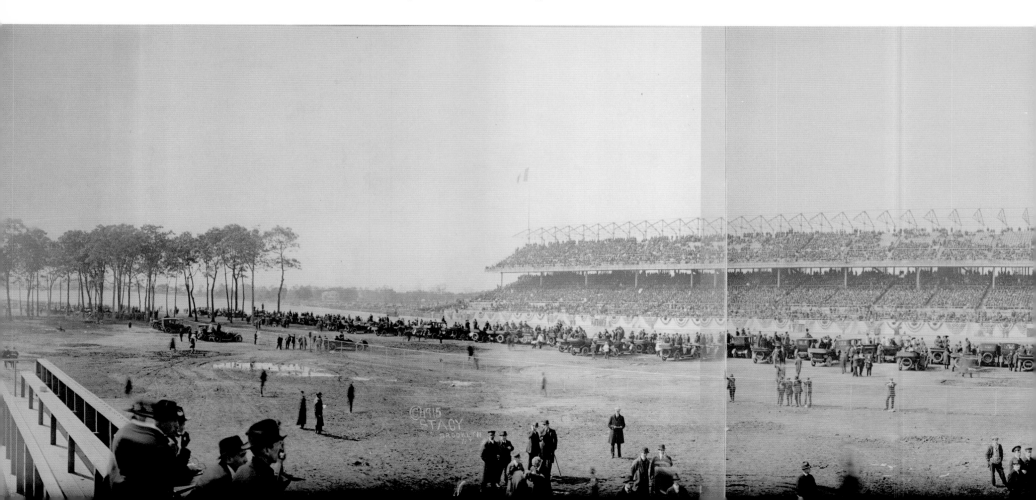

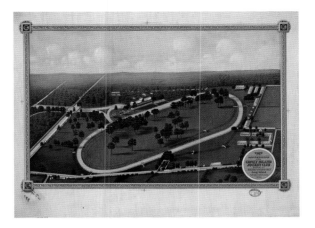

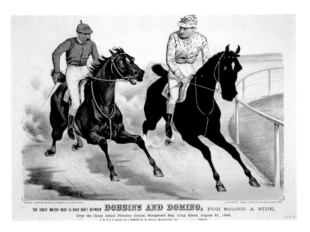

ABOVE (LEFT AND RIGHT) *Two period illustrations of the elite Coney Island Jockey Club's track that drew the best horses and the most lucrative purses to Sheepshead Bay.*

BELOW *The Speedway brought crowds to the southern shore of Brooklyn in the early years of the twentieth century.*

HORSES TO RACECARS

In 1913, a group of auto racing enthusiasts converted the track to the Sheepshead Bay Speedway. The main investor was Harry Harkness, son of an oil magnate. A race car driver, yachtsman and aviator, he might have kept the speedway going through the sheer force of his personality and wealth, helped along by his rumored connections to the notorious gangster and racetrack operator Arnold Rothstein, but he died in the Great Flu Epidemic of 1919. His death ended the speedway's financial backing and marked the final end to the Sheepshead Bay track. In 1923, all 125 acres were cut up into small building plots and sold at auction for housing development.

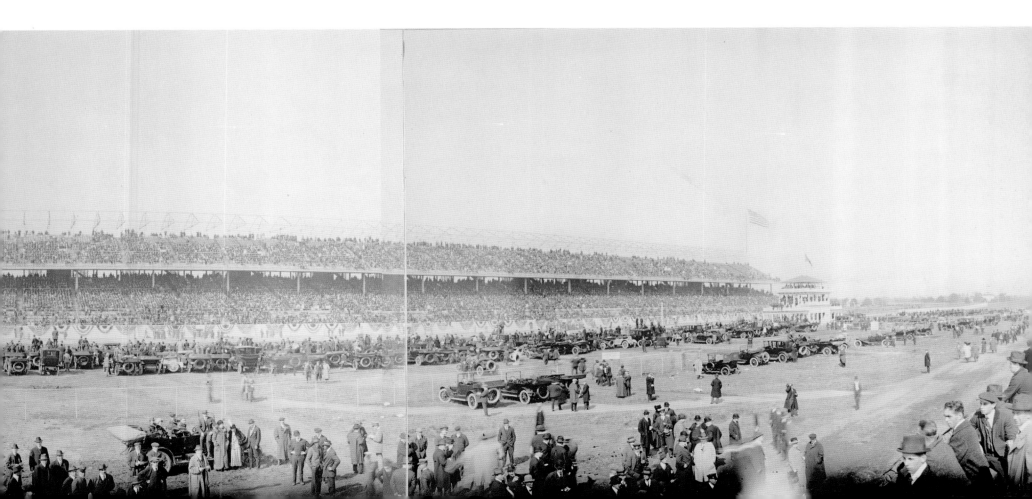

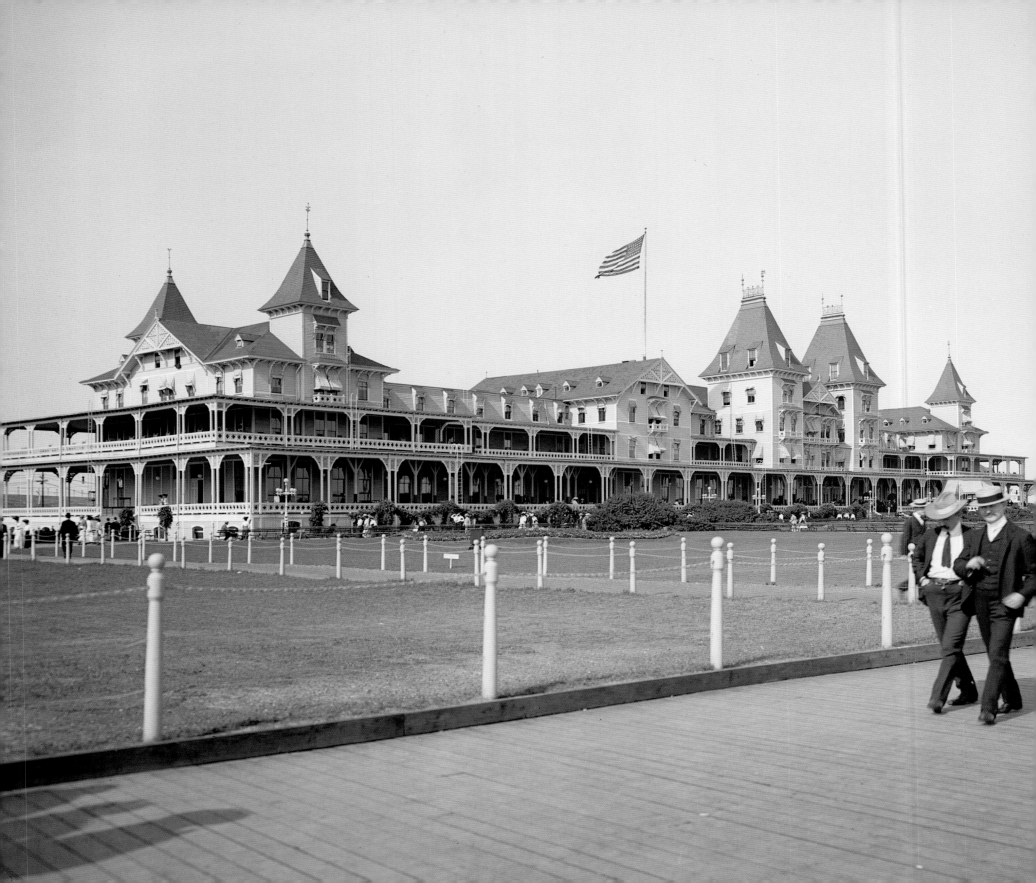

Brighton Beach Hotel RAZED 1921

Built in 1876, this was the first of the grand hotels at the eastern end of Coney Island. Unlike the Manhattan Beach Hotel, which catered to wealthy Manhattanites and would not deign to put the word "Brooklyn" in its name, this hotel was marketed to "good middle-class Brooklynites." Doctors,lawyers, white-collar office workers and businessmen and their families came here to sit on the hotel's wide veranda, stroll along its oceanfront boardwalk, and mingle with other respectable people.

The hotel was the project of a group of powerful businessmen and politicians, including some of the men who had built the Brooklyn Bridge in 1883. They also built the Brooklyn, Flatbush, and Coney Island Railroad to deliver passengers to the hotel's doorstep. With stations conveniently placed near middle-class Brooklyn neighborhoods, families could spend the summer at the hotel, within commuting distance for the husbands, or just train down for a concert at the oceanfront bandstand

and return home by evening. It was a middle-class refuge from the working-class crowds at Coney Island's sideshows, beer gardens and rough taverns. But more exciting entertainment was soon available nearby. Just three years after the hotel was built, the Brighton Beach Racetrack opened and the hotel also began to draw a faster crowd of Wall Street high rollers, actresses and socialites who came for the races.

The hotel developers had bought their property from William Engeman, an enterprising man who had big plans for the area. With a fortune made in the Civil War selling mules to the Union Army, he had bought up two hundred acres of the beachfront property when it was nothing but marshland and sand dunes. He opened the two-story Brighton Beach Bathing Pavilion in 1878 and the racetrack in 1879. Along with the hotel, these two operations made Brighton Beach a profitable investment in the late nineteenth century.

WEATHERING THE STORM

Financially successful, the hotel was even strong enough to overcome the ravages of the Great Blizzard of 1888. The storm, which shut down cities throughout the northeast, washed away the shorefront under the hotel, leaving some of the buildings standing on piles in the ocean. But with vast amounts of capital invested in the hotel, the owners were able to carry off a major feat of contemporary technology. The 300-foot-long hotel was jacked up off its pilings, railroad tracks were laid underneath, and the entire structure was placed on 120 flatcars, which pulled the building back from the encroaching sea.

Although the hotel was able to stand up to Mother Nature, it could not survive the waves of political change in the early 1900s. After reformers prevailed in the state legislature and outlawed betting at the track in 1910, the Brighton Beach Racetrack, like the Sheepshead Bay track, closed and the hotel's racing patrons stopped coming to Brooklyn. Sustained for a while by its family clientele, the Brighton Beach Hotel lasted until 1921, a decade longer than the elite Manhattan Beach Hotel. Once the subways reached the area in the 1920s, housing developers followed and all traces of these grand hotels vanished.

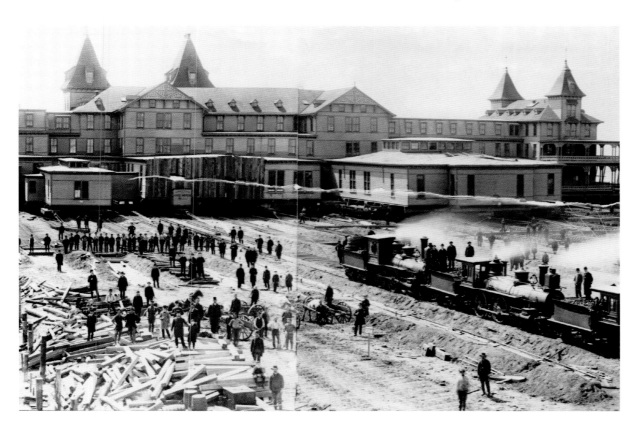

OPPOSITE PAGE *Built as a gracious and spacious retreat for comfortably well-to-do Brooklynites, the hotel also drew racing fans and socialites.*

LEFT *After the Great Blizzard of 1888 washed away the hotel's shorefront, locomotives pulled the entire structure back from the encroaching sea.*

Wall Street Curb Brokers END OF AN ERA 1921

Stock trading on Wall Street began, so the story goes, with a group of men under a Buttonwood tree in 1792. That year, twenty-two brokers signed the Buttonwood Agreement setting forth their membership rules. The business was largely in government bonds that Alexander Hamilton, the first Secretary of the Treasury, had issued to cover debts incurred during the American Revolution. The New York securities market did not become truly active until 1817 when the New York Stock Exchange was formed. It moved its base of operations ten times before opening its current headquarters at Wall and Broad Streets in 1865. During this time, a group of independent traders were doing business out on the streets, just as the Buttonwood brokers had done before. Known as the curb brokers, they would continue their outdoor trading until 1921 when they moved into their first indoor headquarters.

The curb brokers got started by representing the "little guy," small businesses that were too poor to be traded on the New York Stock Exchange, also known as the Big Board. A group of brokers who did not belong to the Exchange began to work with these companies, trading their stocks in auctions conducted out in the street. They took orders at the curb and used hand signals to relay buy-and-sell orders to clerks in adjacent buildings.

At first, they were a loosely organized group with few standards. They handled mostly speculative stocks from small companies with risky enterprises. But as the country and its business opportunities expanded, the volume of activity rose to numbers never seen before. After the Gold Rush of 1848, the number of shares in mining companies exploded and the curb brokers were selling more than the Stock Exchange. They also began trading oil shares after the first American well started pumping in Pennsylvania in 1859, and eventually shares in iron, steel, textiles and chemicals.

OPPOSITE PAGE *Curb brokers literally traded stocks at the street curbs, relaying buy-and-sell orders to clerks in the adjacent windows. The columns of the New York Stock Exchange building, where larger companies traded on the "Big Board," can be seen along the left side of the street.*

BELOW AND RIGHT *Two views of curb brokers crowding Broad Street just south of the New York Stock Exchange.*

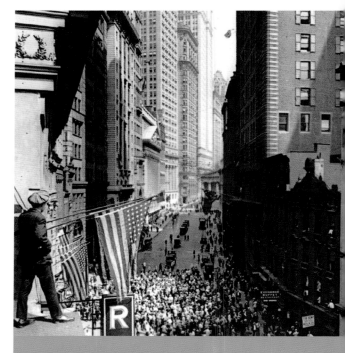

MOVING UP TO THE "BIG BOARD"

In 1911 they established a formal constitution with brokerage and listing standards and became officially known as the New York Curb Market. Even after moving inside a building in 1921, they used the same hand signals for decades and still called themselves the Curb Exchange. By 1930, it was the leading international stock market, listing more foreign securities than all other U.S. markets combined. As smaller firms became well known, they often moved to the Big Board, but the Curb Exchange continued to attract new business. In 1953 it changed its name to the more respectable American Stock Exchange. Although it was much smaller than the New York Stock Exchange, AMEX was the second largest securities exchange in the country for many years. In 2008, it finally moved to the Big Board, merging with the New York Stock Exchange.

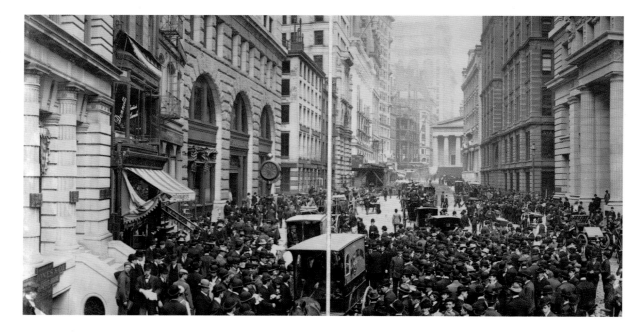

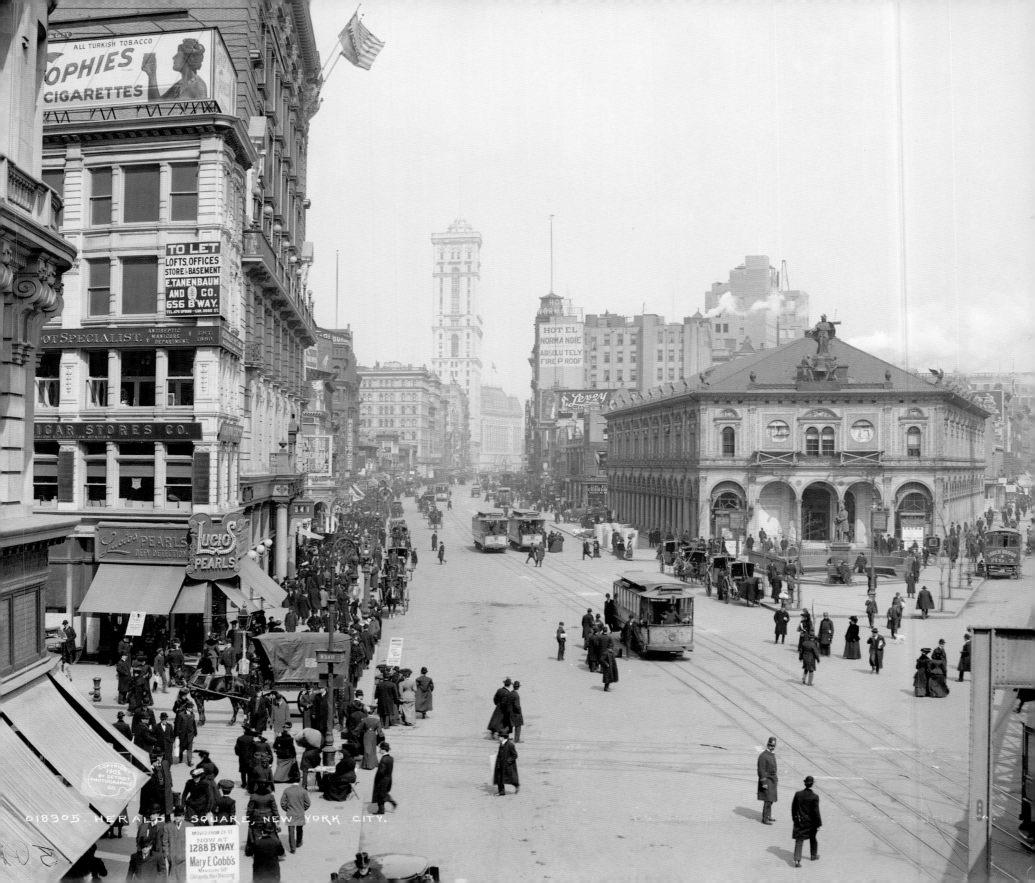

New York Herald Building DEMOLISHED 1921

When George M. Cohan sang "Give my regards to Broadway, Remember me to Herald Square," in his 1904 Broadway musical, the square's namesake, the New York Herald Building, was still standing. But by the time James Cagney made the line a national refrain in his 1942 film, *Yankee Doodle Dandy*, the Herald Building was long gone and nearly forgotten. Herald Square, the intersection of Broadway, 34th Street and Sixth Avenue, is famous for many things, particularly Macy's huge department store, which has been there since 1905. But few New Yorkers are alive today to remember the Herald Building, the beautiful Venetian-style palazzo built in 1894 that was home to the also defunct *New York Herald* newspaper, once the most popular and profitable paper in the country.

Designed by Stanford White, the building filled out its trapezoid site and was as flamboyant as the *Herald*'s headlines. James Gordon Bennett, Sr., the *Herald*'s founder maintained that the function of a newspaper is "not to instruct but to startle." While the building was only two stories high, its roofline statuary grabbed attention. A ten-foot-tall bronze Minerva rose above a five-foot bell, flanked by two bell-ringing blacksmiths who struck on the hour. Twenty-six bronze owls lined the roof's perimeter and their electric eyes blinked on and off throughout the night. The owl was the publisher's choice, meant to be an all-knowing symbol, and the entire building was a dynamic advertisement for the paper. The wide arcaded windows on the Broadway side were stuffed with printing presses, creating a perpetual show for passing pedestrians.

OPPOSITE PAGE *Designed as a Venetian palazzo, the New York Herald Building was at the apex of Herald Square. Rising in the background is Times Tower, home of the* New York Times.

BELOW *Elevated tracks once ran alongside the building on Sixth Avenue.*

BOTTOM RIGHT *An illustration of H.M. Stanley's discovery of Dr. Livingstone, an expedition financed by the* New York Herald.

"DR. LIVINGSTONE, I PRESUME"

The paper established its international reputation when it financed H.M. Stanley's 1869 expedition into Africa to find David Livingstone, a missionary doctor who had not been heard from for years. As the *Herald* reported, Stanley's statement when he found Livingstone in 1871, "Dr. Livingstone, I presume," became one of the most famous lines in journalism. Bennett's son launched a European edition in 1887 and moved to Paris. But his attempt to manage the New York operation by telegram took its toll on him and the paper. After his death in 1918, the paper merged with its smaller rival, the *New York Tribune* (see pages 112–113). The *New York Herald Tribune* moved to West 40th Street and the Herald building was demolished in 1921.

The merged paper eventually evolved under successive owners into the current *International Herald Tribune*. Owned by the *New York Times*, it circulates in more than 180 countries. In Herald Square, the only sign of the *New York Herald*'s former headquarters is the bell clock. It was incorporated into a forty-foot-tall Bennett monument, unveiled in 1940. Except for a period of restoration in 2007, the two bronze bell ringers, nicknamed Stuff and Guff, have been swinging their hammers to ring the bell on the hour for the past seven decades.

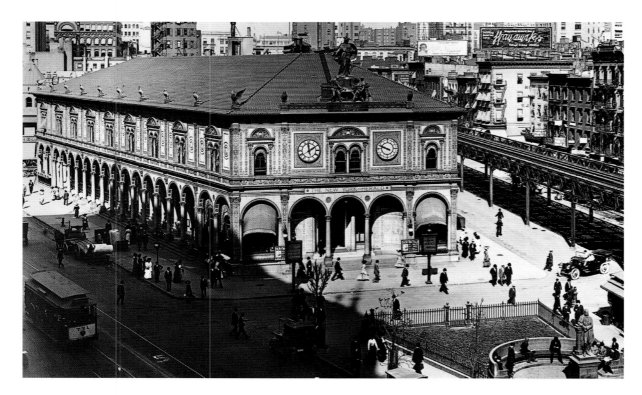

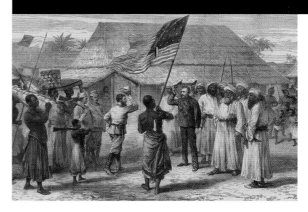

Windsor Arcade DEMOLISHED 1921

The Windsor Arcade was the first mall ever built in Manhattan but it was nothing like the sterile malls of today. Considered one of the most beautiful retail buildings ever constructed in the city, it was modeled on the enclosed streets of small shops found in London or Paris. Built in 1901 on Fifth Avenue between 46th and 47th streets, the low, block-long building was filled with genteel shops

designed to attract wealthy customers: Steinway & Sons Pianos, art galleries, bookstores, china and glass stores, and portrait photography studios.

But the advance of commerce was not welcome by Fifth Avenue's wealthy residents. Even the real-estate press, which praised the arcade, did so with an underlying suspicion about commercial buildings. The *Real Estate Record and Guide*

found it "ornate and attractive—just conspicuous enough to advertise the popular purposes of the building, but not so conspicuous as to be vulgar and obtrusive."

It was called the Windsor Arcade simply because it replaced the Windsor Hotel. Compared to stores, hotels were acceptable neighbors, particularly ones like the Windsor, where Mr. and

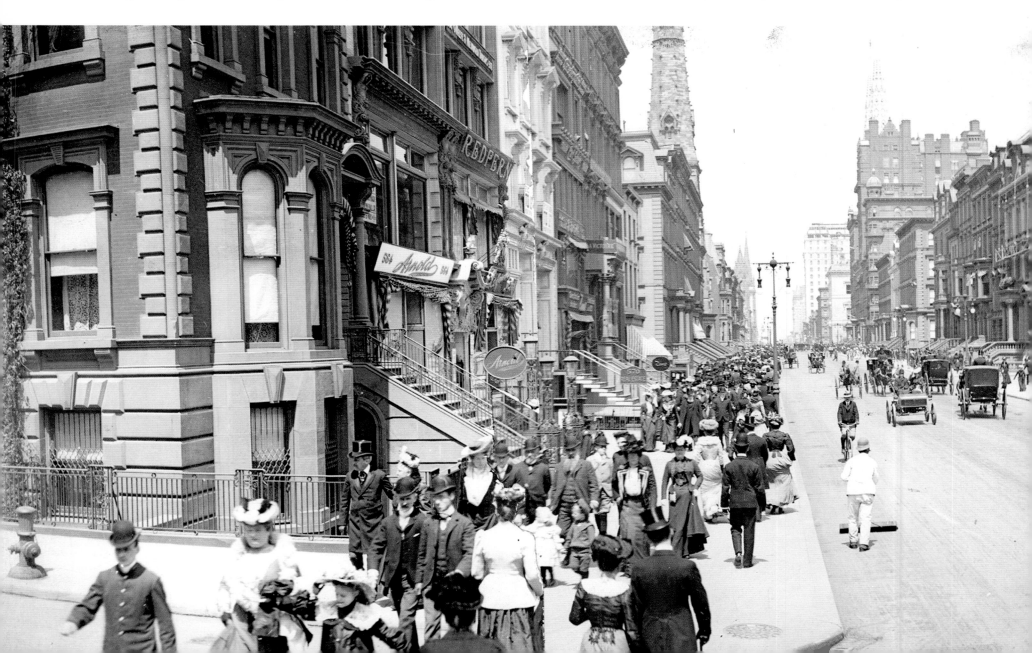

Mrs. Andrew Carnegie had lived before they built their Fifth Avenue mansion. Unfortunately, the Windsor Hotel burned in 1899 while the St. Patrick's Day parade was marching up Fifth Avenue. As beautiful as it was, the Windsor Arcade had been built as a temporary structure, a "taxpayer" holding this prime Fifth Avenue block for higher-paying developers to come. Before long, the people who looked askance at the arcade would have a much bigger store in their midst. In 1911, W. & J. Sloane, the high-quality furniture store, replaced the northern half of the arcade with an eight-story

building. It was an elegant establishment with showrooms reproduced in English and French period styles. The carriage reception room on 47th Street was modeled on a room designed by the seventeenth-century English architect, Christopher Wren. Sloane's, formerly on Broadway and 19th Street was well-known to the wealthy residents of New York. The Breakers, the Newport mansion of Cornelius Vanderbilt II, and even the White House had been decorated with Sloane furniture and rugs. But it was much nicer when the store was not in your own neighborhood.

The southern half of the arcade was later altered into offices and then demolished in 1921 to make way for the S.W. Strauss bank building, a monumental edifice designed by Warren and Wetmore, architects of Grand Central Terminal. Clearly, commerce was on the march up Fifth Avenue and the Windsor Arcade had been only a small advance party for bigger troops to come.

BELOW *Windsor Arcade (right) was a sumptuous but short-lived mall of elegant shops at the heart of Fifth Avenue.*

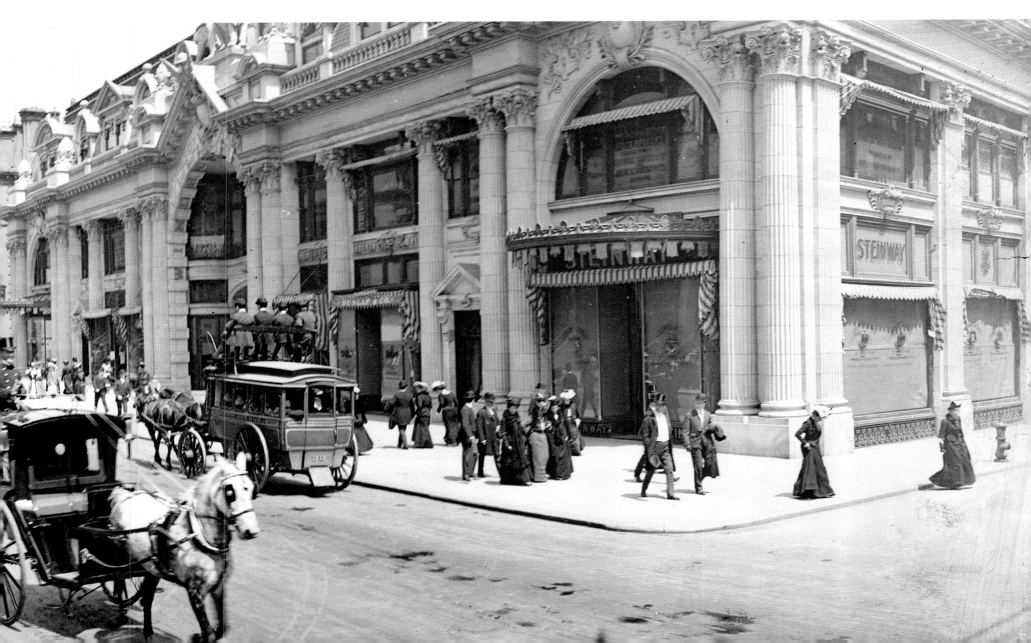

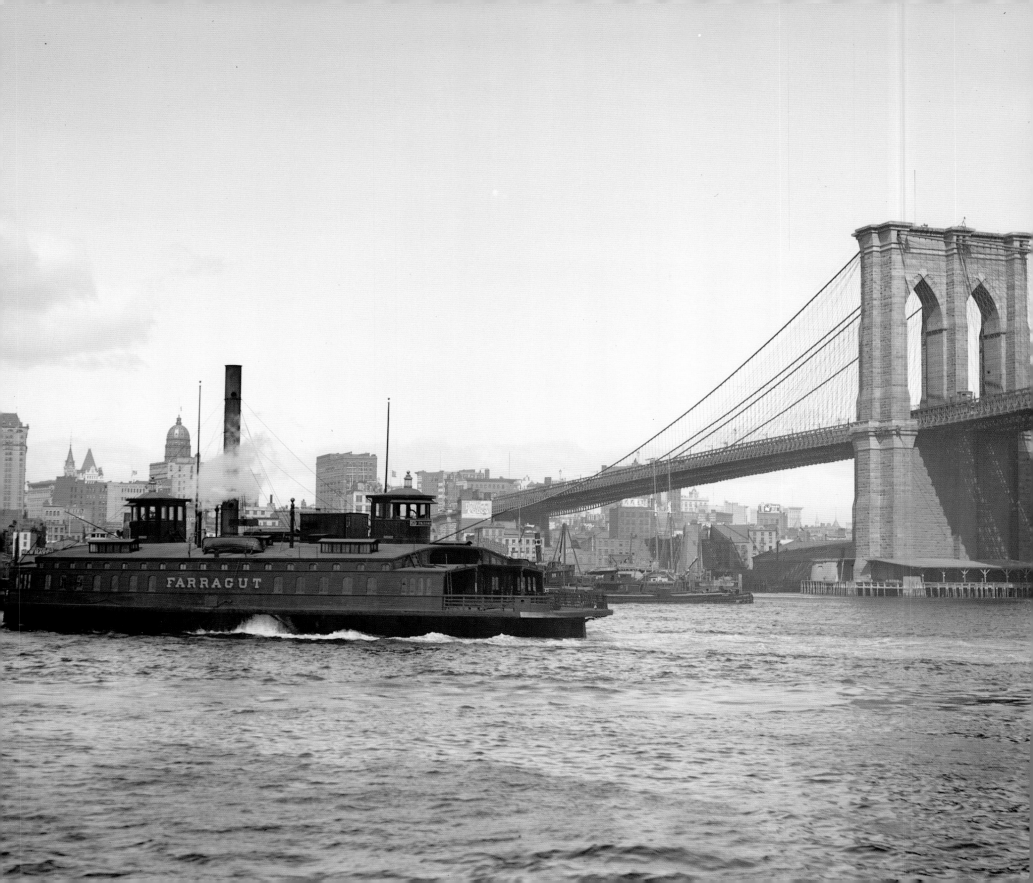

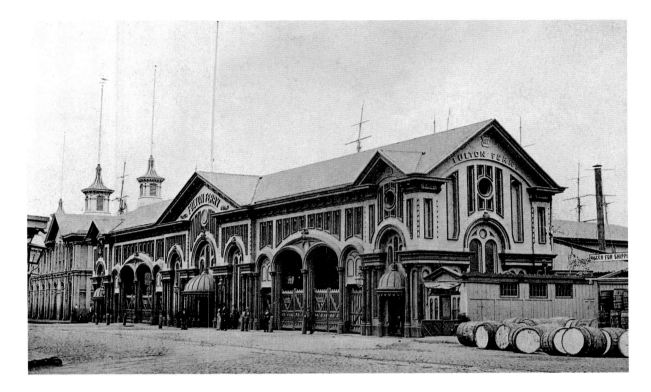

Fulton Ferry Service ENDED 1924

As a city of islands, New York always relied on a network of ferry routes, and the busiest one, the first route between Manhattan and Brooklyn, has a colorful history as old as the city itself. It began in the 1630s when passengers used a horn to call the Brooklyn boatman who was usually farming his nearby fields. The road leading to the ferry in rural Brooklyn was laid in 1704 and became the principal thoroughfare, the one farmers followed to bring their animals and produce to Manhattan markets. From the beginning, the ferry route was tightly controlled by Manhattan and hotly contested by Brooklyn. Based on its colonial charters, Manhattan owned all waterfront property, even in Brooklyn, and received all rent and tax payments from the lucrative ferries. Brooklynites bristled at this arrangement and in 1748 an angry crowd burned the Brooklyn ferry house in protest. Manhattan replaced the building and during the Revolutionary War British loyalists held festive celebrations there in honor of the King's birthday. This was the same

spot where George Washington and more than 9,000 soldiers slipped into rowboats on a foggy night in 1776 and escaped advancing British troops.

The service became known as Fulton Ferry in 1814 when Robert Fulton's steam-powered boats took over the route. The Fulton ferryboats, thirty feet wide by eighty feet long, were called floating bridges, and carried thousands of passengers, along with horses, coaches, wagons, and stacks of produce. The roads leading to the ferry landings in both Manhattan and Brooklyn were each named Fulton Street and bustled with traffic and businesses. Robert Fulton died just a year after his ferry service began, but it continued to grow, merging with other lines to form the powerful Union Ferry Company, uniting operations on both sides of the river. In 1865, the company built a grand ferry terminal at the foot of Fulton Street in Brooklyn. Nearly filling the wide street, the two-story building and its towering pyramidal roof would be the main gateway to Brooklyn for the next two decades.

RUINED BY ICE

Yet at the high point of its operation, the ferry service was already headed for decline. During the winter of 1866, ice flows clogged the river, idling ferries for weeks and increasing public demand for a bridge. Just four years after the new Brooklyn terminal opened, construction of the Brooklyn Bridge began right next door. Although plans for the bridge had been in the works for years, the Union Ferry Company did not hesitate in going forward with the elaborate new terminal. They could not imagine Brooklyn without a ferry service. But the bridge, completed in 1883, would change transportation beyond everyone's imagination. Subject to the vagaries of weather, the ferry was no match for the bridge. While it managed to keep running for years after the bridge opened, ridership kept declining and the boats finally stopped in 1924. The grand Brooklyn terminal was demolished two years later. In recent years, only water taxis have been running between Brooklyn and Manhattan, stopping at the Fulton Ferry Landing pier, which was rebuilt for recreation. In his 1856 poem, "Crossing Brooklyn Ferry," Walt Whitman imagined that his readers "a hundred years hence" would share his passion for the waterfront. "Just as you feel when you look on the river and sky, so I felt." His words are inscribed on the fence of the Fulton Ferry Landing pier where people gather to marvel at the river, the Manhattan skyline, and the Brooklyn Bridge.

OPPOSITE PAGE *Called "floating bridges," the steam-powered ferries ran for years after the opening of the Brooklyn Bridge (right), but ultimately could not compete with the great bridge. The dome of the New York World Building (left background) was replaced by an auto ramp to the bridge (see page 87).*

ABOVE *Manhattan's South Street terminal for the Fulton Ferry.*

Madison Square Garden DEMOLISHED 1925

Before the age of radio, television, and movies, entertainment was always live, at times even spectacular, as presented in the grand theaters known as pleasure gardens. The most impressive of these venues in late nineteenth-century New York was Madison Square Garden, a pleasure palace built in 1890. It was not the first Madison Square Garden in New York, nor would it be the last. Two more would follow in the twentieth century, keeping the name but not the location in Madison Square. But this one, born in the Gilded Age and demolished before the end of the roaring twenties, would always be remembered for its fantastic design and sensational events, both created by the building's famous architect, Stanford White.

The first pleasure garden at Madison Square was a converted train station, abandoned when Cornelius Vanderbilt erected the first Grand Central

Depot in 1871 (see pages 24–25). His grandson, William Kissam Vanderbilt, operated the old station as a concert hall for a time and gave it the name, Madison Square Garden. William's true love was horse racing and he formed a group of investors to replace the building with a new entertainment center that could accommodate the National Horse Show, an annual event of the exclusive Equestrian Society. White served as an investor, and the architect and impresario, creating much more than a place for horses. It included a dizzying array of facilities that all operated simultaneously: a vast amphitheater with 10,000 seats, a 1,500-seat concert hall in the style of Louis IV, a theater with 1,200 red plush seats, and a rooftop theater with 300 tables.

The amphitheater had a huge skylight, which opened for summer performances. In the evening it

sparkled with thousands of electric light bulbs hung from the rafters. The floor held not only horse shows, but also circuses, boxing matches, and bicycle races and could be flooded for water spectacles. It also hosted America's first automobile show in 1900 and political rallies, including the 1906 New York State Democratic Convention nominating William Randolph Hearst for governor, an event memorialized in the film *Citizen Kane*.

But saddled with a huge mortgage, the Garden kept losing money and went bankrupt in 1916. A new promoter made it profitable for a few more years and raised funds to build a new Madison Square Garden at Eighth Avenue and 50th Street in 1925 (see pages 124–125). The same year, twenty-one years after White's sensational death (see pages 40–41), his glorious creation was demolished, replaced in 1928 by the New York Life Insurance Building, still standing tall over Madison Square.

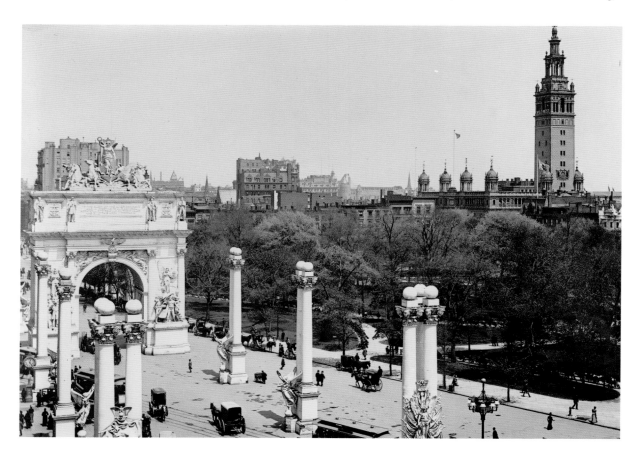

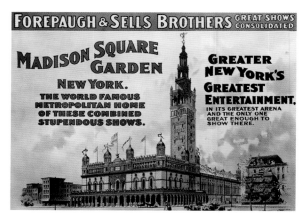

RIGHT *The tower atop Madison Square Garden dominated New York's nineteenth-century skyline. It housed the architect's studio, which became the focus of a sensational murder trial.*

LEFT *The Naval Arch at Madison Square was built to celebrate Admiral Dewey's victory in the Spanish-American War. Like Madison Square Garden, it was also demolished.*

ABOVE *An advertisement for the Madison Square Garden's "stupendous shows."*

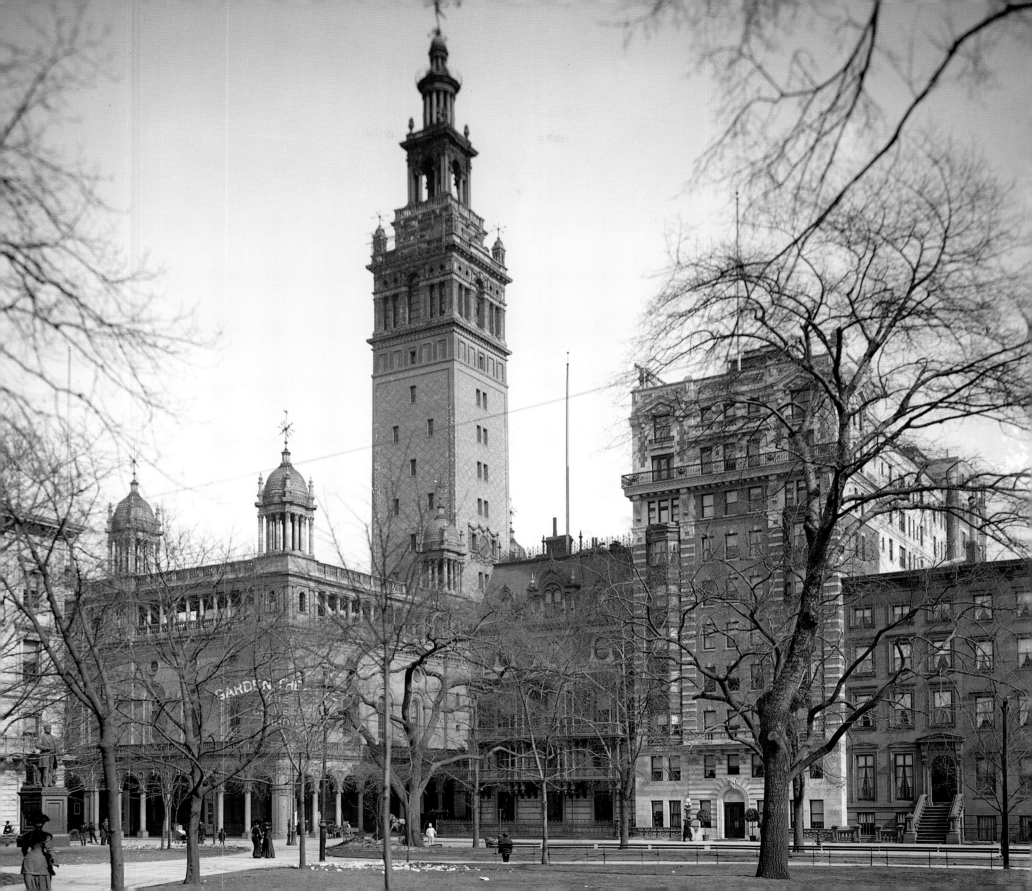

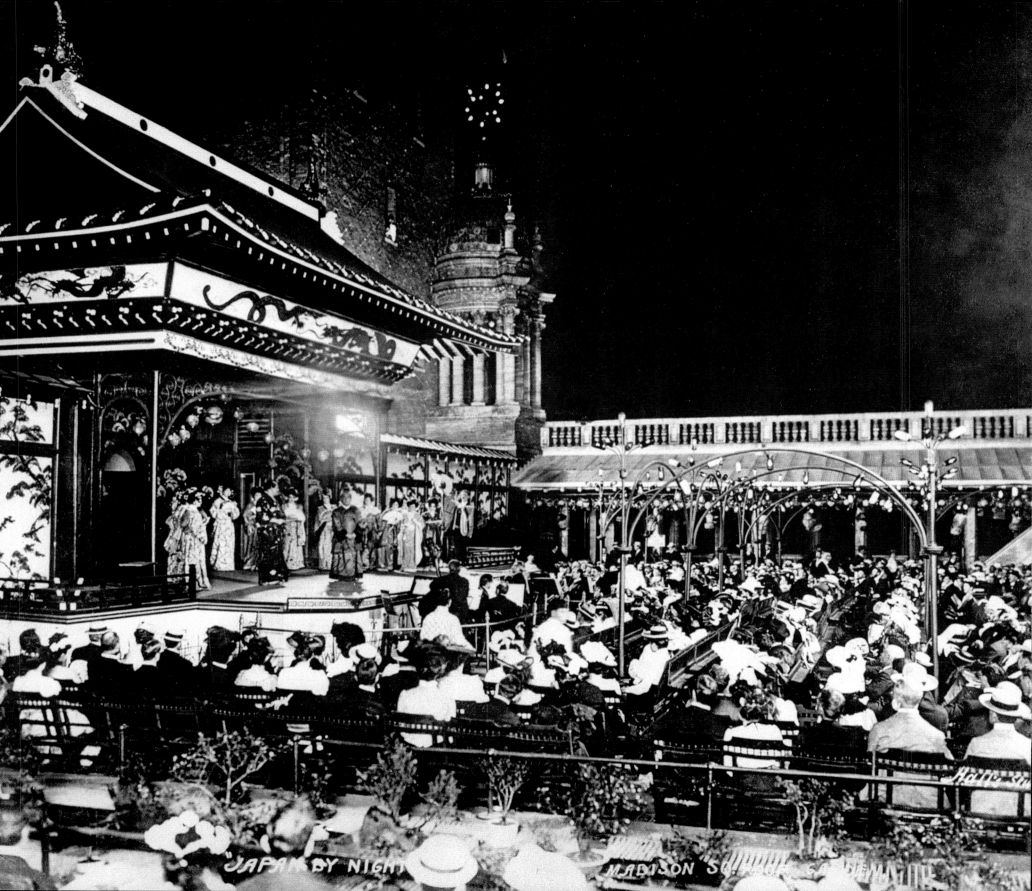

"JAPAN BY NIGHT" MADISON SQUARE GARDEN

Murder at Madison Square Garden 1906

As the architect and impresario for Madison Square Garden, Stanford White and his wealthy partners conceived the building as a place for an elite audience drawn from their own circle of New York society. But this idea was doomed to failure because the limited audience could not support the Garden's vast amphitheater. White soon began to devise spectacles for a popular crowd. He could not have imagined that his own murder would play out like a grisly melodrama at the rooftop theater.

The rooftop led to the building's crowning glory, the 315-foot-high tower, a Moorish-Renaissance campanile modeled on one in Seville. It dominated the city skyline and embodied White's architectural and personal passion. He had lobbied hard to get it built, even though it added a substantial sum to the already over-taxed budget. He crowned the tower with a huge revolving figure of Diana the Huntress, created by his friend, the noted sculptor Augustus St. Gaudens. The figure was nude, which drew complaints from the New York Society for the Suppression of Vice, but it kept its perch nonetheless.

The moralists became even more outraged when testimony at the murder trial revealed the events that had taken place within the tower. White had created a number of tower apartments, some of which were used as studios by prominent artists of the day, including the sculptor Daniel Chester French and the architect Whitney Warren, one of the designers of Grand Central Terminal. But White often used his studio, draped with bear, tiger, and leopard skins, as a place for intimate dinners with young women. A frequent guest was Evelyn Nesbit, a chorus girl and artist's model whom White met in 1901, when she was sixteen and he was forty-seven, married and living with his wife and children on their Long Island estate. In 1905, she married the millionaire Harry Thaw. Although her relationship with White had ended years before, Thaw, a cocaine addict, was obsessively jealous. On June 25, 1906, he followed White to the Garden's rooftop theater. In the midst of a musical performance, during the song, "I Could Love a Million Girls," Thaw approached White's table and fired three pistol shots at his head, killing him instantly. At first, the audience thought that the shots were part of the performance, but quickly fled the scene.

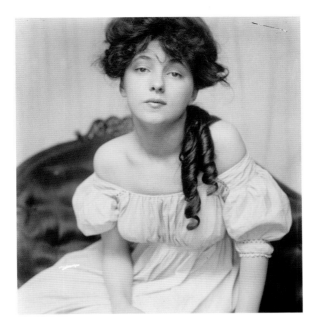

At the trial, Nesbit, bribed by her mother-in-law, testified that White had raped her and that her husband was defending her honor. Thaw was judged insane, incarcerated for a few years in a mental hospital and released in 1915. Nesbit divorced Thaw, went on to a marginal career as a vaudeville performer and silent film actress, and died in 1967. Although the trial scandalized White's reputation at the time, he left an extraordinary architectural legacy, both lost and still lasting in New York City.

OPPOSITE PAGE *The Garden's rooftop theater where Stanford White was murdered during a musical performance.*

ABOVE AND LEFT *Evelyn Nesbit, the focus of the murder trial, and her husband, the murderer, Harry Thaw.*

TOP LEFT *The inspiration for the crime of passion, Nesbit posing as a photographer's model.*

William. K. Vanderbilt Mansion DEMOLISHED 1925

To the contemporary eye, photos of William Kissam Vanderbilt's mansion at 660 Fifth Avenue and 52nd Street may look like just another Gilded Age pile. But in 1885, three years after its completion, it made such a strong impression on architects of the day that they listed it as one of the ten best buildings in the United States, surpassed only by the U.S. Capitol, number two, and H. H. Richardson's Trinity Church in Boston, number one.

Just thirty-nine years old when he decided to build the mansion, William was able to undertake the project with a sizable inheritance from the estate of his late grandfather, Commodore Cornelius Vanderbilt. He chose one of the country's most preeminent architects to design it, Richard Morris Hunt, who had created many notable New York buildings, and would later design the Astor Mansion on Fifth Avenue and 65th Street (see pages 48–49). William, busy with his horses and business affairs, including the newly built Sheepshead Bay Racetrack in Brooklyn (see pages 26–27), left most of the architectural decisions to his twenty-five-year-old wife, Alva, the Southern-born daughter of a cotton king. Alva had lived for a time in Paris after the Civil War and apparently had a fondness for things French, hence Hunt created a mini-French chateau for his clients.

The house was an architectural and social triumph for the young Vanderbilts. Up until this time, even the richest families in New York lived in brownstone rowhouses that looked much the same from the outside and had the same over-furnished Victorian rooms. The mansion's spacious, opulent interiors, designed in period styles and filled with art treasures, set a new standard for ostentatious luxury. The house also gave Alva the opportunity to challenge the reign of Mrs. William B. Astor as the queen of New York society. Mrs. Astor did not invite

the Vanderbilts to her annual January cotillion, the most important social event of the year. Alva decided to inaugurate her new home with a costume ball and enticed Mrs. Astor's young daughter to attend. Refusing to disappoint her daughter, Mrs. Astor accepted social defeat and an invitation to the Vanderbilt ball in March 1883. She was one of 800 guests who walked up the red carpet and through the sixty-foot-long, twenty-foot-wide entrance hall to the fifty-foot by thirty-foot hall where they danced past midnight. At 1:00 a.m. they went to the top-floor gymnasium to dine under the glare of electric bulbs, the first installed in a New York house.

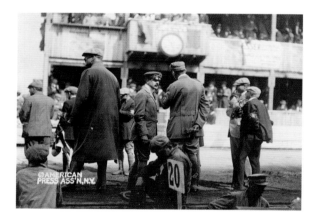

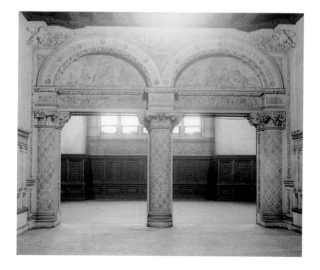

DIVORCE AND DESTRUCTION

In 1895, Alva shocked society by divorcing William and marrying another New York millionaire, Oliver Belmont, the son of William's friend and horseracing colleague, August Belmont. Although he was five years her junior, Oliver died suddenly in 1908. Alva spent the rest of her life and a good deal of her money supporting the women's suffrage movement. At her funeral in 1933, all of the pallbearers were women. After the divorce, William moved to France, built another chateau, and spent most of his time breeding race horses. He died in 1920 and his second wife moved to New York's newly fashionable Sutton Place. The Fifth Avenue mansion was boarded up for several years. Too expensive to maintain, the once glorious pile fell to the wrecking ball in 1925.

OPPOSITE PAGE *The mansion's opulent interiors set a new standard for ostentatious luxury in the Gilded Age.*

RIGHT ABOVE *William K. Vanderbilt, with goggles, at an automobile race.*

RIGHT BELOW *Interior of the great hall, stripped for demolition.*

TOP RIGHT *Alva Vanderbilt in costume for her triumphant ball in 1883.*

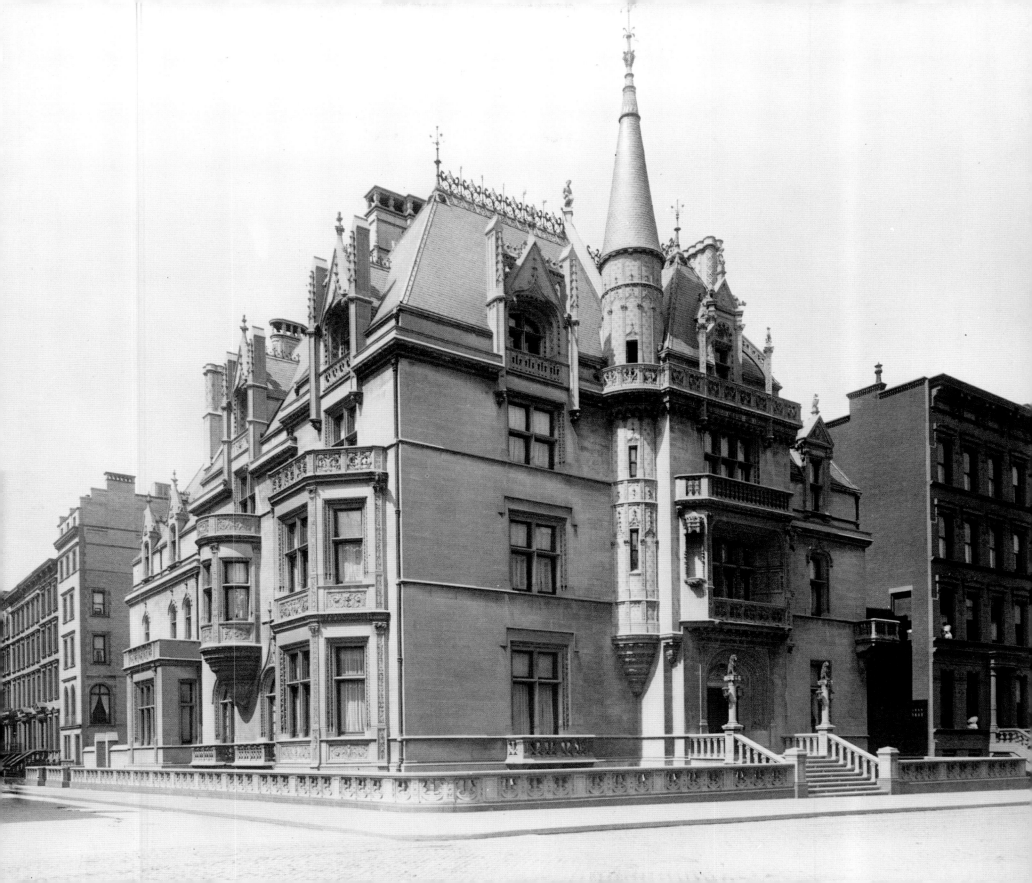

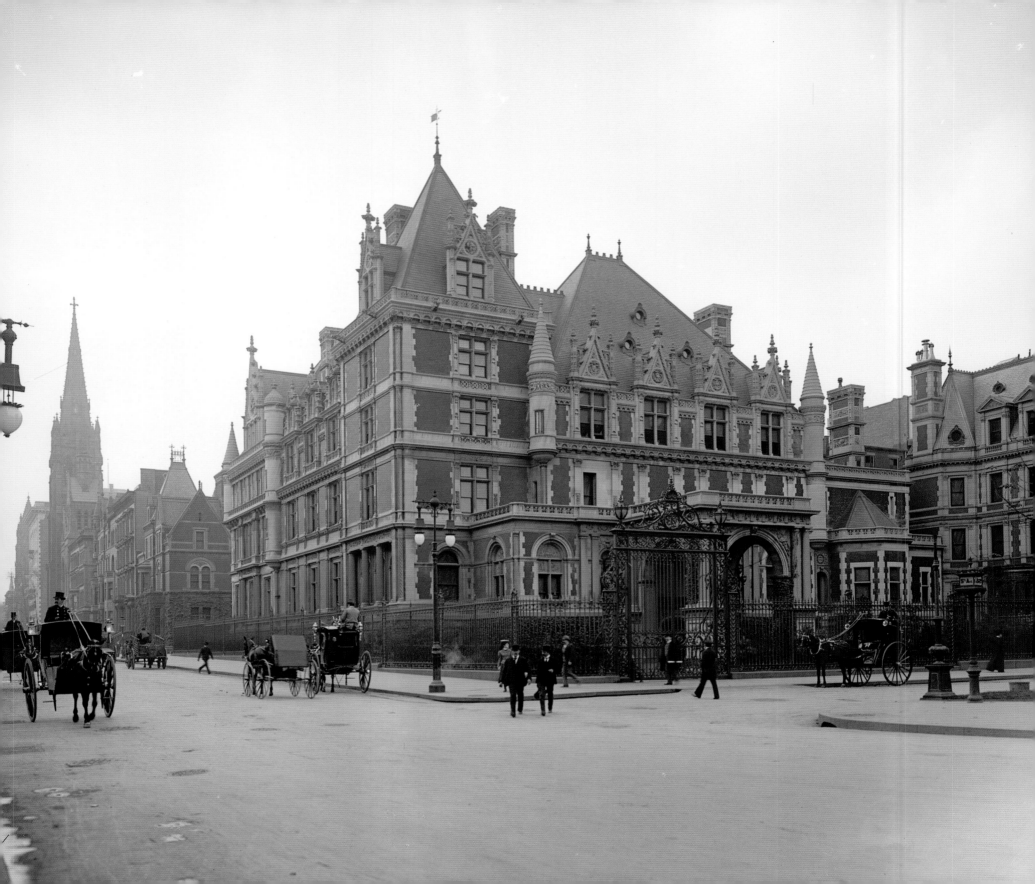

Cornelius Vanderbilt Mansion DEMOLISHED 1926

Unlike his younger brother, William, Cornelius Vanderbilt II preferred running the family railroad to racing horses. Like his grandfather and namesake, Commodore Cornelius Vanderbilt, he was a workaholic. But when it came to building a home on Fifth Avenue, Cornelius followed William's lead in sparing no expense—they didn't have to. Their father, who also lived in a Fifth Avenue mansion and died in 1885, left William sixty-five million dollars and Cornelius sixty-seven. These bequests were in addition to the millions they had received after their grandfather died in 1871. In this era before income tax, there was money to burn. Cornelius's extra two-million-dollar inheritance from his father was a bonus for being the eldest son and a clear signal that he was now the head of the family. As such, he needed a bigger house than his brother's—bigger than nearly any other house in the city.

He had already built a house in 1882 on West 57th Street, just half a block from Fifth Avenue, and now decided to clear the rest of the block and expand the house to the avenue, taking up the entire block between West 57th and 58th streets. The site was enormous and perfectly located, facing Central Park. The lush, 843-acre park had been completed in 1873 and offered miles of bridle paths and carriage drives, the place where the Vanderbilts could ride alongside other members of their privileged class on horseback or in their elegant broughams and barouches. Two prominent architects of society mansions designed the expanded house, George B. Post and Richard Morris Hunt. Post added a grand entrance with a *porte-cochère*, massive gates that had been forged in Paris, and a formal garden facing the park, one of the first for a New York townhouse. Completed in 1893, the huge mansion was an urban version of a French chateau with each room decorated in a different period style and furnished with actual parts of French and Spanish castles.

Living in luxury, Cornelius and his wife, Alice Gwynne, were nonetheless a serious couple who had met teaching Sunday school and were active throughout their lives in philanthropic causes. His work habits may have led to the stroke he suffered in 1896, and his death in 1899 at the age of fifty-six. His widow kept the house for another quarter century, while everything around her changed. Neighboring mansions gave way to shops, offices, and hotels, and her taxes increased by 400 percent. One of her sons had died when the *Lusitania* went down, another had been left out of the will for marrying the wrong woman, and her daughters agreed that the best option was to sell the home for seven million dollars in cash. Too expensive to be converted to commercial use, it was demolished in 1926 and replaced in 1928 by the Bergdorf-Goodman store, an eight-story building designed to look like a French chateau. Some of the Vanderbilt treasures were salvaged, including a marble fireplace now in the Metropolitan Museum and the front gates now in front of Central Park's Conservatory Garden. The home was the largest, but not the last Vanderbilt mansion in New York City. One still stands at 647 Fifth Avenue, now a Versace store. It was George W. Vanderbilt's pied-à-terre when he was not at his main house, Biltmore in Asheville, North Carolina, the largest privately owned home in the United States.

LEFT *The mansion was New York City's largest residence of the day.*

ABOVE *Cornelius Vanderbilt II.*

RIGHT *In just twenty years from the turn of the century, the rise of the automobile had a dramtic impact on the streetview of Fifth Avenue.*

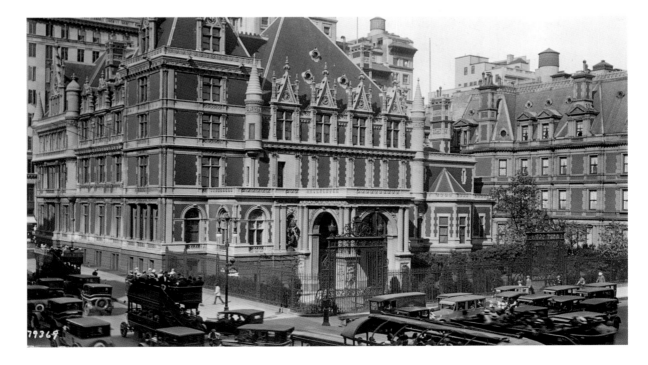

Temple Emanuel and Temple Bethel

MERGED 1927

Two of New York City's most prominent Jewish congregations built magnificent temples on Fifth Avenue in the nineteenth century. Both were lost in the twentieth century when the congregations merged and built a new temple, the largest in the city. Temple Emanuel, built in 1868, and Temple Bethel, built in 1891, were elaborate examples of the Moorish-Revival style, fashionable at the time, particularly for synagogues because it recalled the golden age of Judaism during the Islamic occupation of Spain. The first congregants were German immigrants who arrived in New York with little money in the 1840s and became highly successful in finance and business. Like most of the German Jews who arrived in New York in the same period, they were followers of Reform Judaism, a movement that took root in the early 1800s in Germany, and discarded many traditional Jewish practices and beliefs. They spoke English rather than Hebrew in temple and firmly believed in cultural assimilation. They were part of the wealthy Jewish elite that would emerge in late-nineteenth-century New York, made up of eminent bankers and financiers, such as Jacob Schiff and Felix Warburg, and successful entrepreneurs such as Isidor and Nathan Straus, who built the current Macy's Department Store.

Architecturally impressive, both temples were important enough to take their place on the city's most fashionable avenue where many prominent churches were also located. Temple Emanuel's designers, Leopold Eidlitz and Henry Ferbach, were also immigrants who had achieved success as New York architects. Eidlitz, a master of the Moorish-Revival style, also designed showman P. T. Barnum's Connecticut home, "Iranistan." Temple Emanuel, located on Fifth Avenue and 43rd Street, had twin turrets and a colorful exterior decorated in yellow stone with red and black roof tiles. But the interior was church-like with a cruciform sanctuary, choir loft, and organ. These features, adopted by Reform congregations, were frowned upon by Eastern European Jews who immigrated decades after the Germans and followed traditional Jewish practices in their much smaller synagogues.

Temple Bethel made a commanding presence further north on Fifth Avenue and 76th Street. The huge building, topped by a massive dome ribbed in a traditional Moorish pattern, was the first house of worship to face Central Park and dominated views of the Fifth Avenue skyline from the park. The magnificent interior was an ornate, lofty sanctuary of marble, onyx, and gold highlighted by a Tiffany stained-glass window.

In the 1920s, the congregations decided to merge in a single, new temple. The Moorish style was out of fashion, and some congregants took the view that it had marked Jews as somewhat alien, even un-American. Temple Emanuel was demolished in 1927, but its name would continue to identify the new temple, a grand, but less exotic structure built in 1929 on Fifth Avenue and 65th Street, the former site of the Astor Mansion (see page 48–49). Temple Bethel lost both its name and its magnificent building. It was used for a few years by the Park Avenue Baptist Church, John D. Rockefeller Jr.'s congregation, while building its skyscraper Riverside Church in 1931. During World War II, the old temple became a dormitory for service men and fell to the wrecker's ball in 1947. The new Temple Emanuel is still the largest religious sanctuary in the city, with more seats than in St. Patrick's Cathedral. Its form of worship is "practical reform," which includes some of the once discarded traditional practices preferred by the descendants of Eastern European Jews who have moved up to Fifth Avenue.

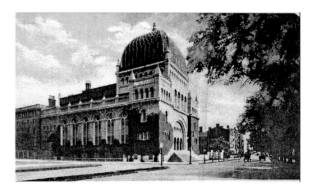

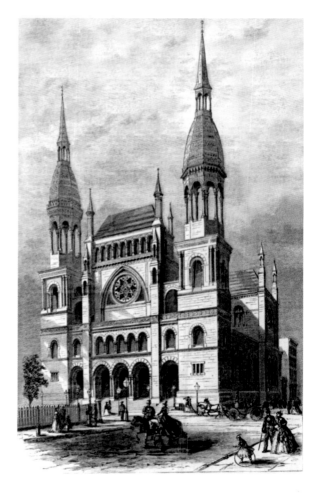

OPPOSITE PAGE *Temple Bethel as seen from Central Park.*

RIGHT *Temple Bethel (top), demolished 1927, and Temple Emanuel, demolished 1947.*

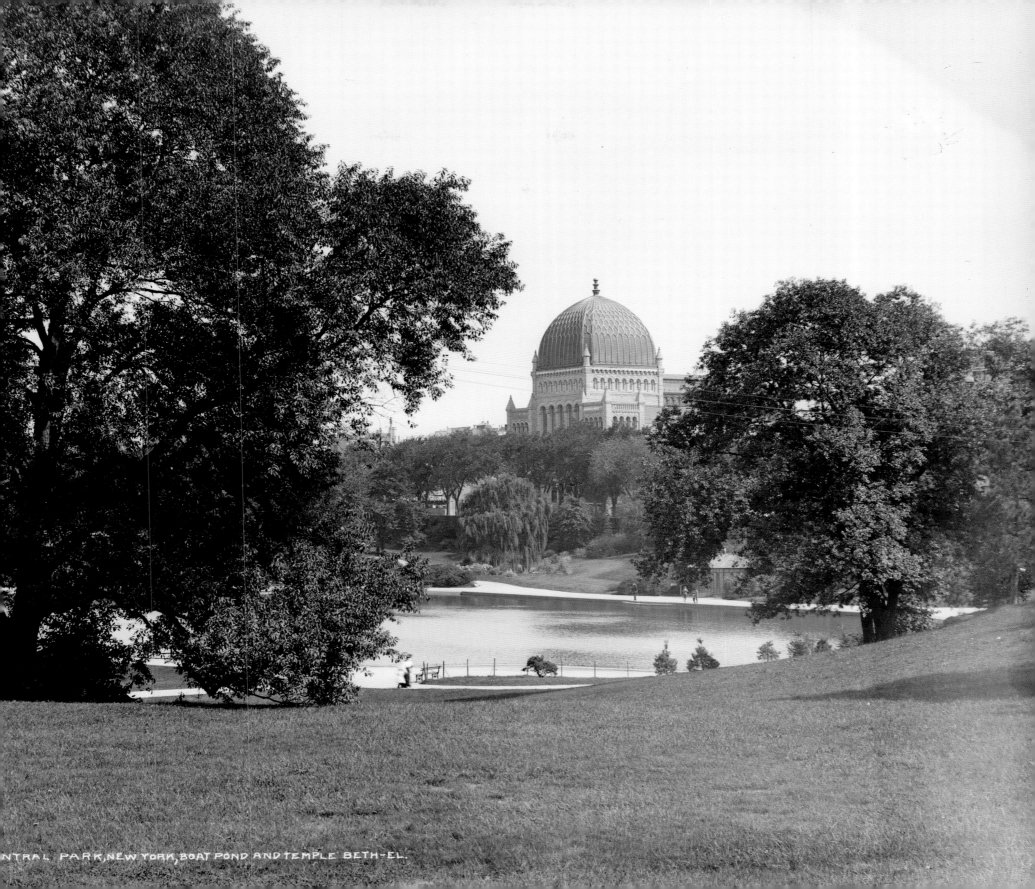

NTRAL PARK, NEW YORK, BOAT POND AND TEMPLE BETH-EL.

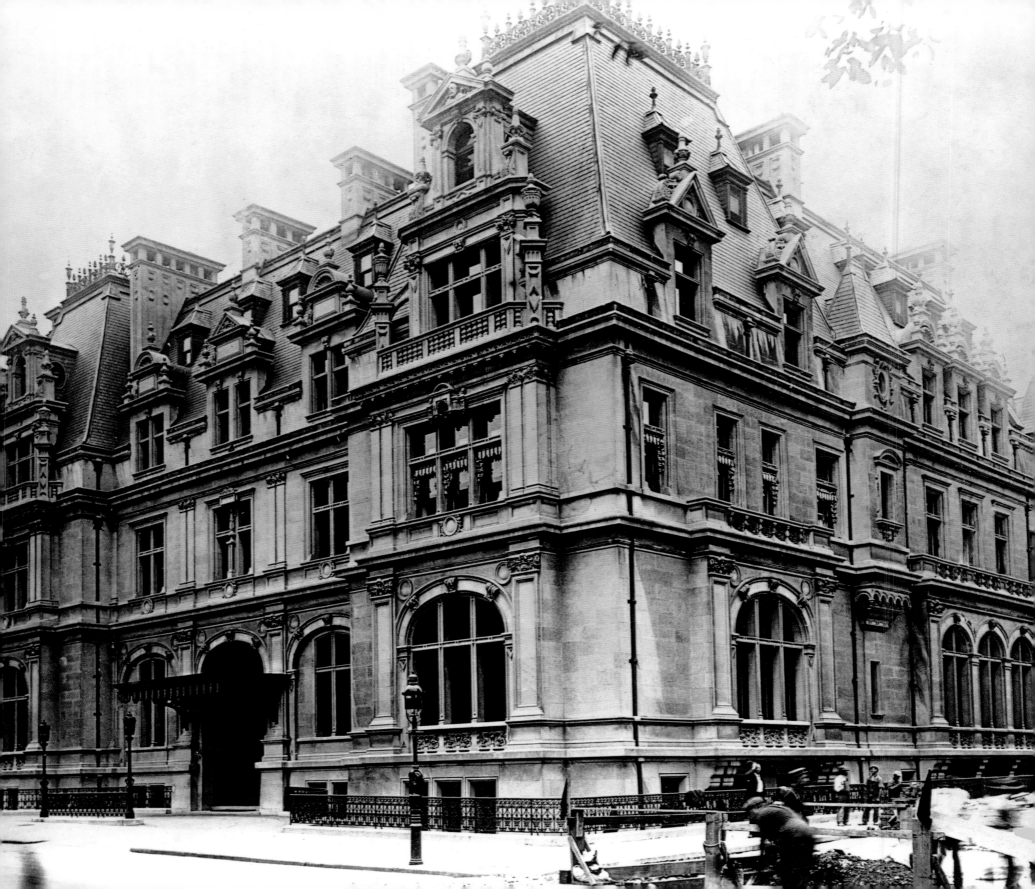

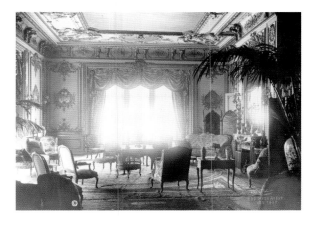

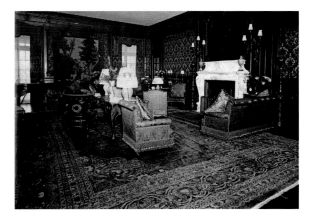

Astor Mansion DEMOLISHED 1928

Facing Central Park, this palatial Fifth Avenue residence at the corner of 65th Street was a double palace, ample room for Mrs. William B. Astor, her son, John Jacob Astor IV and his family, and on special occasions, 1,000 guests invited to their joint ballroom. Mrs. Astor's move here in 1896 was a clear signal to society that this section of Fifth Avenue was the place to be. The Astors had always led the way. In the 1850s, they had moved up to Fifth Avenue and 34th Street, a time when old New York Society was still centered around Washington Square in Greenwich Village. In the 1880s, the Vanderbilts built their mansions as far north as Fifth and 58th Street. But Mrs. Astor, queen of New York society in the Gilded Age, would move the best families even farther north.

The Astors controlled a New York real estate empire, amassed by the patriarch, John Jacob Astor in the first half of the nineteenth century. Mrs. Astor, the formidable Caroline Webster Schermerhorn, descendant of wealthy Dutch settlers in New York, married the patriarch's younger son and through adept social maneuvering became known as *the* Mrs. Astor, a title usually reserved for the wife of the eldest son. Her nephew, William Waldorf Astor, never forgave his aunt for usurping a title that he strongly believed should have passed to his own wife. He eventually got his revenge. The William Astors' previous home on Fifth Avenue and 34th Street was next to the home of their nephew's parents. After his father's death in

1890, William Waldorf demolished the home and replaced it with the Waldorf Hotel, a luxurious building, but a large, noisy one that effectively chased his aunt out of her own home.

Never outdone, even after her own husband's death in 1892, Mrs. Astor built her much larger, more lavish Fifth Avenue mansion for herself and her son's family. The architect Richard Morris Hunt made this French Renaissance palace the most commanding presence on the avenue and it soon became the new center of New York society. The Astors sold their former home at 34th Street to build the Astoria Hotel, eventually joined with its neighbor to become the first Waldorf-Astoria (see pages 50–51).

Supported throughout her life by the family's real estate holdings from opulent hotels and Times Square theaters to extensive slum properties, Mrs. Astor enjoyed a luxurious life, entertaining lavishly in her gold and white ballroom with its rug woven of peacock tails. But life changed for the dowager queen after the turn of the century. Younger society women, more interested in lively parties than ancestry, took the spotlight while Mrs. Astor retired to senility, dying at the age of seventy-seven in 1908. Her son built two more grand hotels, the St. Regis and the Knickerbocker, and then took a trip on the *Titanic* with his young wife in 1912. When the ship began to sink, he found space for her in a lifeboat and stayed behind to die with many other masters of finance and industry. He left her

a comfortable trust fund and the Fifth Avenue mansion—but not if she remarried. She did, allowing Vincent, John Jacob's son by his first marriage, to inherit the house and the family fortune. Vincent did what Astors had never done, contribute generously to civic causes and sell some of the family property, including the Waldorf-Astoria. He also sold the mansion for three and a half million dollars to a Jewish man who gave the site to Temple Emanuel for the congregation's new synagogue, built in 1929 (see pages 46–47).

First Waldorf-Astoria Hotel DEMOLISHED 1929

The Waldorf-Astoria was the grandest hotel in New York City's grandest era. Built in the 1890s, it was the embodiment of the Gilded Age, exuberant in its expression of palatial European architecture and lavish in its comforts provided by an army of servants.

It housed and fed thousands of guests each night in rooms decorated with marble columns, gilded ceilings, tapestries, and richly carved wood. Henry James called the hotel's amazingly efficient operation "a gorgeous golden blur, a paradise." The very name still speaks of luxury, although most people now associate it with its successor, the existing Waldorf-Astoria on Park Avenue and 50th Street, a sleek 1930s replacement. Nearly forgotten today, the original was once as famous around the world as the Empire State Building, the skyscraper that replaced it

The site, on Fifth Avenue and 34th Street, is hard to imagine without modern towers. But when the hotel was built, between 1893 and 1897, the block was a low-rise residential neighborhood lined with stately brownstones. William and John Jacob Astor III, brothers and heirs to the family fortune, had lived here with their families in side-by-side homes since the 1850s. Their homes were replaced by the hotel, which was built as two separate buildings by their sons, feuding cousins. The Waldorf went up first as an act of spite by William Waldorf. After his father's death, he built the thirteen-story hotel to overwhelm the next-door home of his despised aunt Caroline. Her son, John Jacob Astor IV, at first planned to demolish his mother's house and build stables to stink up his cousin's fancy hotel. But since their fortunes were tied together, he reconsidered and instead built the Astoria—an even taller, larger and more splendid building.

The architect of both buildings was Henry Hardenbergh, who would design the Plaza Hotel in 1907. The Waldorf-Astoria functioned as one hotel, but the cousins agreed that if their alliance fell apart, they could seal off the ground-floor connection between the two buildings. The hotel's success was so great that it never happened. The connection was a wide hall that became a favorite strolling—some said strutting—place for fashionable New Yorkers and international guests. It was nicknamed Peacock Alley, a name still in use in the current Waldorf-Astoria. The hotel was much more than a place for travelers. Many members of society maintained apartments there, dining in the restaurants with visiting royalty, aristocrats, and diplomats. It opened at a time when wealthy New Yorkers began to entertain outside of their homes. Thousands danced and feasted in the hotel's opulent banquet halls and ballrooms, where champagne flowed and sumptuous meals were served, prepared by the hotel's famous chef, Oscar of the Waldorf.

But fashionable society continued to move uptown in the twentieth century and during the long years of Prohibition that began in 1920, the hotel slowly died of thirst. By 1929, it was gone, its brilliant glamour overshadowed by the newest stars of the New York scene, the Empire State Building and the new Waldorf-Astoria, both opened in 1931.

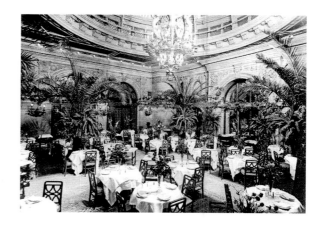

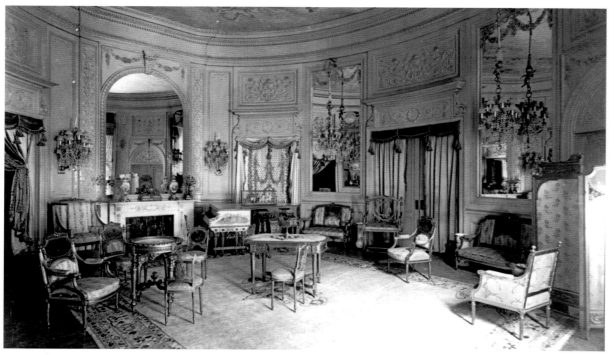

RIGHT *Built as two separate hotels by feuding Astor cousins, the combined operation offered New York's most lavish accommodations. It was replaced by the Empire State Building.*

LEFT *Marie Antoinette Room.*

ABOVE *Palm Garden Dining Room.*

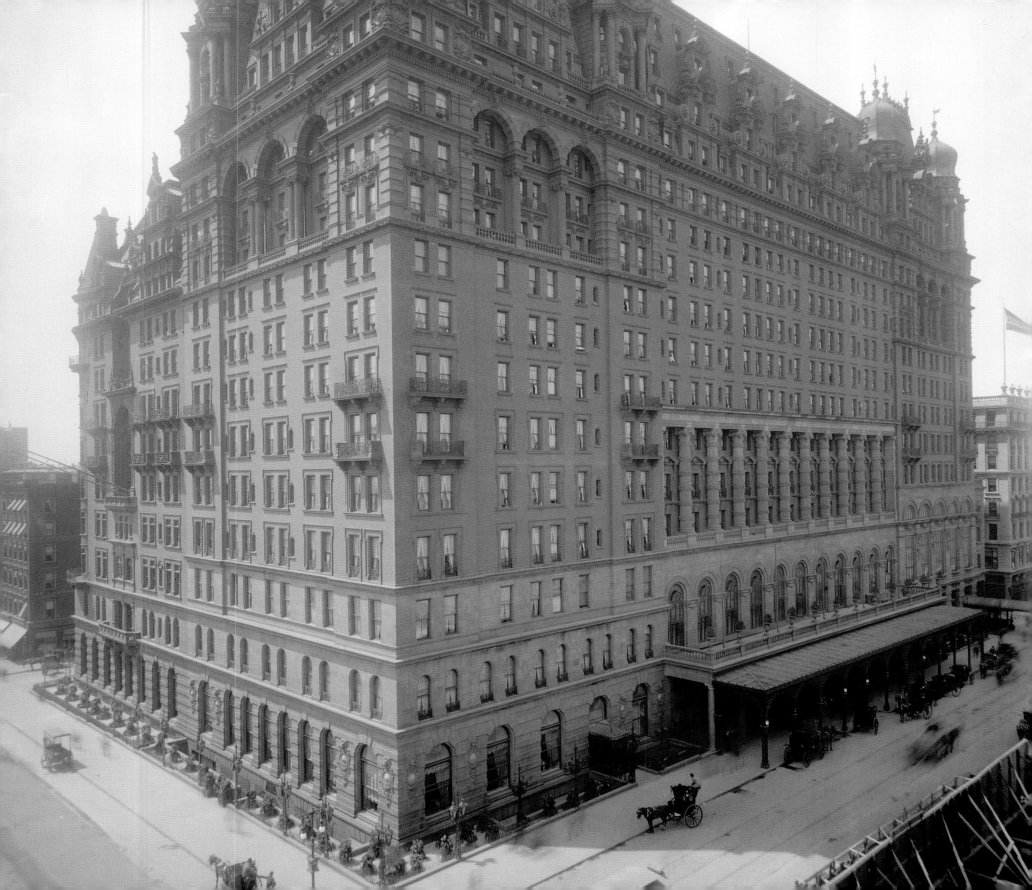

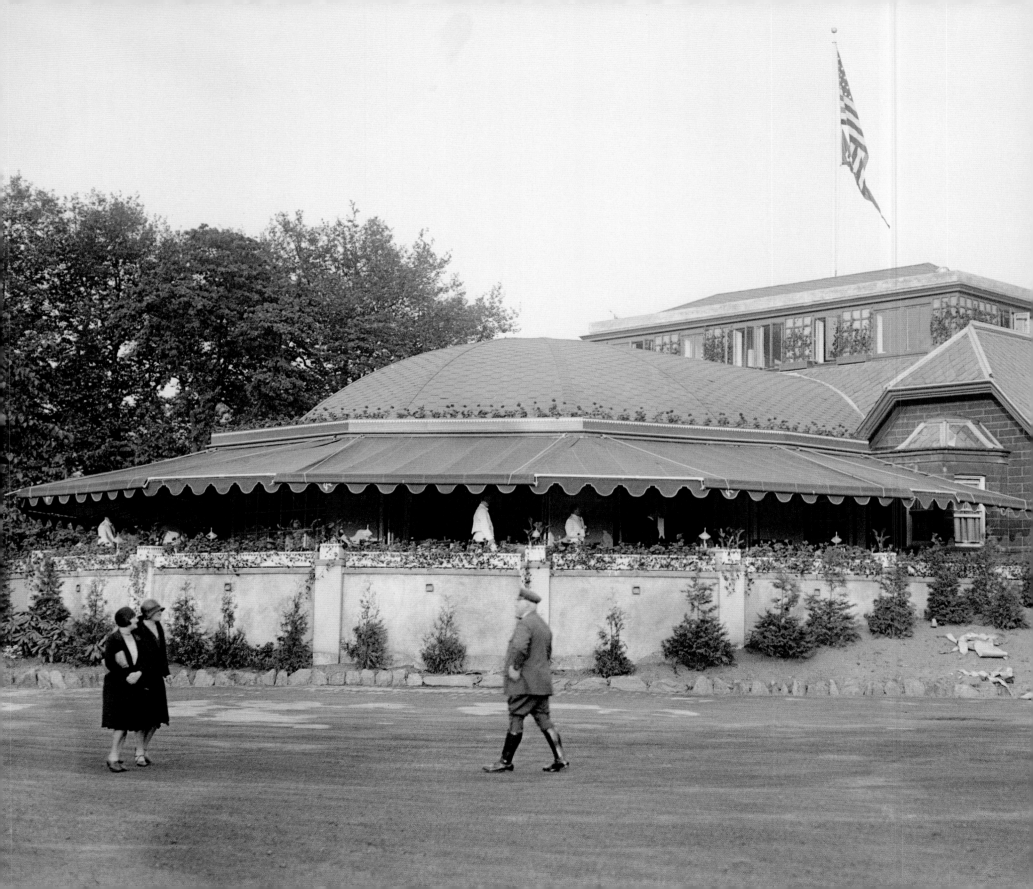

Central Park Casino RAZED 1934

The Central Park Casino was the last gasp of the roaring 1920s, one of New York's most glamorous nightclubs, an enclave of café society illegally tucked into a public park. Built as the modest Ladies' Refreshment Salon in 1864, it was enlarged and transformed in 1929 into a glittering suite of rooms for dining, drinking, and dancing. It was the pet project of New York City Mayor James Walker, a popular figure known for his charm and flamboyant lifestyle. Slim, elegantly dressed and fast-talking, "Jimmy" Walker, also known as "Beau James," was a symbol of the Jazz Age. His career ended with a corruption scandal in 1932, soon followed by the demise of his favorite hangout.

While he regularly earned popular support for championing public works in his first term as mayor, he also permitted the proliferation of speakeasies during Prohibition and frequented many of them in the company of chorus girls. He left his wife for the showgirl Betty Compton and made the Casino their private club. Walker made sure one of his pals got the lease for the building and encouraged him to spend $400,000 to transform it to Jimmy's and Betty's liking. A magnificent lobby led to a domed pavilion that accommodated more than a hundred people and opened to the park with a continuous wall of glass doors. The Casino's interior was decorated by Joseph Urban, an Austrian architect who had designed theatrical sets for the Metropolitan Opera House (see pages 120–121) and Ziegfeld Follies. His design for the ballroom—a black glass ceiling hung with crystal chandeliers, chairs covered in gold fabric, and silver leaf on the walls—became the model for a Fred Astaire film in 1940. Socialites brought their own champagne, which their chauffeurs kept cool in the Rolls Royces lined up outside. In a private, upstairs suite, favorite politicians were entertained by Broadway chorus girls, rushed to the Casino after their shows by motorcycle escorts. In a small adjoining office, the mayor held court for the politicians and favor-seekers. Friends joked that he spent more time there than at City Hall.

OPPOSITE PAGE *Built as a modest refreshment salon, the casino was transformed by a flamboyant New York Mayor into a lavish nightclub.*

TOP *Workmen removing windows in preparation for the casino's demolition.*

ABOVE *Waitresses in costume for a special event.*

TOP RIGHT *Celebrities at the casino in 1930, including film star/singer Eddie Cantor, boxing champ Jack Dempsey, and a bevy of Hollywood chorus girls.*

DOUBLE DOWNFALL

In the mayoral election of 1929, Walker had overwhelmingly defeated the reform candidate Fiorello LaGuardia. But after an investigation revealed that Mayor Walker took large sums of money from businessmen seeking city contracts, he was forced to resign in 1932. He attempted a political comeback, but lost the support of New York's Democratic Party after the Roman Catholic Archdiocese objected to his extramarital affair with Compton. LaGuardia became the next mayor in 1934 and promptly demolished the casino, calling it a stain on a public park. Politically correct for the day, the action denied the city a great work by Joseph Urban and a lovely building by one of the park's chief architects, Calvert Vaux. Bob Hope portrayed Walker in the 1957 film, *Beau James*, a romanticized version of his life.

Central Park Menagerie **REPLACED 1934**

Before there was a zoo in Central Park—even before the park was completed—New Yorkers began to drop off an odd collection of animals: raccoons, foxes, wolves, porcupines, eagles, pelicans, peacocks, alligators, and even a boa constrictor. Hundreds were kept in cages in the basement of the Arsenal, the park headquarters on Fifth Avenue and 64th Street. Civil War General William T. Sherman donated three buffalo he had picked up in his march through Georgia, and General George Custer, fighting Indians in the West, sent a bear, all tied to poles behind the building.

This rag-tag collection was not at all what the park commissioners had in mind, particularly those with expensive homes along Fifth Avenue. They had seen elegant zoological gardens in Paris and London and wanted the same for New York. No other American city had one and they promoted the idea, just as they had done for the Metropolitan Museum of Art (see pages 6–7). The first proposal was for a privately run zoo, open to the public during the week but only to paid subscribers on Sundays. The plan would have effectively closed the zoo to members of the working class whose only day off was Sunday. Fortunately, it was put down by more democratic voices, and a permanent, free menagerie, including the cages seen here, was built behind the Arsenal in 1870. The parks department began to buy animals instead of just accepting donations, and despite the limited space, the menagerie had a variety of big beasts—elephants, hippos, and a herd of bison.

The 1880s brought the arrival of the star attraction, the first chimpanzee ever shown in the United States, a subject of fascination at a time when Darwin's theories were spreading across the country. He was called Mike Crowley, a name that Irish-Americans took as an insult and protested to the parks department, according to Elizabeth Blackmar and Roy Rosenzweig in *The Park and the People*. But the name stuck, and when "Mr. Crowley" took ill, newspapers reported regular bulletins about his condition, and even faith healers came to pray for him. He survived and lived to see his biography published as a popular paperback.

The menagerie's growing popularity led to complaints from wealthy Fifth Avenue residents offended by the smell of the animals and the behavior of the working-class crowds. By the 1890s,

prominent big-game hunters, including Theodore Roosevelt, were calling for a new place for the zoo, much larger than the park's cramped cages and nine acres of ground. Their influence led to state approval in 1895 for a zoo in the Bronx run by a private zoological society. Today, the Bronx Zoo, comprised of 265 acres and operated by the Wildlife Conservation Society, is the largest metropolitan zoo in the country. While the Society tried to absorb the Central Park Menagerie in the 1890s, New Yorkers would not give it up, and it became one of the park's most popular attractions. Conditions deteriorated, however, and by the end of the 1920s, the menagerie was a sorry collection of sick animals and rats. It was demolished and replaced by new zoo buildings in 1934, but the cycle would repeat itself in the 1970s when the zoo became a "Rikers Island for animals," a reference to the city's notorious jail. The new zoo, the Wildlife Conservation Center, opened in 1988. Operated by the same society that now runs all city zoos, it provides humane accommodations for the animals and is the first for-pay facility in the otherwise all-free Central Park.

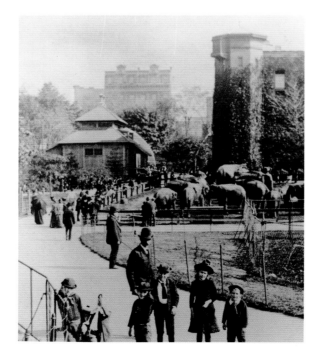

RIGHT *Housed in simple cages, the animals were a major park attraction.*

LEFT *Although the grounds were limited, the menagerie included a herd of elephants and other large animals.*

TOP *Actual sheep once grazed in Central Park's Sheep Meadow before they were moved to Brooklyn's Prospect Park in 1934.*

ABOVE *One of the elephants receiving a manicure.*

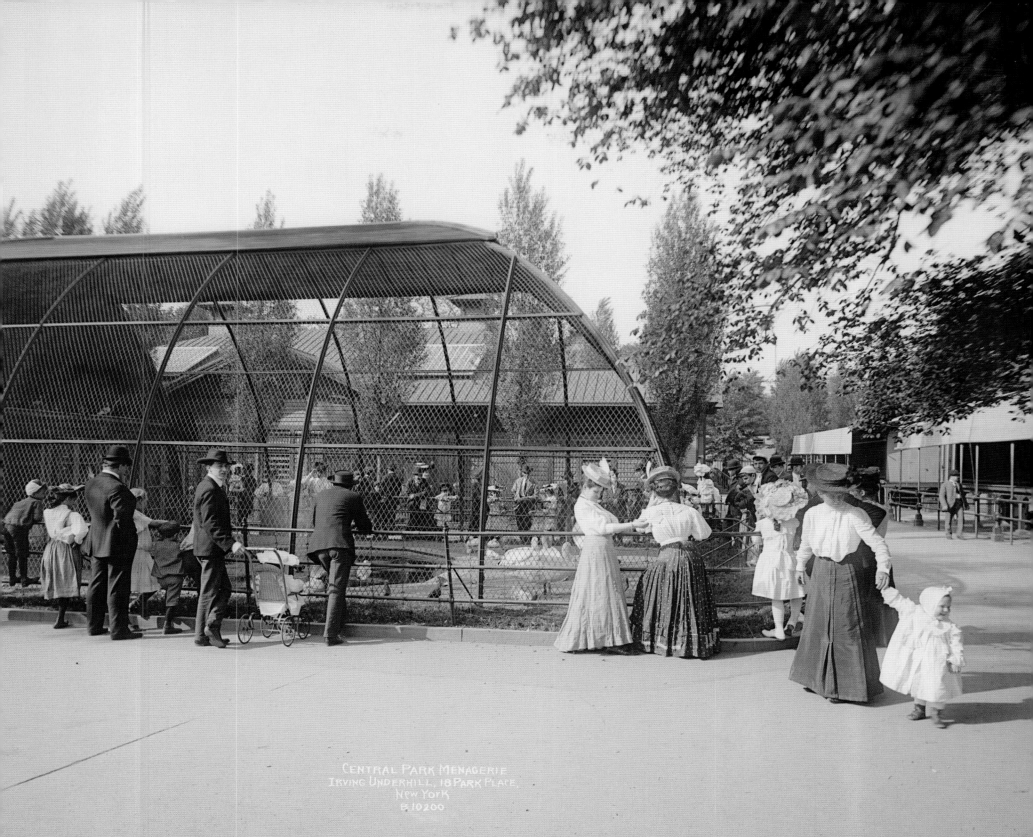

CENTRAL PARK MENAGERIE
IRVING UNDERHILL, 18 PARK PLACE,
NEW YORK
B 10200

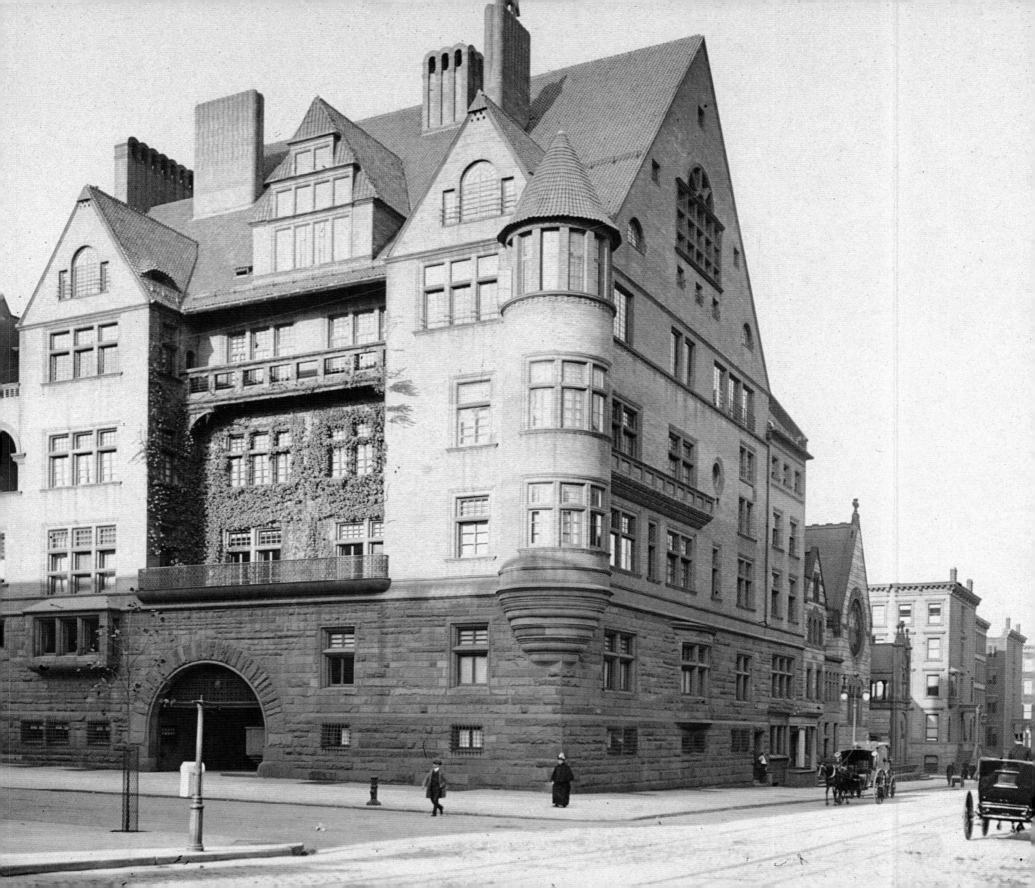

Tiffany Mansion DEMOLISHED 1936

Two of the greatest names in American decorative arts and architecture created this massive Manhattan mansion in 1885. Louis Comfort Tiffany, the renowned glass artist, and Stanford White, the prolific and creative architect, worked as a team to create this grand vision of the German Renaissance on Madison Avenue and 72nd Street. Just one block east of fashionable Fifth Avenue, it housed two generations of the Tiffany family, including Louis' father, Charles Tiffany, founder of the world-famous jewelry emporium.

Louis was not involved in the family business when the house was built. His innovative, sensual designs were too unusual for his father, who had built the company fortune with a wealthy, conservative clientele. Louis' work was part of the Art Nouveau and Aesthetic Movement, an artistic crowd that his father considered fast. To keep a parental eye on his son, Charles asked White to design a home with separate apartments for himself, his two daughters, and Louis and his wife and four children. Money was no object, since Tiffany & Company was selling more than six million dollars a year in diamond rings alone. Charles left most of the details of the house design to Louis and

White, who created a unique, fifty-seven-room ensemble of apartments stacked around a courtyard.

Louis Tiffany had revolutionized the production of stained glass in the late 1870s and established his own firm in 1879, embellishing New York mansions and private clubs. Within a few years, he would achieve national fame by redecorating the White House in 1882. He and White had worked together in creating the Seventh Regiment Armory in 1880. Now a Park Avenue landmark, the monumental building has rooms filled with their extraordinary decorative objects. Their design for the Tiffany mansion began with Louis' sketches, which White developed into a picturesque evocation of German townhouses from the sixteenth and seventeenth centuries. It was called a "princely château," a fortress-like building with a great arched entranceway. Three stories decorated in brick and terra cotta rose above the entrance to an immense roof of silver-black tiles. Within were vast spaces with gargantuan fireplaces, walls ornamented with Japanese swords and Indian carvings, and lamps and windows of luminous, multicolored glass. Louis' top-floor studio, located in the great expanse under the roof, was the

equivalent height of three or four conventional stories. At its center was a mammoth, four-sided fireplace culminating in a tree-trunk like chimney. Suspended from the sloping ceiling was a constellation of iridescent glass lamps of every shape and color.

Charles never moved into his apartment, staying with his wife in their comfortable Murray Hill home on lower Madison Avenue. Louis' wife died in 1886 and after remarrying, he and his new wife spent most of their time at Laurelton Hall, their country home on Long Island. Over the years, the town home was rented out to Louis' friends and business associates. After Charles's death in 1902, Louis became vice president and artistic director of Tiffany & Company, which sold his enameled jewelry from 1907 until 1933. Louis died that year in the Madison Avenue house. While his work became internationally known, by the time of the Great Depression, the Tiffany mansion was an unfashionable behemoth. Torn down without any public protest in 1936, it was soon replaced by a luxury apartment building.

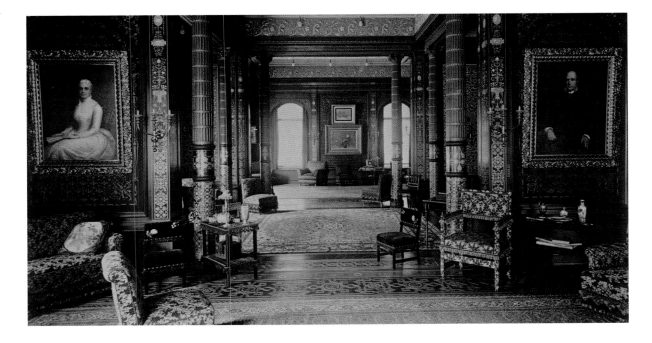

OPPOSITE PAGE *The massive mansion was built as separate apartments for Charles Tiffany, founder of the famous jewelry store, his son, the glass artist Louis Comfort Tiffany, and other family members.*

LEFT *Drawing room in one of the apartments.*

ABOVE *Charles Tiffany, in Tiffany & Company's early location on Union Square.*

The Tombs City Jail CONDEMNED 1938

It is no surprise that the Manhattan jail known as the Tombs has an unhappy history. Some historians blame the nickname on the architecture of the original building, erected in 1838 and modeled on an engraving of an ancient Egyptian mausoleum. But it was those dark, dank prison cells that gave it the atmosphere of a mausoleum for the living. And its corrupt administration only added to its frightening reputation. Every jail built on this Lower Manhattan site, including the latest version, has been called the Tombs, but it was the first two that really looked the part and made the name stick.

The problems began with the selection of the prison site over what had been a small lake called Collect Pond, once the fresh water source for colonial New York City. By the late eighteenth century, it was polluted with sewage and garbage dumped by the growing population. Condemned, drained, and filled in 1811, it nonetheless never lost its swampy, foul-smelling atmosphere, which led to the formation of the surrounding slum, known as the Five Points. As portrayed in the 2002 film, *Gangs of New York*, the crime-ridden neighborhood was apparently a good place to put a prison in 1838. Formally called the New York Halls of Justice and House of Detention, it also contained the city's courts and police headquarters. But the heavy masonry of the complex, built on top of the unstable landfill, began to sink soon after it opened. Its Egyptian Revival architecture did not impress Charles Dickens, who exclaimed in his *American Notes* of 1842, "What is this dismal fronted pile of bastard Egyptian, like an enchanter's palace in a melodrama?" Scandalized by corruption, deplorable conditions and prison escapes, it was demolished and replaced in 1902.

OPPOSITE PAGE *The Tombs second incarnation, built in 1902, looked like a medieval castle.*

ABOVE *The entrance seemed to say, "Abandon all hope, ye who enter here."*

RIGHT *The "Bridge of Sighs" connected the courts to the jail.*

TOP RIGHT *This 1902 photograph includes the first building, right, which was modeled on an Egyptian mausoleum. It would be demolished the same year.*

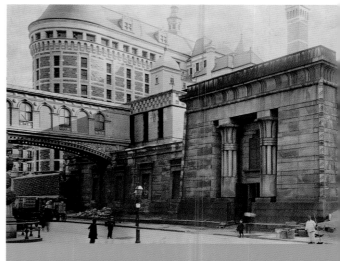

HISTORY REPEATING ITSELF

The new Tombs was a tower that looked like a medieval castle and was connected by a bridge to the Criminal Courts Building. The connection was known as the Bridge of Sighs, recalling the Venetian one memorialized in a poem by Lord Byron as the place where prisoners sighed at their last view of Venice. The call for prison reforms continued in the early twentieth century and, in 1938, the progressive New York City Mayor Fiorello LaGuardia condemned the 1902 Tombs and broke ground for a modern complex that was completed in 1941. By the 1970s, it presented security and health problems once again. Part of it was demolished and the remaining part was remodeled in 1983. A new 500-bed tower opened in 1990 and was renamed the Bernard B. Kerik Complex in 2001 in honor of the city corrections commissioner and later police commissioner. But in the latest example of history repeating itself, the name was dropped after Kerik was convicted of corruption and in 2010 began a four-year prison sentence, fortunately for him, not in the Tombs.

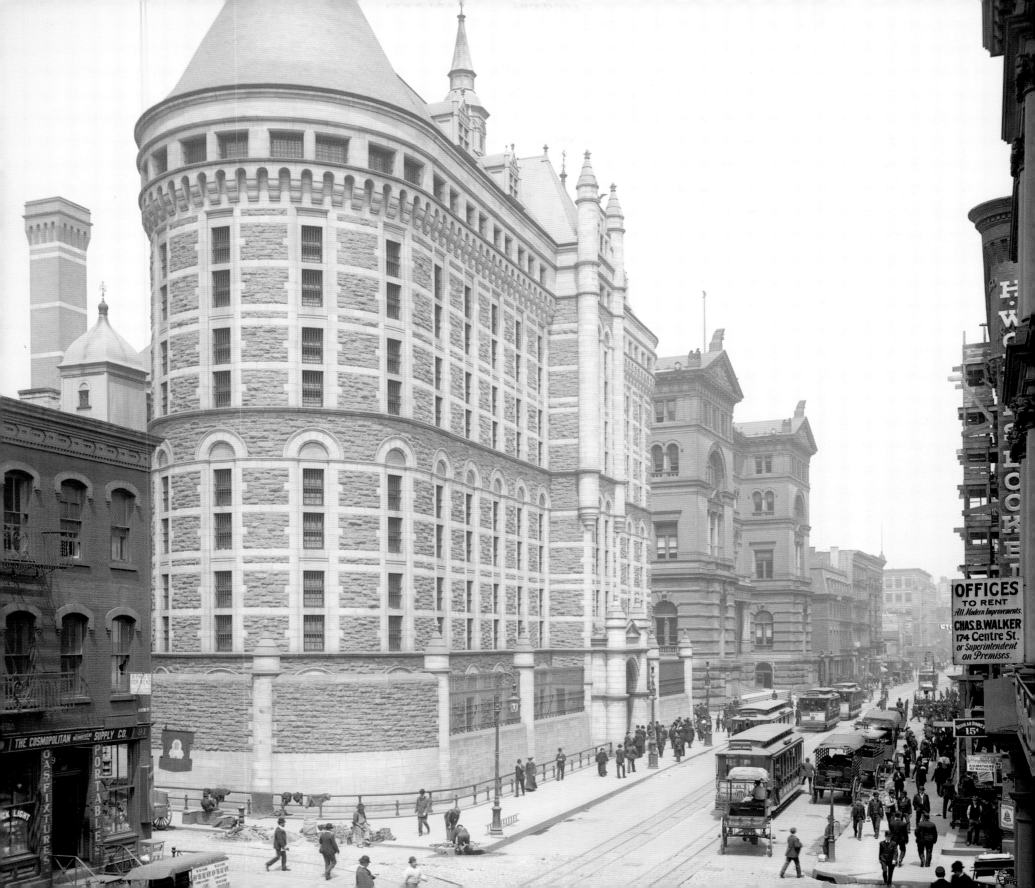

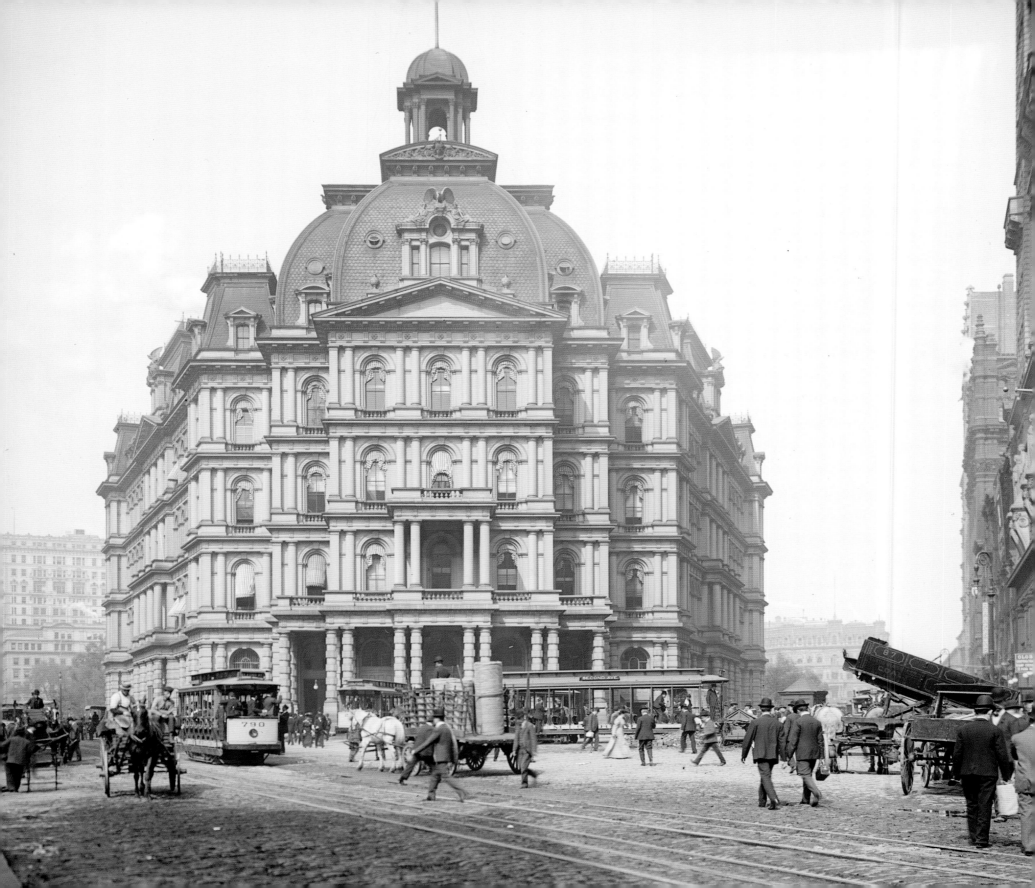

City Hall Post Office DEMOLISHED 1938

It would be hard to pick a New York City building less loved than the old post office in City Hall Park. Critics hated everything about it, its site, construction, cost, and final appearance. The complaints began as soon as the site was announced and continued throughout its life from 1878 to 1938. Larger than any other government building in New York at the time, it took up a prime public site and its architecture was more bombastic than anything else built during the Gilded Age. It was hard to ignore and drew criticism like flies.

When the building site at the southern tip of City Hall Park was selected in 1866, the editors of the *Real Estate Record and Builders' Guide* fumed with exasperation: "Why willfully and gratuitously select the most inconveniently located piece of ground that could possibly have been found on the whole island?" The small park was one of the city's few "breathing spaces" in an area clogged with traffic. The *New York Daily Tribune* (see pages 112-113), located next to City Hall Park on Newspaper Row, warned that the large building at the tip of the park would be "like a boil on the end of a man's nose."

The commission in charge of selecting an architect and formulating a design took three years. Alfred Mullett, supervising architect of the Treasury Department, molded the collaborative effort into a final design. The end product was a combination of nearly every ornamental feature of nineteenth-century architecture—cast iron columns, mansard roofs, a dome, and a cupola. It looked like a building designed by a committee, but it would be known as "Mullett's Monstrosity."

No one denied that a new post office was long overdue. The city's only post office had been operating since 1845 in an old church building and by 1870 the makeshift facility was handling more than one hundred tons of mail each day. But the new building, like the mail, was late in coming. After the ground was broken in 1869, Congress was slow to authorize the construction funds and the work dragged on in fits and starts. In the meantime, the budget kept increasing, drawing even more complaints about the high cost. One of the reasons for the expense was its unusually thick walls—ten and a half feet of iron-reinforced brick and granite. Its window frames were made of plate armor similar to the type used in battleships. Two of the building's

four floors were reserved for federal courts and in the wake of the Civil War Draft Riots of 1863 that had terrorized the area for five days, the government was apparently still worried about defending its property.

Finally completed in 1878, the post office dwarfed every other building around it, realizing fears that "venerable City Hall would shrink into the dimensions of some old-fashioned toy." While some professed admiration for what had become the world's largest post office, many others remained critical for years to come. When new plans for City Hall Park came up again in the 1920s,

the post office was one of the first candidates proposed for demolition. But it lasted until 1938, when it finally came down so that the park could be improved in preparation for the 1939 World's Fair. Today, its large footprint is open to the sky, filled only by a public walkway, trees and fountains.

OPPOSITE PAGE *The architecture of the post office was more bombastic than that of any other building of the bombastic Gilded Age.*

BELOW *The huge building completely blocked views of City Hall, which is directly behind the post office in this view.*

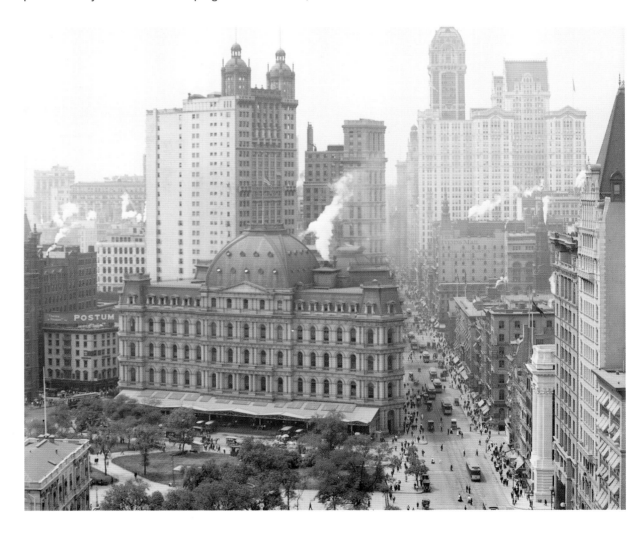

Hippodrome DEMOLISHED 1939

New York is famous for the lights of Broadway, glorified in the musicals of the 1930s, but the biggest and brightest theaters were already dazzling audiences at the start of the twentieth century. Just two years after the theater impresario Frederick Thompson lit up Coney Island with his fantastic Luna Park in 1903 (see pages 78–81), he turned on the lights at the New York Hippodrome, amazing New Yorkers once again. His new Manhattan venue was the largest theater in the world and presented the most extravagant popular spectacles.

Located on Sixth Avenue between 43rd and 44th streets, just a block from the Broadway Theater District, the Hippodrome had corner towers topped with huge globes outlined in electric lights. Inside were 5,300 seats and a vast stage with an apron that projected into the audience. Much larger than the Broadway stages, it boasted two full-sized

circus rings that could hold a thousand performers at a time. Even more amazing, the apron was submersible, lowering into a huge glass tank below the stage for water pageants and diving shows, featuring "plunging horses" and the popular "million-dollar mermaid."

The gala opening in 1905 presented a four-hour extravaganza of wildly divergent entertainment. The first act, *A Yankee Circus on Mars*, included space ships, horses, elephants, acrobats, clowns, hundreds of singers and dancers and a sixty-piece orchestra. The second act, *The Raiders*, was a spectacular, although fictional, enactment of the Union Army's raid on Andersonville, the notorious Confederate prison. Gunfire and explosions sounded as men on horseback plunged into the water tank and swam across as though it were a lake. True to the ancient theme of the hippodrome, the theater had animals both on stage and in the architecture. Elephant heads topped the columns, plaster horses galloped up the arches, and live animals roamed in cages. In one of the most popular acts, the Great Houdini made an elephant disappear on stage.

ONE LAST EXTRAVAGANZA

The high costs of running these productions eventually made the Hippodrome a losing operation. In the 1920s, it downsized to vaudeville, movies, boxing, wrestling and other sports, but had one last burst of glory in 1935. Billy Rose, the Broadway showman and lyricist (whose songs include "Me and My Shadow" and "Only a Paper Moon") produced Rodgers and Hart's *Jumbo* on the Hippodrome's stage with big stars of the era, Jimmy Durante and Paul Whiteman's orchestra, along with aerial acts and, of course, an elephant. Unfortunately, like Thompson, Rose proved to be another impresario with more ideas than finances, and the production lasted only five months. In 1939, the Hippodrome's great stage went dark for the last time. Its name has resurfaced in two quite different operations. In 1952 the site of the theater was rebuilt with an unworthy namesake, an office building and parking garage called the Hippodrome Center. In the 1970s, the Little Hippodrome, a drag and comedy club, opened on East 56th Street. Casting the Hippodrome's glamour in a new light, it staged the final New York performances in 1975 of the glam rock group, the New York Dolls.

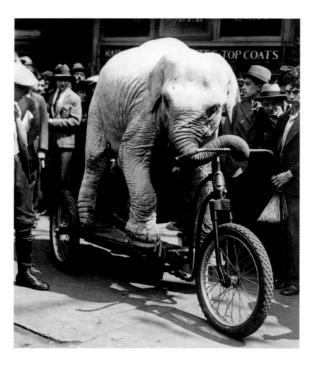

RIGHT *The Hippodrome was the largest theater in the world when built in 1905. The Sixth Avenue elevated tracks (see page 70) once ran alongside the huge building.*

FAR LEFT *Several scenes in* There's No Business Like Show Business *were set in the Hippodrome.*

LEFT *Elephant acts, including the tricycle-riding Topsy, were a feature at the Hippodrome.*

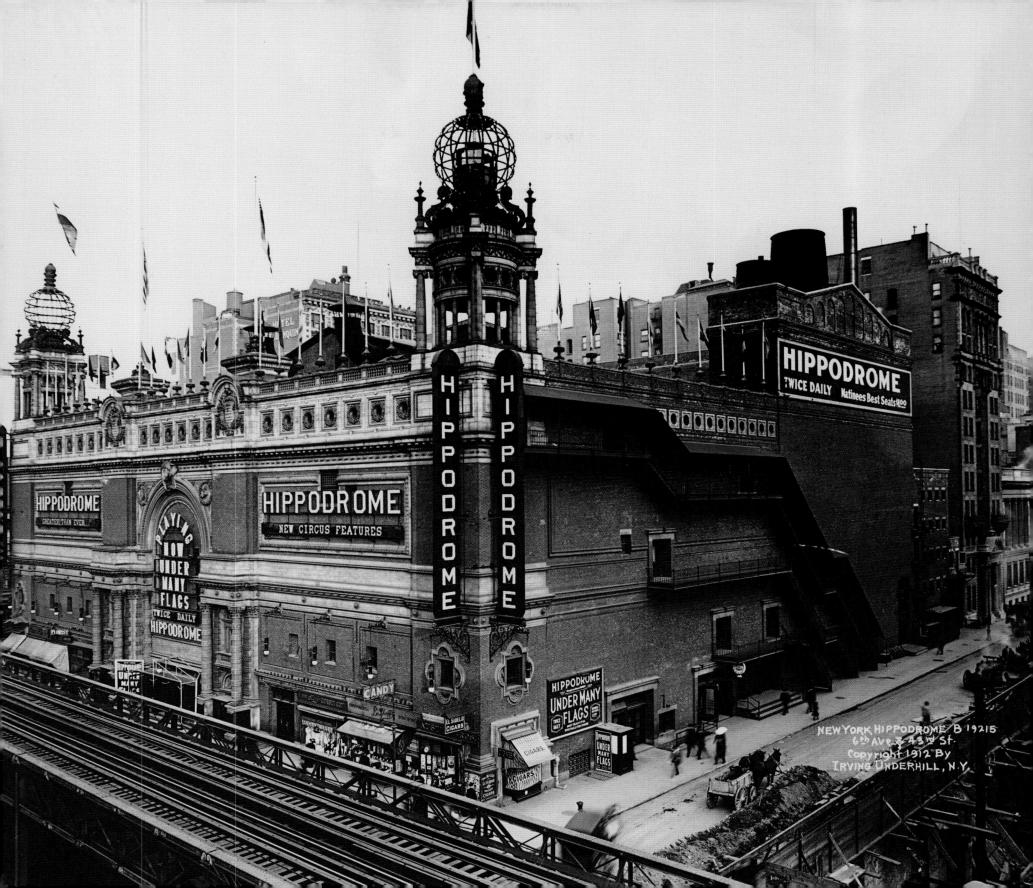

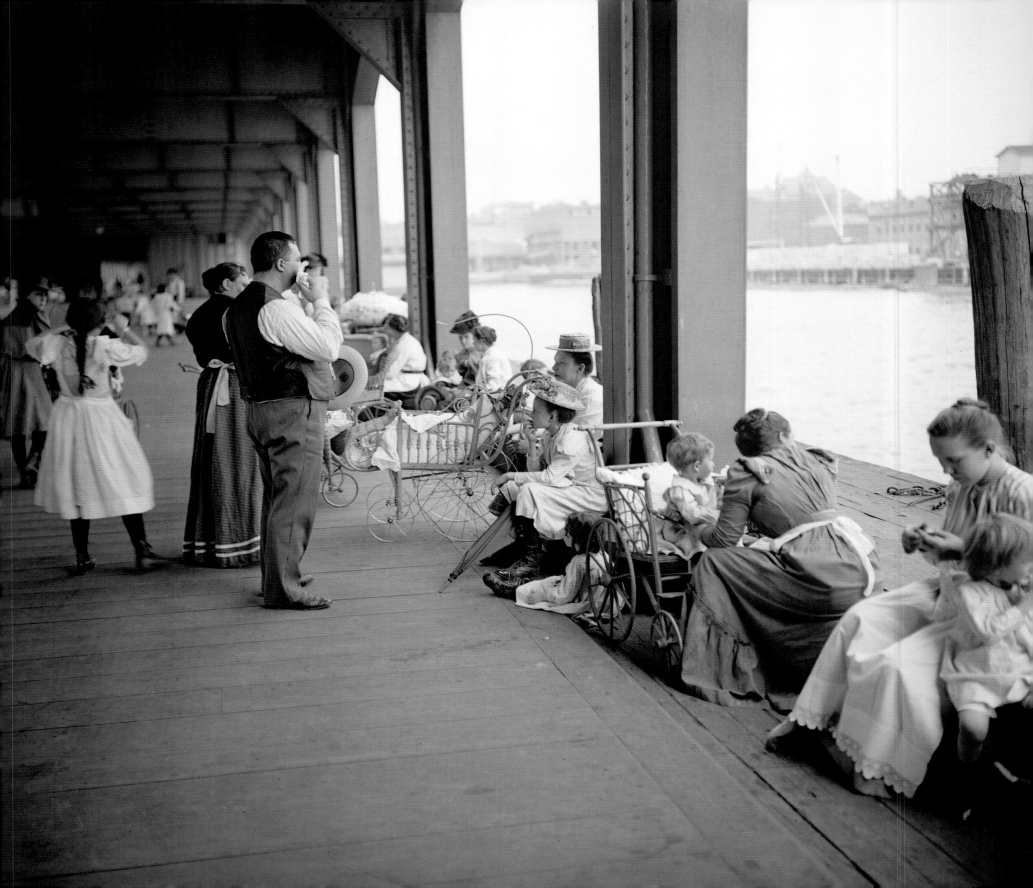

Floating bathhouses and Play Piers for the Poor DISCONTINUED CIRCA 1939

While wealthy New Yorkers were living in luxurious mansions in the Gilded Age, the poor were barely surviving in deplorable slum conditions. In 1889, Jacob Riis published *How the Other Half Lives*, shocking upper- and middle-class New Yorkers who were either ignorant of or indifferent to these conditions. Poverty had always existed in the city, but the wave of immigration that rose after the Civil War created unprecedented numbers of people suffering severe hardships. Riis's photos and graphic descriptions exposed the squalor of immigrants living in cramped, dark, unventilated tenements. An immigrant himself who had experienced poverty in the city, he recommended ways to alleviate the squalid conditions. One of these was to build recreation piers on the waterfront as places where tenement dwellers could get fresh air and relief from their stifling apartments during the summer. He called them Play Piers, reflecting his concern for the plight of children who worked alongside their parents in tenement sweatshops or in factories. The piers were places where children could not only engage in supervised play, but also receive regular medical examinations by visiting doctors.

Riis's book had a powerful impact and shortly after its publication, the first Play Pier opened on the Lower East Side at the foot of East Third Street and the East River. Its great success led to five others near poor neighborhoods in downtown and uptown Manhattan and a sixth in Brooklyn. Open from early in the morning until late in the evening, they were filled with children during the day and adults taking a break from work at night. On the days that doctors visited, mothers would line the piers with their babies in prams.

The rivers surrounding the city had always provided relief on hot summer days for swimmers willing to jump in at any accessible place. After the Civil War, health advocates urged the creation of floating bathhouses, a luxury for tenement dwellers who did not have running water in their apartments. The first bathhouses were placed in the Hudson and East rivers in 1870 and by 1890, fifteen were in operation. These were large wooden structures floating on pontoons that enclosed big tanks of water, one for adults and one for children, with dressing rooms around the perimeter. They were towed in place each June and towed back in November to winter docks. Eagerly awaited each summer, they were enormously popular and used by millions of people. But by the 1920s, the rivers, polluted with sewage and industrial outfalls, were tainting the baths, which were gradually taken out of service. Only three were operating in 1938 and they were soon gone, replaced by eleven large swimming pools built in the city during the 1930s.

The recreation piers also disappeared after highways built along the rivers in the 1930s made it difficult and dangerous to get to the waterfront. New Yorkers had to wait until the twenty-first century to enjoy new recreation piers built as part of the Hudson River Waterfront Park. In 2007, a new floating pool also made its debut in the new Brooklyn Bridge Park. Inspired by the original floating baths, it was converted from an old cargo barge to a sleek, seven-lane, twenty-five-meter-long pool. It now resides on the Bronx waterfront.

OPPOSITE PAGE *Play Piers offered tenement dwellers fresh air, recreation, and even doctor examinations.*
BELOW LEFT *A doctor examining a baby on a Play Pier.*
BELOW *Women lining up to enter a floating bathhouse.*

Tiffany & Co. Jewelry Store ABANDONED 1940

When Audrey Hepburn gazed into Tiffany's windows in the 1961 film *Breakfast at Tiffany's*, she made the store a New York City icon. Its place on Fifth Avenue and 57th Street was fixed in the national consciousness. It seemed as if it had always been there, a perennial symbol of longed-for luxury. But Tiffany's founder was, in fact, mortal and worked his way up just like any other New York merchant. The current site is the company's sixth location, and the present building, a sleek 1940s design, is not its grandest piece of architecture. That distinction belongs to its previous home, twenty blocks south on Fifth Avenue and 37th Street. Built in 1906, it was the creative expression of a much different era that looked to the Italian Renaissance for inspiration.

Charles Tiffany founded the company in 1837, selling stationery and fancy goods on Lower Broadway. He and his partners began selling jewelry in 1841 as Tiffany, Young and Ellis. He bought out the partners in 1853 and changed the name to Tiffany & Company. As business improved, it expanded to larger quarters in two different Broadway stores and then to Union Square, always with a large clock upheld by Atlas on the facade. After Charles died in 1902, his son, Louis Comfort Tiffany, became involved in the business for the first time. Stanford White, who had worked with Louis in designing the Tiffany mansion in 1885 (see pages 56–57), was hired to design the new store on Fifth and 37th Street.

White based the design on a Venetian palazzo, covering the steel frame with three tiers of marble Corinthian columns that gave the building a grandeur greater than its seven stories. Wide windows spanned the columns, letting in ample light to the interior showroom. Precious gems, cut crystal, bronze statues, and other treasures were displayed in cases of teak, steel, and brass under a lofty ceiling supported by marble columns. The top floor contained a vast exhibition hall spanned by Guastavino tile arches and lit from above by a sixty-foot-long elliptical skylight.

Neither White nor Louis Tiffany lived to see the magnificent building abandoned. White was shot and killed in 1906, the same year the building opened (see page 41), and Louis died in 1933. In the ever-changing city, fashionable shops were moving uptown once again and the company built new headquarters at 57th Street in 1940. The only remnant of the 1906 building is the 1853 figure of Atlas holding the clock, which stands above the entrance on a limestone facade free of ornamentation. White's palazzo now holds offices and storefronts easily passed by.

RIGHT *Tiffany & Co.'s previous home on Fifth Avenue and 37th Street was the store's grandest architectural setting.*

LEFT AND ABOVE *Louis Comfort Tiffany and one of his glass creations. Louis became involved in the jewelry store for the first time following his father's death in 1902.*

1939 World's Fair DISMANTLED 1940

Caught between the Great Depression and the approaching Second World War, New Yorkers lost themselves in a dream world of the future at the 1939–1940 World's Fair. Spread over more than 1,200 acres, the fair was a city of exciting possibilities that rose on a reclaimed ash heap in Queens. A decade earlier, F. Scott Fitzgerald's celebrated novel *The Great Gatsby* had described the site as a "valley of ashes—a fantastic farm where ashes grow like wheat into ridges and hills and grotesque gardens." Miraculously transformed, the new landscape sprouted 375 new buildings, demonstrating how all aspects of life—housing, science, transportation, food production, and entertainment—would also be reshaped.

This was New York's second world's fair, held nearly a century after the first one in 1853 on the site of today's Bryant Park in midtown Manhattan. Hosted in the Crystal Palace, a glass and iron dome modeled on one built two years earlier in London, the first fair celebrated the "Industry of All Nations." New York's Crystal Palace burned in 1858 and by 1939, nineteenth-century industrial tycoons had built vast corporate enterprises. They expressed the fair theme, "Building the World of Tomorrow," as a brave new world for the American consumer. Visitors took delight in a tantalizing array of new products presented for "Mr. and Mrs. Modern," from diesel engines, television, and air-conditioning to color film, nylon stockings, and pressure cookers. They strolled through the twenty-one model homes in the "Town of Tomorrow," a vision of future suburbia, and drove new Fords on the "Road of Tomorrow," a half-mile long expanse with a three-tiered spiral ramp. Some of the corporate pavilions took the shape of their products, including the giant National Cash Register building, the most graphic symbol of selling the future.

For sheer fun, visitors took rides on the 250-foot-high Parachute Tower (later moved to Coney Island's Steeplechase Park), and a couple got married in one of the tower's aerial seats by a pastor also suspended high above the ground. By far, the biggest attraction was Futurama, General Motors' depiction of the world in 1960 that simulated a cross-country plane trip above a vast, seven-lane highway system dotted with new towns and industries. Essentially, it was a vision of the future defined by the car. But it also held out the hope of abundant energy sources and radically new construction techniques that could overcome every obstacle to mankind's achievements.

LEFT *Fair visitors lined up on an elevated walkway to enter the enormous Perisphere.*

RIGHT *An illustration of the parachute jump that debuted at the fair and was later moved to Steeplechase Park in Coney Island (see page 106).*

FAR RIGHT *Colorful posters advertising the fair are now prized by collectors.*

"I HAVE SEEN THE FUTURE"

Visitors leaving the Futurama exhibit were given pins reading "I have seen the future." But the immediate future would be far from the utopian scenes at the fair. While New York's first world's fair ended in a fire that destroyed the Crystal Palace, the visions of the 1939–1940 fair were soon consumed by war. The political turmoil was felt on the fairgrounds. After Stalin signed a non-aggression pact with Hitler, the Soviet pavilion, topped by a seventy-foot-tall worker, was dismantled and sent back to Russia. The site was landscaped and renamed the American Common. The Japanese pavilion, intended to be a permanent structure, was burned by vandals after the attack on Pearl Harbor. Even the towering symbols of the fair, the 610-foot-tall Trylon and the 180-foot-diameter Perisphere, were quickly demolished, sold to Bethlehem Steel for war tanks and weapons.

Elevated train tracks REMOVED 1940–1941

The elevated railways were the best and worst structures built in New York City in the nineteenth century. As the first widespread form of rapid transit, they were the single greatest force for expanding the city and allowing its population and businesses to grow. They also got rid of the unsavory effects of horse-drawn transportation—the smell and dirt of manure in the streets, epidemics of equine flu, and mistreatment of the animals. Most horses lasted only five years in the harsh conditions. But the railway locomotives spewed cinders and ash on pedestrians below, shook buildings, and darkened the streets, creating havens for crime under the tracks. Horrified by the blight, Henry James described the entire superstructure as an "immeasurable spinal column and myriad clutching paws of an antediluvian monster." When most of the "els" were taken down in the early 1940s, New Yorkers rejoiced.

The incentive for building elevated tracks was the impossibly clogged city streets, a constant tangle of horse-drawn omnibuses, streetcars, carts, wagons, and private carriages that created long, chaotic commutes. Surface railroads, which blighted swaths of land along their tracks, were clearly not the answer. The problems were especially challenging in the long and narrow island of Manhattan, which one observer noted was "much better shaped for a cucumber than a city."

Elevated trains or aerial railways, as they were called, were proposed early in the century, but the first one did not get off the ground until 1867. It traveled up Ninth Avenue on Manhattan's West Side, pulled by cables connected to a steam-powered generator. The cables often snapped, halting the train and forcing the passengers to climb down from the tracks by ladders. The operator went bankrupt but the line was taken over by a new company that replaced the cables with steam locomotives and extended the line northward, attracting more riders each day.

Big-money investors like Andrew Carnegie formed more companies and began to spread their lines like tentacles throughout the city. Powerful men like Jay Gould wrestled for control, taking over through stock manipulation as they had done with national railroads. The lines extended from one end of Manhattan to the other, picking up suburban and long-distance passengers at Grand Central Depot in the 1870s. They stretched across rivers into the outer boroughs, crossing the Brooklyn Bridge soon after it opened in 1883, reaching the Bronx on a drawbridge over the Harlem River by 1890 and Queens after the Queensboro Bridge opened in 1909. Houses sprung up and new neighborhoods were formed. The extensive network changed the way of life for New Yorkers, allowing them to live, work, and shop in different parts of the city.

But with riders increasing every day, the trains became as crowded as the streetcars and much noisier. The start of the subways in 1904 relieved some of the pressure, while the els now served a new purpose, connecting subway stations. Ridership on the els reached its greatest annual level in 1921: 384 million passengers. Two years later, a number of lines were abandoned as subways began running parallel to the elevated tracks. During the Depression, els were taken down to raise property values and a cascade of the major lines came down in the early 1940s. A few lines still operate in the outer boroughs, but Manhattan, except for a few short spurts, is free of overhead tracks. While the sun shines on the once blighted areas, New Yorkers now complain about the subways.

RIGHT *New York's first elevated train route traveled along Ninth Avenue on Manhattan's West Side and made a sharp turn, shown here at 110th Street.*

BELOW LEFT *This view of the Ninth Avenue elevated line reveals the early construction of the Cathedral of St. John the Divine in the left background.*

BELOW *Elevated trains once ran above the Bowery in Lower Manhattan.*

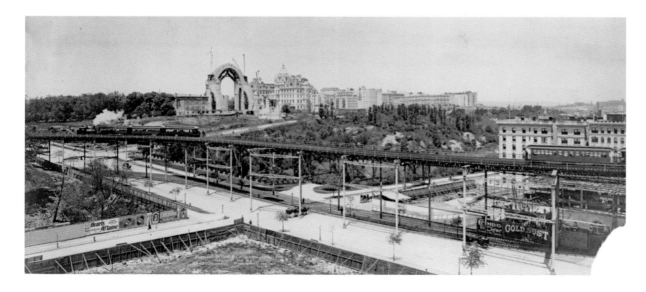

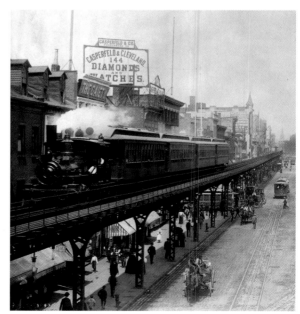

110TH STREET "L" STATION, NEW YORK.

Castle Garden Aquarium **DISMANTLED 1941**

Thousands of tourists line up today at Castle Clinton to buy tickets for ferries to the Statue of Liberty and Ellis Island. Just a shell of what it used to be, the building has a long and colorful history, longer than the statue or the island. Two centuries old, it was first a fort and later transformed to house very different activities: a concert hall called Castle Garden, an immigration center, and the New York Aquarium, the castle's biggest and longest-running attraction. For nearly half a century, from 1896 to 1941, sea creatures of all kinds swam within its tanks to the delight of millions of wide-eyed New Yorkers. The show stopped when the city's master builder, Robert Moses, decided that the building was in the way of his plans for a new bridge from Manhattan to Brooklyn. The fish had to go, but the castle, at least what was left of it, was saved at the last minute by a more powerful politician.

The fort, a wide, stone circle of massive walls, was built at the Battery on Manhattan's southern tip to protect New York against British attack in the War of 1812, an attack that never came. Never firing a shot in anger, the fort became the place where venerable heroes were honored in triumph and in death with cannon salutes. Roofed over in 1823, it became an entertainment center, most famously P. T. Barnum's concert hall where Jenny Lind, the "Swedish Nightingale," made her American debut in 1850. In 1855, it became the landing station for the flood of European immigrants coming to the United States, the place where nearly eight million people came ashore before Ellis Island opened in 1892. Converted to the aquarium in 1896, it gained two stories, corner turrets and a crenellated top, like an actual castle. Covered with a white stucco finish, it looked more like a toy castle, one that became a fantasy home for fish. Fearsome creatures—giant morays, alligators, and sharks—along with friendlier penguins, sea lions, and many other exotic species filled three floors of tanks. Free and easily accessible, the aquarium drew an average annual attendance of two and a half million people, by far the most heavily attended public institution in New York.

But it held little attraction for Moses, who wanted to blast the entire building out of the way in 1941 in order to build a bridge from the Battery to Brooklyn, linking up with the system of highways that he had strung throughout the city and suburbs. As the head of several powerful government agencies, he controlled the purse strings for federal funds, which the city had come to rely upon for public works during the Depression. Lauded by local politicians and the press, he was rarely and never successfully opposed. This would be his first defeat. Deaf to public protests, he met his match when President Franklin D. Roosevelt's wife, Eleanor, sided with the protestors. FDR, no friend to Moses, encouraged the Department of Defense to determine that the bridge would interfere with navigation and pose a threat to New York's wartime security. A tunnel was built instead, but Moses had his revenge by dismantling the aquarium. Thousands of fish were shipped off to the Bronx Zoo and aquariums in other cities, where they waited for the new home that Moses promised to build in Coney Island. The castle was gutted, leaving only the stone walls, which Moses also would have demolished if not for a last-minute court ruling. The new aquarium at Coney Island did not open until 1955, paid for not with federal funds, but with city tax dollars and admission fees.

OPPOSITE PAGE *The aquarium was built in 1896 within an 1812 fort and became the most heavily attended public institution in the city.*

LEFT *An illustration of the spacious interior and its multiple fish tanks.*

ABOVE *An aerial view of the aquarium facing New York Harbor.*

Normandie (USS Lafayette) CAPSIZED 1942

One of the world's greatest ocean liners, the svelte Art Deco beauty, *Normandie*, was destroyed at a New York pier in the early years of World War II. Although she was built in France, her spectacular demise would be remembered as a New York disaster, largely because of the sensational photos of the huge, burning ship lying on her side between two city piers. Only seven years old, her short-lived life of luxury was caught up in the war. Essentially a prisoner of war in New York, she was undergoing a degrading transformation to a troop ship at the time of her death.

She was conceived during the roaring twenties when European shipping companies began to build luxurious vessels for upper-class tourists, particularly for Americans who sailed to Europe to escape the long years of Prohibition. The ships themselves were like glorious hotels with alcohol flowing at every level. While Prohibition was over by the time the *Normandie* made her maiden voyage from Le Havre to New York in 1935, she had other unique qualities to offer. Her slim hull and slanting bow cut an attractive figure and her Art Deco publicity poster, a full-frontal view still collectible today, made her a pin-up girl as famous as any 1930s movie star. But she was not made just for looks. Below the waterline, her turbo-electric engines made her one of the fastest ships of the day, breaking a record on her first voyage. Inside, she was all Art Deco and Streamline Moderne luxury. The first-class dining room, three hundred feet long, was the largest room afloat. Longer than the Hall of Mirrors at Versailles, it was just as dazzling, with illuminated pillars of Lalique glass. The children's dining room was decorated by the famous children's book author, Jean de Brunhoff, who covered the walls with murals of Babar the Elephant. The rich and famous sailed on the *Normandie*, including the biggest names of the day, Marlene Dietrich, Fred Astaire, Ernest Hemingway, Noel Coward, Irving Berlin, Walt Disney and many others.

DEATH BY FIRE AND WATER

The ship made 138 round trips, but before the last return to Le Havre in 1940, France fell to the Nazis and she was seized by the U.S. Coast Guard in New York. In 1941, the U.S. Navy decided to make her into a troopship and renamed her the USS *Lafayette* in honor of the French general who had fought in the American Revolution. The conversion, which took place at Pier 88 on the Hudson River at West 48th, led to the disaster. On February 9, 1942, sparks from a welding torch ignited thousands of life vests filled with a flammable material. The fire spread rapidly, running along the rich, wood paneling that still lined the interior. Firefighters' on shore and on fireboats in the river sped to the scene, but their powerful streams of water filled one side of the vessel and caused it to capsize. It lay on its side for months like a beached whale. Sabotage was suspected but never proved. Stripped of its superstructure, the hull was taken to a repair shipyard in Brooklyn, but the cost of restoration was considered too great. It was sold for $162,000 to a salvage company and scrapped in 1946. Fortunately, many of the splendid furnishings had been salvaged before the fire. Larger pieces were snapped up by collectors, but occasionally, a piece of crystal or silverware turns up on the *Antiques Roadshow*.

French Line C.G.T.
SOUTHAMPTON TO NEW YORK
EXPRESS LUXURY SERVICE
"ILE DE FRANCE" "NORMANDIE"
ENQUIRE WITHIN

RIGHT *Capsized by water poured into her hull, the sleek vessel lay on her side like a beached whale between piers on Manhattan's West Side.*

FAR LEFT *An Art Deco poster advertising the Normandie's French Line.*

LEFT *These ornate bronze medallions were salvaged from the* Normandie *and now adorn the Remsen Street entrance to Our Lady of Lebanon Maronite Catholic Cathedral in Brooklyn.*

Brooklyn Bridge Train Terminals DEMOLISHED 1944

Long before the Brooklyn Bridge was built, John Augustus Roebling, its visionary engineer, had laid plans for trains crossing the bridge. He had worked it all out. Four tracks would carry specially built trains pulled by an endless cable that would be powered by a giant, stationary steam engine on the Brooklyn side. He also envisioned elevated trains bringing people to the bridge, even before this new rapid transit system was up and running. But John Roebling would not live to see either the bridge or its trains. He died in an accident in 1869, just as construction of the bridge was about to begin. His son, Washington Roebling, would carry out his father's plans, despite his own disabling injury suffered during the bridge construction. Cable cars started running on the bridge soon after its completion in 1883. Five years later, they were carrying more than thirty million passengers a year, making the trip in about five minutes, just as John Roebling had imagined.

The terminal in Manhattan, enlarged several times, became a massive structure jutting over Park Row and nearly touching City Hall Park. The cable cars were eventually replaced by trolleys and by trains running over the bridge from an elevated line terminal built on the Brooklyn side. By 1944, the terminals and trains were gone, replaced by something that neither John Roebling nor his son could have imagined—automobile traffic. For different reasons, Washington had taken a dramatic step to strengthen the bridge, ensuring its ability to accommodate this radical change in transportation. In 1881, he had ordered an additional 1,000 tons of steel for the bridge deck so that it would be strong enough to carry future railroads—the only type of transportation imaginable. The act nearly cost him his job. The bridge was already behind schedule and over budget and the added cost and time spurred politicians to call for Roebling's resignation. He kept his job by a narrow vote of the trustees and saw the bridge to its completion. The decision made the bridge ready to carry autos in the early twentieth century when they began to replace the horse-drawn vehicles that ran alongside the trolleys. And it kept the bridge in service for almost another half century before the first major alterations to the superstructure were necessary.

BUILT FOR POSTERITY

After the elevated trains stopped running over the bridge in 1944 and the old terminals were taken down, a team of engineers inspected the bridge. All that was needed was a new coat of paint. Four years later, the train tracks were removed, the roadways were widened to three lanes in each direction, and new trusses were added. While the Roeblings would be amazed by the number of cars now crossing the bridge—144,000 each day—they would not be surprised by the thousands of people who pass above the roadways on the elevated pedestrian boardwalk that John included in his original design. As he imagined, they do it just for the view.

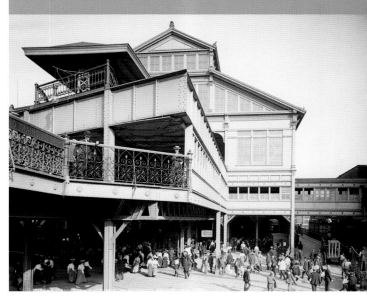

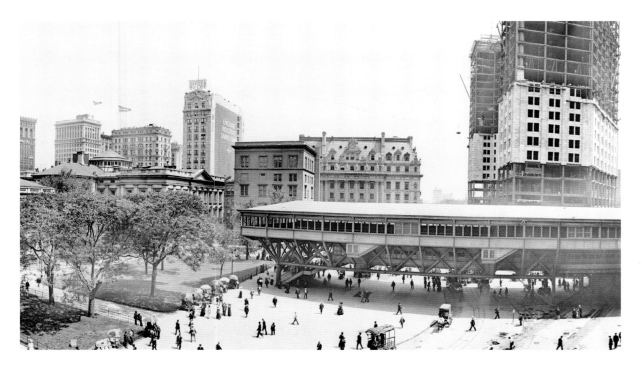

OPPOSITE PAGE *The Manhattan Terminal for the bridge trains was a massive structure that served thousands daily.*

LEFT *The terminal jutted across Park Row, nearly touching City Hall Park. The Municipal Building is in construction on the right.*

ABOVE *Another view of the multi-level terminal.*

Coney Island's Luna Park CLOSED 1946

Everything was larger than life at Luna Park—and that was the whole idea behind this huge amusement park, the first fantasy land created at Coney Island. It grew out of a single ride, the Trip to the Moon, created at the 1901 Pan-American Exposition in Buffalo by two energetic entrepreneurs, Fred Thompson and Elmer Dundy. They brought the ride to Coney Island where it did so well that they invested everything they had and more to build a twenty-two-acre realm of exotic architecture and dozens of new rides and attractions—all in just two years. Luna Park opened in 1903. Its name evoked the domain of Luna, the Roman moon goddess. No one minded or even knew that it was inspired by Dundy's sister Luna. Thompson's architectural flair turned the new park into a kingdom of minarets, Venetian archways, pagodas, gargoyles, and every other imagined shape of far-away lands. It created the illusion of places that most nineteenth-century New Yorkers had only heard or read about. When the plaster city appeared on the West Brighton beachfront, it became Coney Island's most spectacular attraction, an "Electric Eden" outlined in 250,000 bulbs. At a time when electric light was still a luxurious novelty, Luna Park did just what Thompson and Dundy hoped it would do—startle, amaze, and draw thousands of visitors like moths to the flame.

Reality paled within Luna Park's Aladdin-like surroundings. Visitors watched elephants perform on a platform in the middle of a lagoon, took rides on camels, and thrilled to extravagant theatrics that enhanced actual events. A four-story building set on fire each day was always put out just in time. The happy ending was not lost on Brooklynites who remembered or had heard about the Brooklyn Theater fire of 1876 that took the lives of 300 people. The "War of the Worlds" played on America's fresh memory of its 1899 naval victory in the Spanish-American War, and on its inflated sense of infallibility. Seated in the Great Naval Spectatorium, visitors watched sixty ships from Germany, Britain, France, and Spain steam up over the horizon and close in on Manhattan. They cheered as the American fleet sank every single one. After the Wright Brothers made their historic flights, the Trip to the Moon became the "Trip to Mars by Aeroplane." Even everyday food was transformed as in a child's fairyland. In the Candy Delicatessen, vegetables, liver pudding, blood pudding, and a long list of other childhood torments were all made of candy.

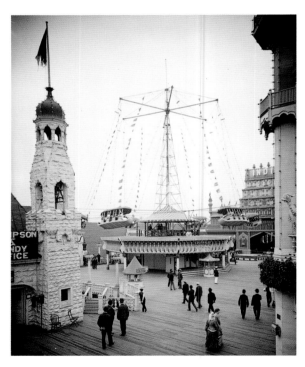

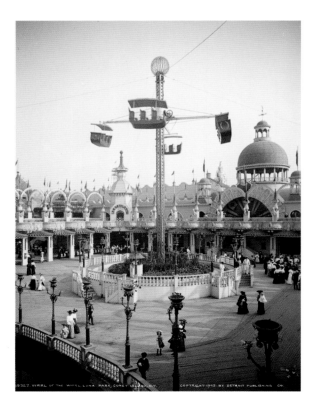

RIGHT *Passing through this grand entrance to Luna Park, visitors entered a fantasy city inspired by the tales of Aladdin.*

FAR LEFT *Camel rides carried out the "Arabian Nights" theme and were one of the most popular attractions.*

LEFT AND ABOVE *The rides took visitors into the air and through storybook pavilions.*

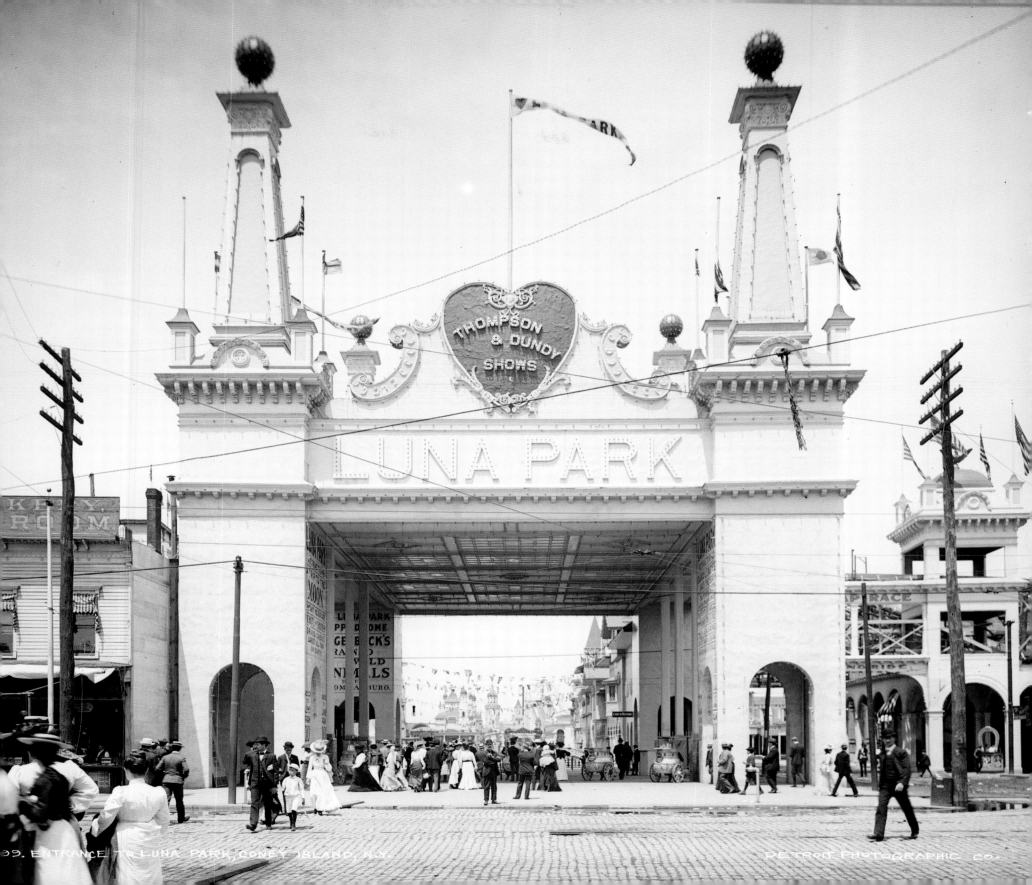

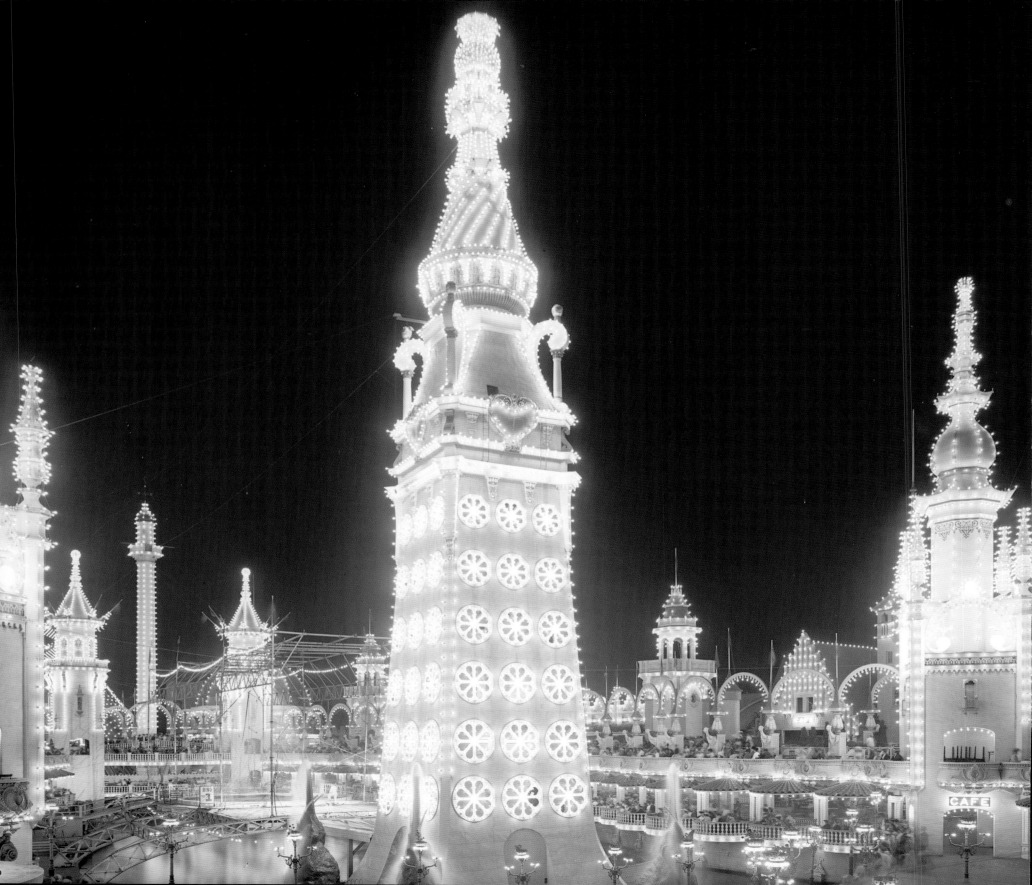

Get Rich Quick

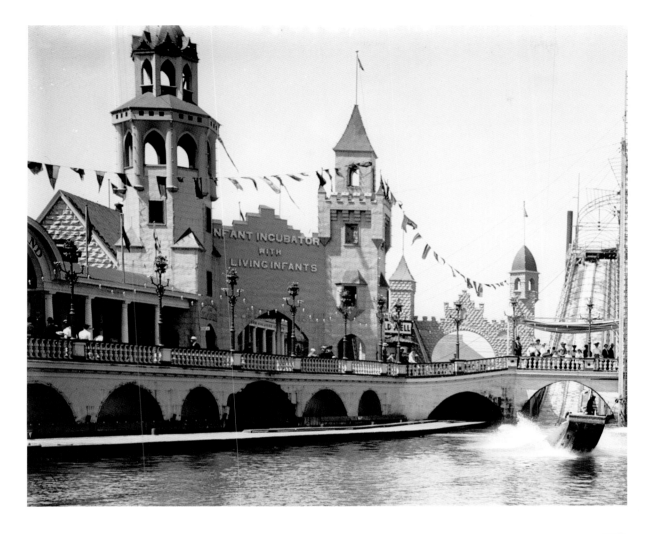

Thompson and Dundy got rich in Luna Park's first year of operation, inspiring another group of investors to open the more ambitious but less successful Dreamland the following year (see pages 18–21). Thompson's fame spread throughout the city and just two years after Luna Park opened, he was invited to create the Hippodrome, a dazzling theatrical venue in Manhattan (see pages 62–63). Luna Park would keep drawing crowds long after its successors failed, but by the 1940s, the thrill was gone. While the new operators had tried to drum up business by putting on more extravagant shows, the mounting bills and outdated rides made the park a risky investment. Nearly destroyed in a fire in 1944, the park closed for good in 1946. In the 1960s, a high-rise apartment building named Luna Park rose on the site of the former fantasy land. The area's amusement parks declined over the next half century, but in 2010, a new collection of kiddie and family attactions called Luna Park opened and in 2011 expanded to the "Scream Zone" of big thrill rides. Nothing like the original fantasy land, it nonetheless has injected a spurt of long-awaited activity into the old Coney Island.

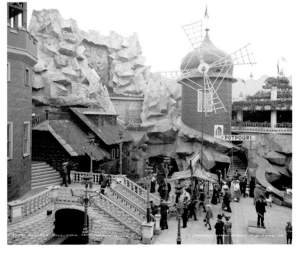

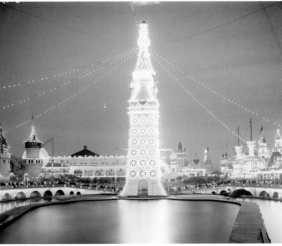

OPPOSITE PAGE AND LEFT *Lit at night, Luna Park's spires became an "Electric Eden."*

FAR LEFT *Even windmills seemed exotic within this storybook Baghdad.*

ABOVE *Strange as it seems, baby incubators were on exhibit in several amusement parks in the early 1900s. A German inventor made the new devices available to convince the public and hospitals to use them. To the right is the famous Shoot-the-Chutes ride.*

Charles Schwab Mansion DEMOLISHED 1948

When the steel magnate Charles Schwab began building a mansion on Riverside Drive and 74th Street in 1901, he was something of a pioneer. Compared to Fifth Avenue and the fashionable East Side, his chosen site on Manhattan's Upper West Side was almost suburban. But perched high above the Hudson River, it afforded panoramic views and spacious development lots. Purchasing the site of a large orphanage, he was able to build "Riverside," not just a mansion, but a New York villa. One of the largest homes ever built in Manhattan, the seventy-five room, eight-million-dollar estate was an extravagant, risky project, even for a multi-millionaire. But Schwab had always been a risk taker—Thomas Edison would later call him a "master hustler." Moreover, he wanted to outdo his partner in United States Steel, Andrew Carnegie, who was building a mere sixty-four-room mansion on Fifth Avenue.

Schwab (no relation to the Charles Schwab brokerage firm) had started out as a laborer in Carnegie's steelworks and by 1897, at the age of thirty-five, was president of the company. The same year that he began his mansion he was a key player in negotiating the secret sale of Carnegie Steel to a group of New York financiers led by J. P. Morgan. They formed the U.S. Steel Corporation and made Schwab the first president. Even before the mansion was completed, he would make the biggest move of his career. After several clashes with Morgan and other executives at U.S. Steel, Schwab left the company in 1903 to run the Bethlehem Shipbuilding and Steel Company in Pennsylvania. Taking a risk on manufacturing a new type of steel beam that would become indispensable in the new age of skyscrapers, he made Bethlehem Steel the biggest independent steel producer in the world. He secured other major contracts for the company, providing steel for the Trans-Siberian Railroad and for munitions and shipbuilding for the Allies in World War I, even before the U.S. entered the war.

"WHAT! ME IN *THAT*?"

The mansion, completed in 1906, was a French Renaissance chateau set in its own landscaped park on a full city block between Riverside Drive and West End Avenue. Schwab entertained lavishly, receiving his guests at the base of a monumental staircase that rose two and a half stories surrounded by balconies. Everyday life in the house was also a luxurious affair with an indoor swimming pool and roof garden. Household goods arrived almost magically, delivered through a long tunnel buried beneath the garden terraces. Schwab indulged in other luxuries as well, a forty-four-room summer estate in Pennsylvania, a private railroad car, high-stakes gambling and a string of extramarital affairs. Even before the Great Depression, he had managed to spend most of his fortune, and the 1929 stock market crash finished it off. No longer able to afford the taxes on Riverside, he offered it in 1934 to Mayor LaGuardia as the official mayoral residence. LaGuardia, a champion of working-class New Yorkers, declined with his famous response, "What! Me in *that*." The mansion was seized by creditors but remained a white elephant and was never occupied again. Schwab spent the rest of his life in a small apartment and died in 1939. Riverside was demolished in 1948 and replaced in 1950 by a brick apartment complex, called the Schwab House.

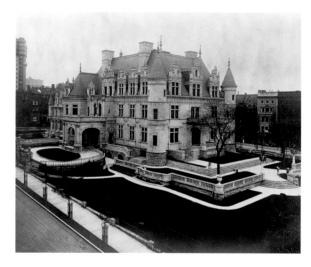

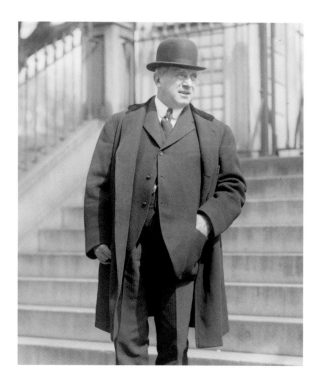

OPPOSITE PAGE *The seventy-five-room mansion was one of the largest homes ever built in Manhattan.*

ABOVE *The mansion took up an entire city block and was surrounded by extensive private grounds.*

RIGHT *Steel magnate Charles Schwab.*

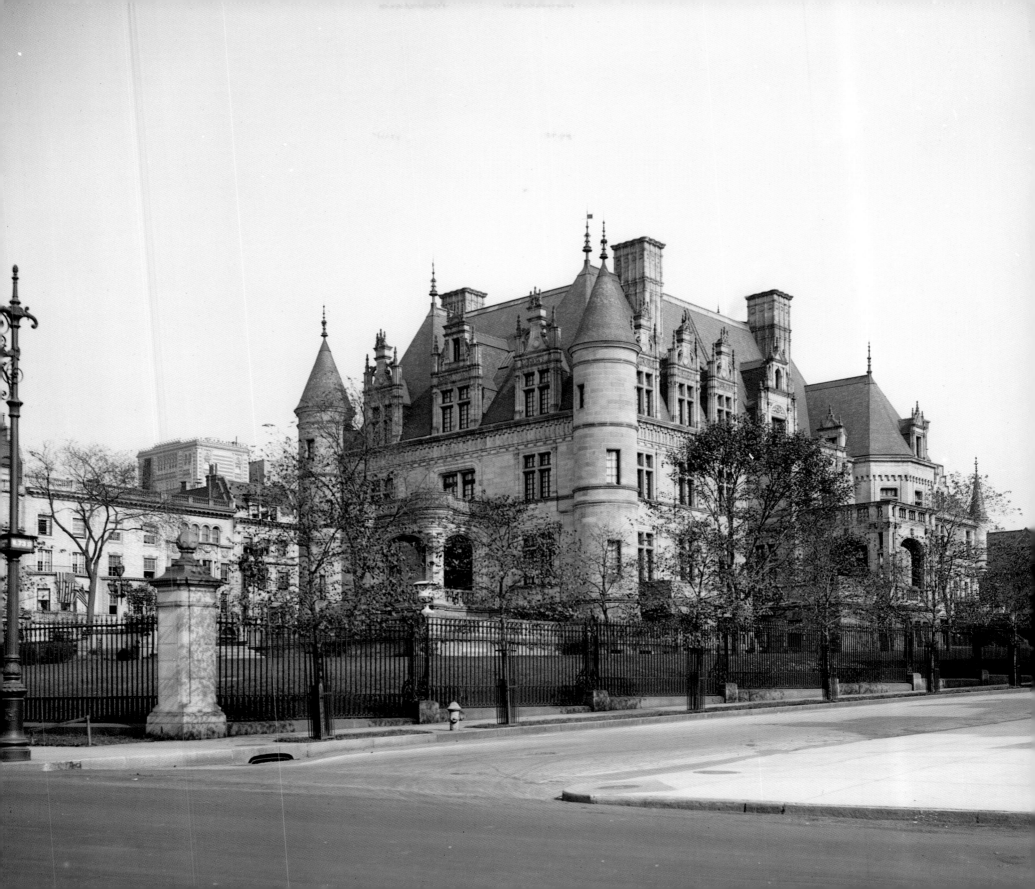

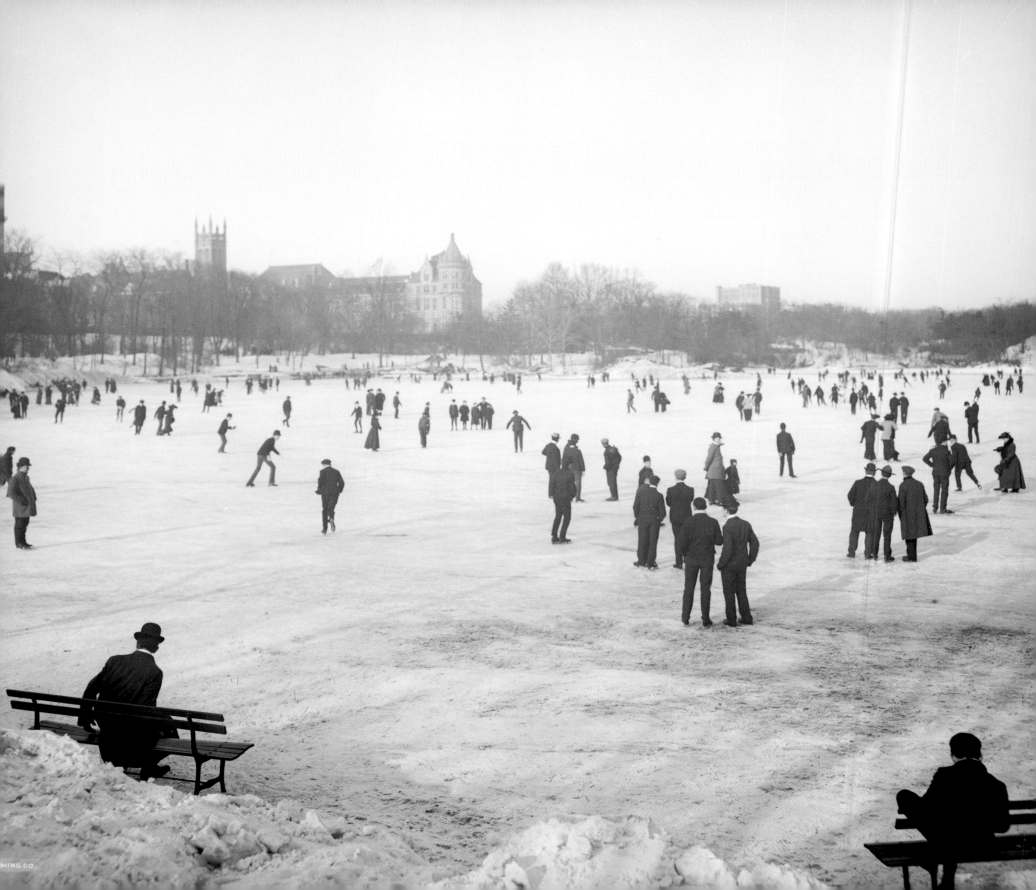

Central Park Features REPLACED 1950s

Central Park, one of the greatest public works of the nineteenth century, was the realization of a romantic landscape modeled on English country parks. Covering 843 acres, it is much larger and more heavily used than any other urban park in America. Throughout its 150-year history, it has gone through a roller coaster ride of decline and restoration. While many of its romantic features are as beautiful today as they were when they were built, it is no wonder that quite a few were lost along the way. The park was actively used throughout its long period of construction from 1858 to 1873. By the end of the 1920s, it was seriously dilapidated and facing encroachment by proposals ranging from housing developments to an airport. Ironically, it was saved by the Depression when the forceful new city parks commissioner, Robert Moses, who served from 1934 to 1960, secured federal funds to repair the park. He also added many new facilities, but clearly subscribed to the philosophy of "out with the old and in with the new."

Among the park's original features were its rustic structures made of naturally formed branches, its first boathouse, and the popular pastime of skating on the lake. All three were replaced in the 1950s before the decade was half over. The park landscape was once dotted with more than one hundred rustic shelters, boat landings, benches, pergolas, beehives, and birdhouses, creating the atmosphere of an English country estate. The largest and most ornate was the Children's Shelter, a summerhouse located on Kinderberg, or Children's Mountain. After years of neglect, it was demolished in 1950 and replaced in 1952 by the brick Chess and Checkers House.

About the same time, the park's original boathouse, a rustic, two-story structure built in 1873, was demolished. It was replaced in 1954 by the Loeb Boathouse, a long, low building with redbrick walls and a copper roof, a gift of investment banker Carl Loeb.

Boating is still popular on the twenty-two acre lake, but the winter scene is no longer filled with ice skaters. As soon as the lake was carved out of a swamp and flooded in the park's first winter, people by the thousands rushed in to enjoy what newspapers called "the skating mania." On an average winter day in the 1860s, thirty thousand people came to skate or watch the skaters. The crowds could be immense on some days, as many as one hundred thousand people. Skating on local ponds had been a popular activity for many years, but many were swallowed by the expanding city. The butterfly-shaped lake in the center of the park and the tranquil pond at its southern end were prized as beautiful winter oases. But since the 1950s, several generations of New Yorkers have grown up without ever knowing that the lake was once a place for skating. In 1945, Moses proposed an artificial rink and persuaded Kate Wollman, daughter of a wealthy stockbroker, to contribute the funds to build it. The Wollman Rink opened in January 1951 on a two-acre site north of the pond, where it drew harsh criticism for interrupting picturesque views. Nonetheless, it has become nearly as popular as the lake and as much of a fixed feature of Central Park.

OPPOSITE PAGE AND FAR LEFT *Before the artificial Wollman Rink, New Yorkers skated on the park's frozen lake.*
LEFT *The Children's Shelter was made of rustic tree limbs.*
ABOVE *The original boathouse, built in 1873.*

New York World Building DEMOLISHED 1955

It was no surprise to anyone who knew Joseph Pulitzer that the new headquarters building he commissioned for the *New York World* would be taller and bolder than any of its rivals on newspaper row. At 309 feet tall, the twenty-six-story building was the world's tallest when it was completed in 1890. Pulitzer, the hard-driving publisher of the *World*, had taken over the newspaper in 1883. At that time, it was a failing publication run by the robber baron Jay Gould, but Pulitzer would turn it into one of the most innovative and successful papers of its day. A Hungarian immigrant who arrived in America with no money and hardly speaking English, he had built his own career with exuberant energy and ideas. He applied the same to the *World* at a time when dozens of other New York newspapers were competing for readers.

A crusader for the working man, he built a mass-market audience with aggressive reporting of sensational articles about scandal, crime, and corruption. He hired Nellie Bly as an undercover investigative reporter, assigning her to the Lunatic Asylum on Blackwell's Island (see pages 96–97) where she feigned insanity for ten days and uncovered widespread abuse of mental patients. As a publicity stunt, she also traveled around the world trying to beat the fictional record of Jules Verne's *Around the World in Eighty Days*. To sustain interest in the story, the paper sponsored a "Nelly Bly Guessing Match," offering a free trip to Europe for the reader who guessed the exact time of her arrival. Helped on the last leg by a private train chartered by Pulitzer, she arrived back in New York in seventy-seven days. While circulation battles with rivals like William Randolph Hearst led to the accusation of yellow journalism, the *World* also attacked big business and exposed squalid conditions in tenements. It also launched the first color supplement in 1896. Under Pulitzer's leadership, circulation increased from 15,000 to 600,000, making it the largest circulating newspaper in the country.

Like its publisher, the *World*'s new headquarters, also called the Pulitzer Building, exhibited a bravura style. Its entrance was a three-story-high portal leading to a seventeen-foot-high rotunda. Above the entrance, tiers of two-story-high windows rose up to the crowning feature, a dome set on a high drum and topped by a cupola. Pulitzer had the idea for the dome and placed his office inside it. From there, he could look down on City Hall and survey the city skyline, once dominated by the 284-foot-high spire of Trinity Church, but now surpassed by his own building.

OBITUARIES

Actively involved with the paper until his death in 1911, Pulitzer is best known today for the journalism prizes awarded in his name. His sons took over the paper and in 1931 sold it to the Scrips-Howard newspaper chain, which promptly shut it down, laying off its staff of 3,000. Only the name survived as part of the masthead for the newly formed *New York World-Telegram*, also now defunct. When Pulitzer chose the site for his new headquarters he had been warned that it was too close to the approach to the Brooklyn Bridge. The warning proved true in 1955, when the building was demolished to make way for an expanded auto ramp to the bridge.

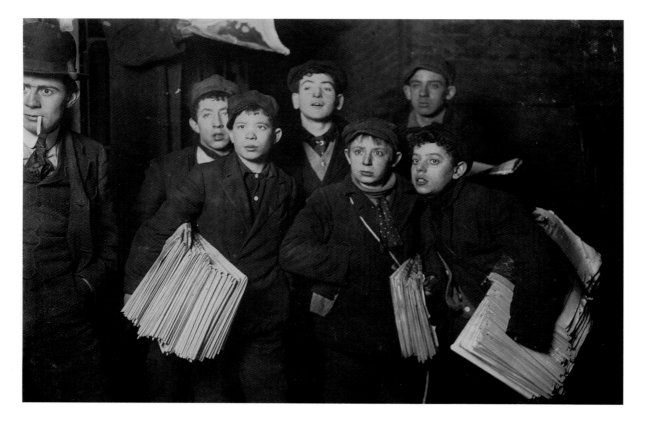

RIGHT *While its headquarters towered over City Hall (foreground), the* New York World *often confronted politicians with exposes of corruption.*

LEFT *Nineteenth-century newsboys worked long hours on the street, just one form of child labor abuse decried in the editorial columns of the* New York World.

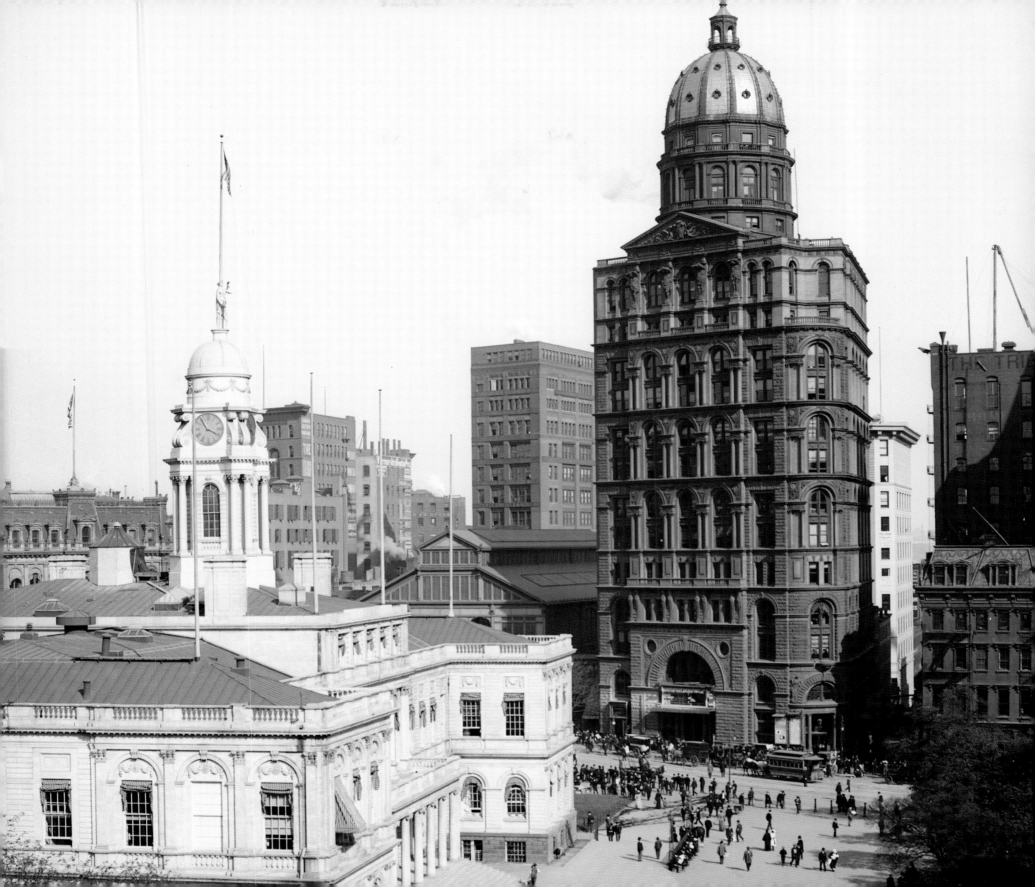

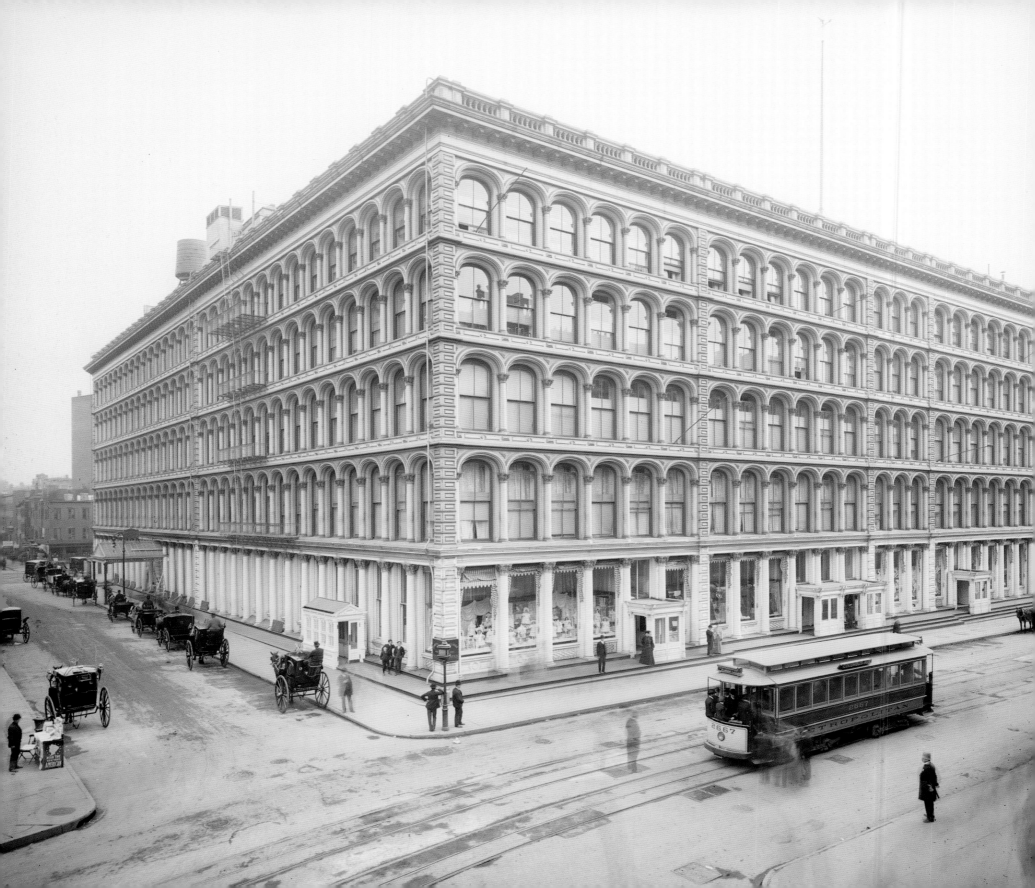

Wanamaker's Department Store BURNED 1956

The vast emporium known as Wanamaker's was the creation of two department store kings, Alexander Turney Stewart and John Wanamaker, who each built one of the store's two huge buildings. Stewart, a Scotch-Irish immigrant, was the pioneer of the enterprise. Hardly a novice, he had built America's first great department store, A. T. Stewart's Marble Palace, at Broadway and Chambers Street, in 1823, a building that still stands just north of City Hall. The richest man in New York City by the 1860s, he expanded the operation north to Broadway and 10th Street in Greenwich Village in 1862 and over the next eight years built what came to be known as the Cast Iron Palace. The painted-white building, which took up the entire block between Ninth and 10th streets, ultimately consisted of eight stories containing twenty acres of selling space. Wide windows and an elegant rotunda channeled natural light into the store.

Stewart had pioneered the way department stores sold their goods, advertising set prices instead of relying on negotiations with buyers. His stores carried ready-to-wear clothing, an innovation at a time when most women shopped for fabrics to sew dresses at home or take to their dressmakers. The Cast Iron Palace was completed in 1870, but after Stewart's death in 1876, it foundered under different owners and closed in 1882. John Wanamaker, a household name ever since he had built Philadelphia's first grand department store in 1876, bought the Stewart store in 1896. He hired the architect Daniel

Burnham, who a few years later would design the Flatiron Building, to build a fourteen-story annex next to the Stewart store. A two-level "Bridge of Progress" and three underground passageways connected the two buildings. When the new subway station opened in 1904 across the street, it provided a direct entrance to the annex.

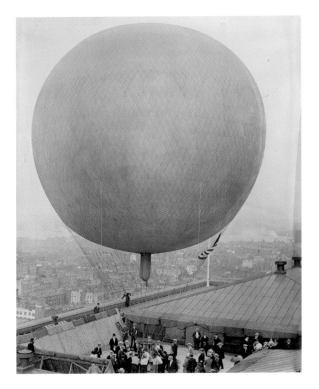

ELEGANT AND UPSCALE

Inside the annex, high ceilings and carefully crafted display cases set a dignified tone. A second-floor auditorium displayed organs and pianos, the store's specialty. The store also was the site of unusual products, including a private airplane displayed in the auditorium, and for historic events. Together with the Marconi Company and Hearst Newspapers, Wanamaker built a wireless telegraph station on top of the annex. In 1912, it relayed news of the sinking of the *Titanic* to crowds waiting outside the store.

While elegant stores that specialized in women's clothing, like Lord & Taylor, moved further uptown, Wanamaker's remained the ultimate name in general merchandise for more than half a century. In the 1950s, the two-building complex was sold for a planned conversion to the "Merchandise Mart of New York." In preparation for the transformation, Wanamaker's goods and interior furnishings were sold at auction. But in 1956, a spectacular fire destroyed the original Stewart Building. An apartment building, called the Stewart House, was later built on the site. Wanamaker's annex survived and is now an urban K-Mart, the only New York City branch of this suburban chain of discount stores.

OPPOSITE PAGE *The "Cast Iron Palace," the first of two buildings in Wanamaker's huge complex, was completely destroyed by fire.*

FAR LEFT *The first-floor furnishings were sold at auction in preparation for selling the building, a plan derailed by the fire.*

LEFT *A tethered hot-air balloon, "Wanamaker No. 1," is launched from the store roof in 1911.*

ABOVE *The store's auditorium was large enough to display a private airplane.*

New York Trolleys TAKEN OUT OF SERVICE 1957

They were drawn by horses, pulled by cables, and ultimately powered by electricity. Called omnibuses, streetcars and trolleys, they were New York City's first forms of mass transit and some lasted well beyond the start of subways. Omnibuses, or oversized stagecoaches, came first and the first one to run along a fixed route began in 1827. It ran along Broadway between the Battery and Bleecker Street, from the southern tip of Manhattan to Greenwich Village. By 1831, three vehicles were operating, each with twelve seats, although they were often cramped with more passengers, both inside and on top. The driver stopped when passengers tugged on a strap attached to his ankle.

Streetcars, or street railways, began operating in 1832. These were horse-drawn coaches with metal wheels that ran on metal tracks. They carried more people, and offered a smoother and more civilized ride. Passengers asked the conductor, who rode at the back, to signal their stops to the driver by ringing a bell. By 1855, they were operating along the length of Manhattan. The same

year, nearly 600 omnibuses were running on twenty-seven Manhattan routes. But the streetcars and omnibuses were not the only horse-drawn vehicles on the streets. Private carriages, wagons, and carts going in every direction tangled with the public vehicles, creating chaotic traffic jams. In 1864, the *New York Herald* proclaimed, "Modern martyrdom may be succinctly defined as riding in a New York omnibus."

After a deadly outbreak of equine flu in 1872, it was clear that the city could not rely on a single power source for public transportation. Cable cars powered by steam engines had started up San Francisco's steep hills in 1871 and began operating on the newly opened Brooklyn Bridge in 1883. By the turn of the century, electricity was available and electric-powered trolleys became the major mode of mass transportation. With electricity delivered through wires running overhead or in underground conduits, trolleys were faster and cleaner than horse cars and cheaper to build and operate than cable cars. Tracks were laid throughout the city,

notably in Brooklyn where the Brooklyn Dodgers were first known as the Trolley Dodgers because the fans had to dodge trolleys while crossing the tracks to get to Ebbets Field.

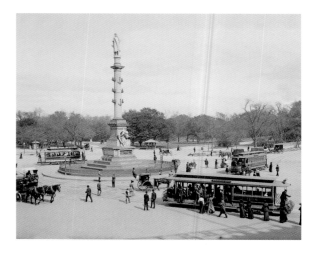

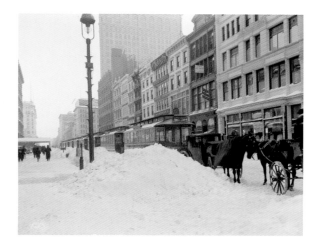

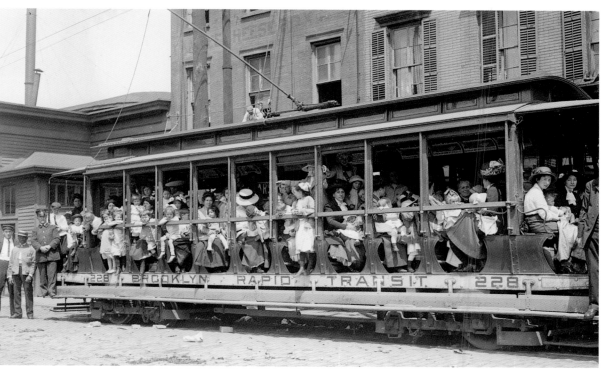

OPPOSITE PAGE *A horse-drawn omnibus makes its way downtown to the Chambers Street Ferry in Lower Manhattan.*

ABOVE *Snow-covered streets were a challenge both for horse-drawn wagons and electric trolleys.*

RIGHT *Women had to hold their children tightly in open-air trolleys.*

TOP RIGHT *Trolleys and horse-drawn vehicles at Columbus Circle, which later became a major subway station.*

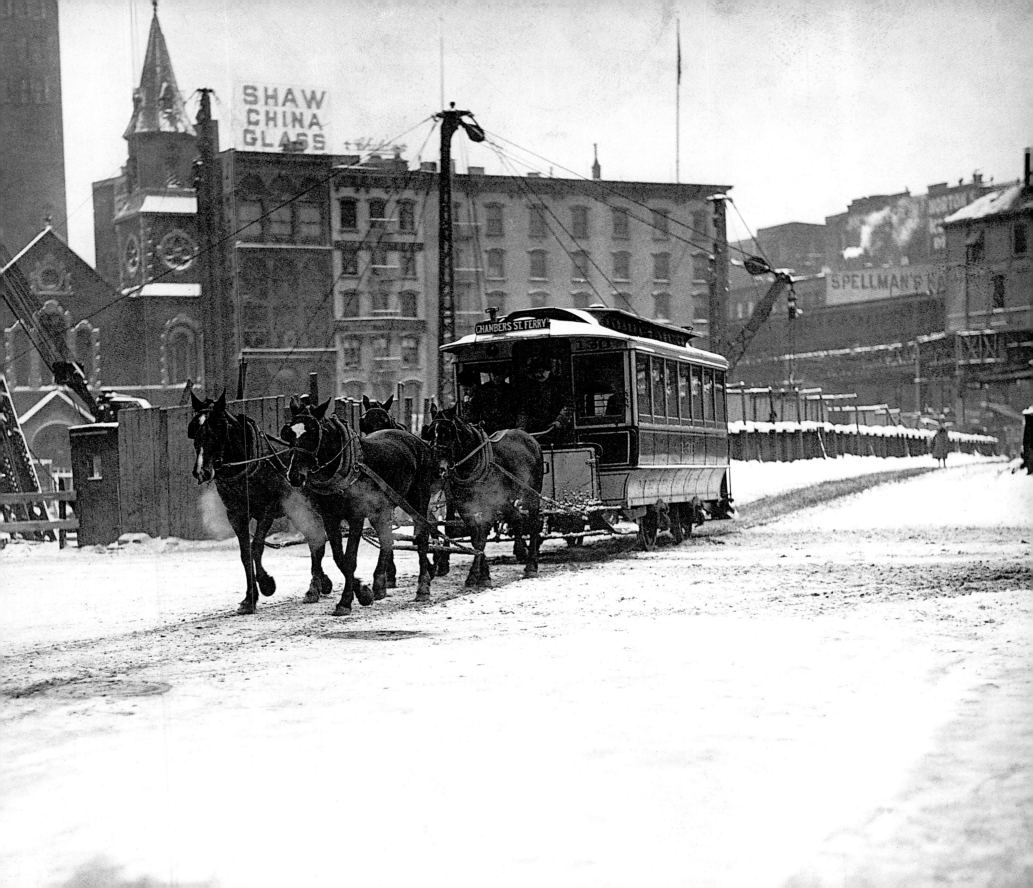

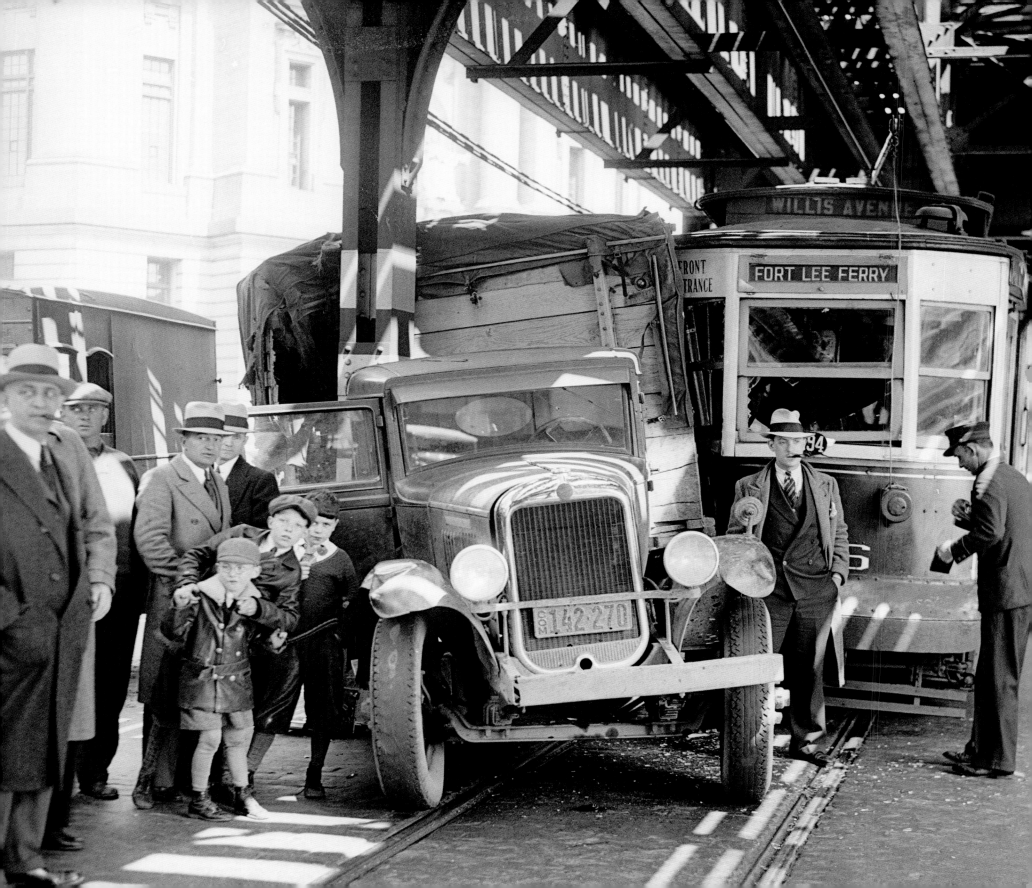

Death Knell

Today, trolleys are a nostalgic icon, but the image owes more to Hollywood than old New York. Judy Garland's trolley song ("Clang, clang goes the trolley…") in the 1944 film, *Meet Me in St. Louis* created a romantic picture of an early nineteenth-century trolley quite different than the rough-and-tumble ones traveling on crowded New York streets. Women in long dresses and big hats had trouble climbing aboard, boys would often hang onto the outside to steal a free ride, and accidents were not uncommon, at times tossing passengers out of the open-air cars. New York was the first American city to use gasoline-powered buses. As early as 1905, the Fifth Avenue Coach Company introduced motor buses and two years later used them to replace all of its horse-drawn vehicles. Motor bus service took off in 1935, propelled by Mayor LaGuardia's order for 700 buses to replace Manhattan's intrusive trolley tracks and overhead wires. Trolleys kept operating for another two decades in some of the outer boroughs, ending in Brooklyn in 1956, just a year before the team once known as the Trolley Dodgers moved to Los Angeles. The very last trolley in New York City made its final run in 1957, traveling across the Queensboro Bridge. With gasoline prices and pollution rising, many people today wish the trolleys would come back.

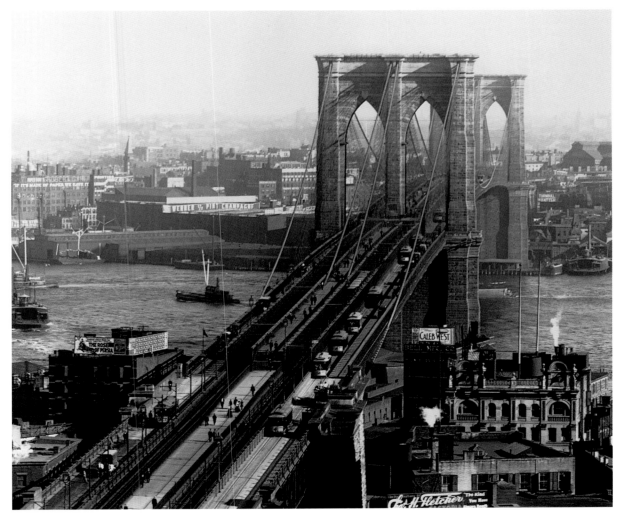

OPPOSITE PAGE *Before colliding with this truck, the trolley was on its way to the Fort Lee Ferry, the Hudson River crossing between New York and New Jersey that preceded the George Washington Bridge.*

LEFT *Trolleys on the Brooklyn Bridge.*

TOP *One of the last Brooklyn trolleys, en route to Coney Island, 1955.*

ABOVE *Trolleys on Lower Broadway, passing St. Paul's Chapel.*

Lower East Side Pushcart Markets

DISAPPEARED 1960s

When new immigrants arrived in New York, they headed for the Lower East Side, a bulge of Manhattan pushing into the East River south of 14th Street. The Irish came first, followed by Germans, Jews from eastern Europe, Italians, Russians, Romanians, Hungarians, Ukrainians, Slovaks, Greeks, Poles, Puerto Ricans, and Chinese. They lived in tenements, hastily built and soon hideously overcrowded with families doubled up by relatives, boarders, and homemade sweatshops. By 1890, the area had 524 people per acre, five times the highest density in the city. By 1910, it was up to 700 per acre, the highest in the world, more crowded than Bombay.

Eastern European Jews, pushed out by pogroms, poverty, and persecution, comprised the largest ethnic enclave. Confined to peddling goods in their homelands, many continued along the same easy route to making a living in America. Little capital was required to start a pushcart, stock it with goods from nearby wholesale markets, and peddle it through the neighborhood. Hester Street, a short stretch between Grand and Canal streets, became the peddler's main concourse, packed from end to end with carts selling food, clothing, tin pots, and everything else needed and affordable for daily life. Other pushcarts settled on nearby Grand, Orchard, and Rivington streets. These open-air

bazaars were places to shop, meet neighbors, do business, and get away from the crowded tenements. They were familiar surroundings, like the street markets in Europe, with everyone speaking the same language.

By the 1930s, storekeepers were loudly complaining that the pushcarts were undercutting their businesses, blocking traffic, and creating unsanitary conditions on city streets. Mayor LaGuardia, always a friend to the working man, tried to solve the problem by keeping everyone in business. His administration built a series of indoor public markets in Manhattan, Brooklyn, and the Bronx, large enough to house groups of pushcart vendors. The Essex Street Market absorbed some Lower East Side vendors, but many would not leave the old, open-air street markets that continued to provide a constant supply of customers. It would take much larger forces to drive them off the streets, forces that would change the entire neighborhood.

OPPOSITE PAGE *Immigrant pushcart vendors lined the streets of the Lower East Side. The building signs in Hebrew letters reflect the neighborhood's predominantly Jewish population.*

BELOW *The Hester Street Market, circa 1902.*

URBAN RENEWAL

Beginning in the 1930s, the city, supplied with federal housing funds, mounted a campaign of urban renewal, designed to wipe away the evils of tenement living. The Hester Street Market was cut in half in 1960 by the new Seward Park Houses, a development sponsored by the International Ladies' Garment Workers' Union, the savior of the Lower East Side sweatshop workers. Many former tenement dwellers, whose parents had slaved over "piecework" in their homes, moved into the modern apartments. After the 1960s, most Jewish and eastern European residents left the neighborhood, replaced by later generations of immigrants from China, Puerto Rico, and other countries. Stores bearing signs in Chinese and Spanish lined the shopping streets, and most of the pushcarts were gone.

While the city had tried to move the pushcarts off the streets in the 1930s, in the 1970s it tried to move some back to restore the vitality lost after crime, drugs, and a failing economy had led to boarded up storefronts. Today, the Lower East Side is a very different neighborhood, populated by a new, affluent generation. Along with high-priced apartments, fashionable boutiques, and hip clubs and restaurants, open-air markets are the latest trend. The Hester Street Fair, which sells vintage clothing, crafts by local artisans, and foodie delights like lobster rolls and Vietnamese sandwiches, operates next door to the eleven-story Hester Street Condominium.

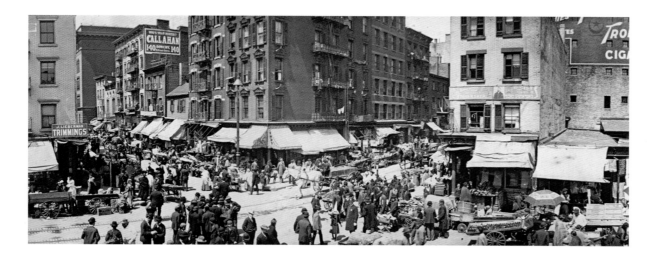

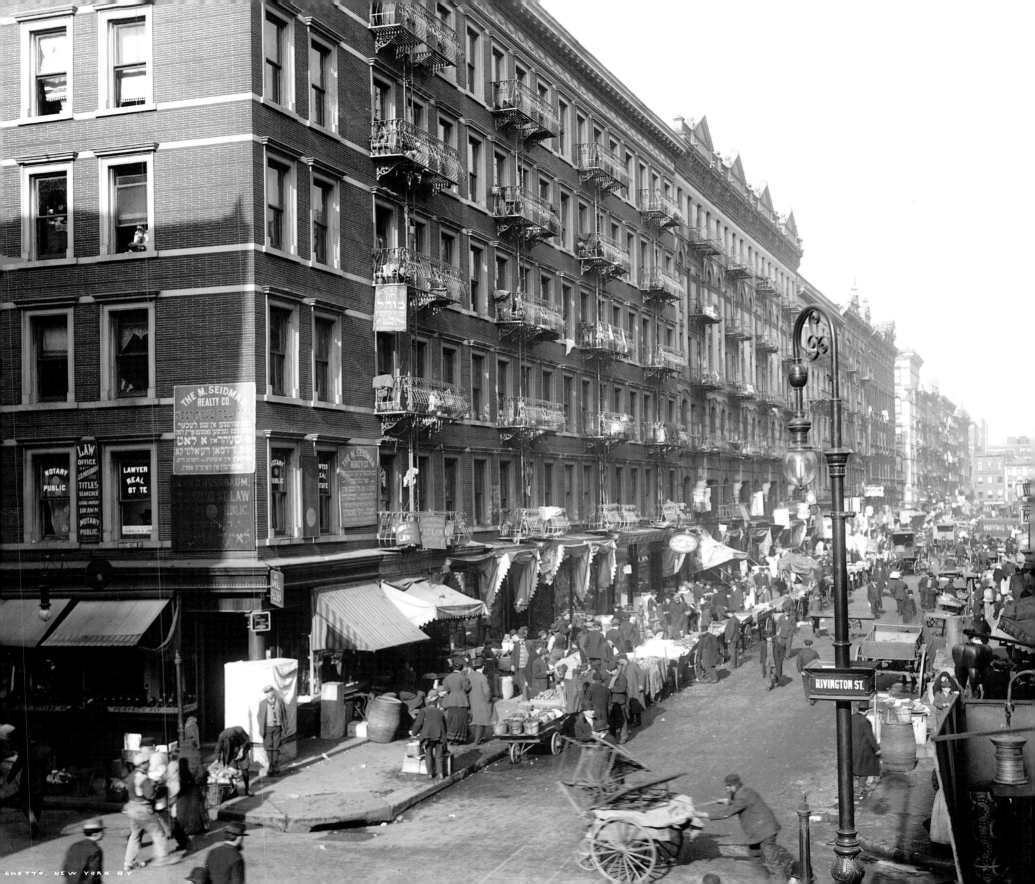

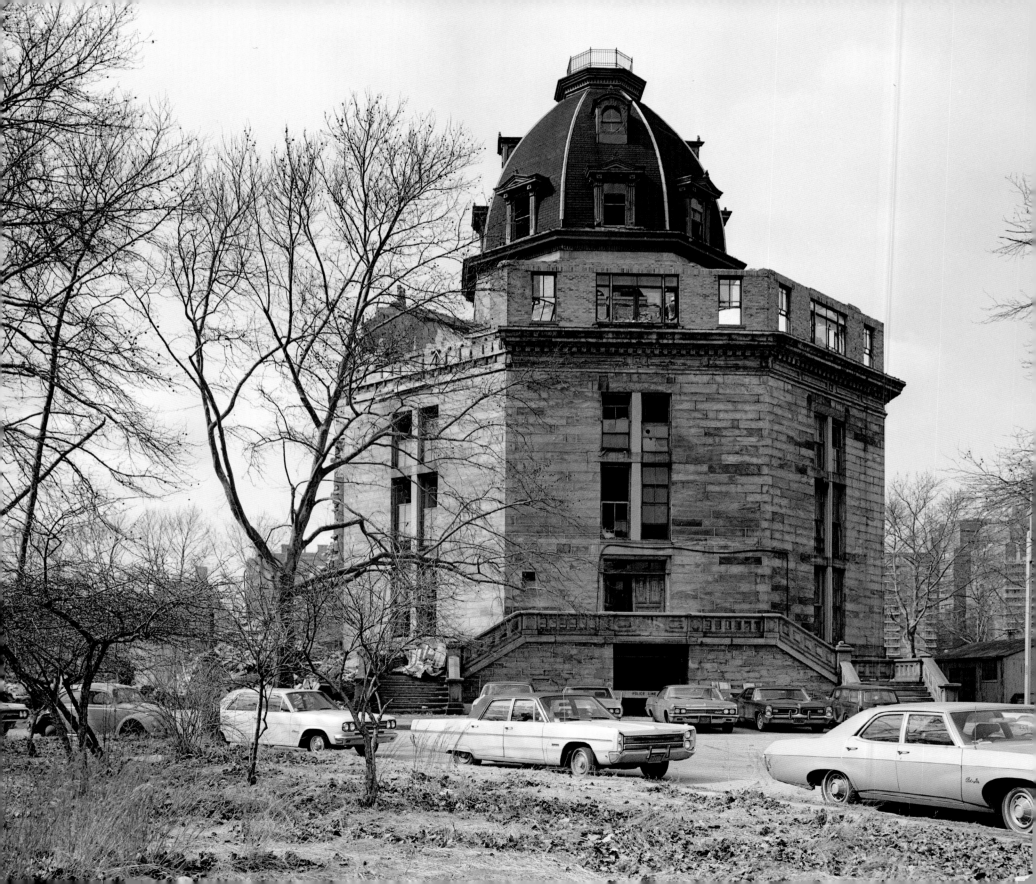

New York Lunatic Asylum MAIN WINGS DEMOLISHED 1960

The name grates on modern sensibilities, but the lunatic asylum is what this institution was commonly called when it was built in 1839. Designed by Alexander Jackson Davis, known for his romantic villas, the picturesque building was an unlikely setting for its unhappy residents. It was part of an unhappy village of institutions for the sick and destitute that was established on Blackwell's Island, located in the East River between Manhattan and Queens. By 1860, the 120-acre island, just one and a half miles long, had a prison, a workhouse, an almshouse, a charity hospital, a smallpox hospital, and the lunatic asylum. Now called Roosevelt Island, it is totally transformed. The asylum, the subject of a sensational exposé in the late nineteenth century, was reduced over the years to a deteriorated fragment of the original building. Near collapse, it was recently rescued by a luxury apartment complex.

The asylum centered on an octagonal tower made of grey schist and embellished with a domed roof, soaring entrance rotunda, spiral staircase, and two flanking wings. Charles Dickens paid a visit in 1840 and recorded his impressions in his 1842 *American Notes*. He found "a lounging, listless, madhouse air, which was very painful…It was badly ventilated, and badly lighted; was not too clean; and impressed me, on the whole very uncomfortably." Dickens recognized that "New York…has always a large pauper population to provide for." But by 1887, the *New York World* reporter Nellie Bly would shock readers with horrifying firsthand accounts of the asylum, describing conditions even worse than in a Dickens novel. Feigning insanity, she spent ten days as a patient in the asylum, where she found spoiled food, dirty water, and harsh, even cruel treatment in rat-infested surroundings. "What, excepting torture," she wrote, "would produce insanity quicker than this treatment?" Her report, published later in the book *Ten Days in a Mad-House*, caused a sensation, brought her lasting fame, and led to an investigation and reforms.

In 1893, the residents of the asylum were transferred to a new facility in another location. The old building became Metropolitan Hospital in 1895, which operated until 1955 when it moved to Manhattan, leaving the old asylum empty. The two wings were demolished in 1960. Only the octagon tower remained, slowly deteriorating for decades. Most of the other institutions had been closed or relocated earlier, and, beginning in the 1970s, the newly renamed Roosevelt Island was developed as a large residential community. The Octagon, as it was known by then, fell into ruin, losing its domed roof to a fire, and becoming just a shell. Restoration work finally began in 2005, making it the centerpiece of a luxury development. Five hundred apartments now occupy the site of the two original wings. The Octagon is better than new, refitted with a new dome and flying staircase. Its rotunda has a fitness center, café, billiards room, gallery, and conference room. Real estate advertisements highlight its historic architecture, skipping the part about the lunatic asylum.

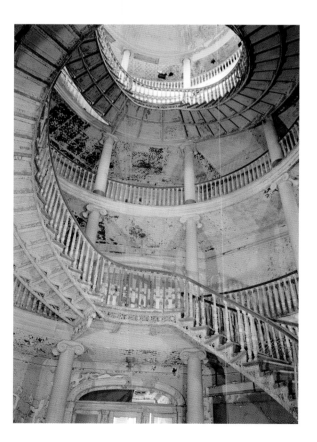

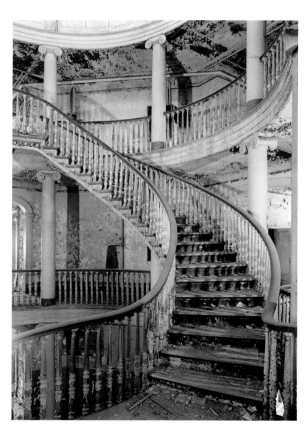

OPPOSITE PAGE *The picturesque building lost its wings in 1960 and the central tower barely survived as a ruin through the rest of the century.*

LEFT *Two views of the deteriorated tower stairway.*

ABOVE *An 1853 engraving showing the main wings of the "lunatic asylum and mad house."*

Ebbets Field DEMOLISHED 1960

To people who grew up as Brooklyn Dodger fans, Ebbets Field was the sanctuary of baseball, the place where everyone worshipped the same beloved team, shared the same hopes, and prayed together for victory. Even when the team failed to win the World Series, losing time after time to the evil New York Yankees, hope sprang eternal with the cry of "Wait until next year." No matter how hard the day at home, school or work, a trip to Ebbets Field always brought comfort, and sometimes even joy. The Stadium opened its doors on April 5, 1913, a day when 25,000 fans filled every new seat. As the *Brooklyn Daily Eagle* reported, "Twenty-five thousands hearts thumped with joy, twenty-five thousand pairs of feet pounded the concrete floor and twenty-five thousand voices roared with delight."

The Dodgers were born as a minor league team in 1883, the same year that Brooklyn celebrated another glorious birth, the opening of the Brooklyn

Bridge. The team owners hired Charles Ebbets, a young printer, to print score cards, sell tickets, and keep the books. He became a stockholder, president, and in 1902, the principal owner. His dream was to build the first permanent, "fireproof" home for the team, which had only played in various open fields with wooden grandstands. Gambling on the purchase of undeveloped land east of Prospect Park, he built the new stadium with steel, glass, brick, and the newly available poured concrete. It rose from its barren site like a modern Roman coliseum, proudly displaying its arched windows, pilasters, and ornate capitals.

Despite its grand surroundings, the team languished, often in last place, and after Charles Ebbets died in 1925, its debts mounted throughout the 1930s. A series of successful managers brought the Dodgers to their golden years with a dream team and winning streaks in the 1940s and 1950s. Dodger president Branch Rickey made history in 1945 when he hired Jackie Robinson, the first black player in Major League Baseball. Robinson overcame racist attacks by players and fans to become a legendary star of the Dodgers and the entire league.

DEFEAT AT THE PEAK

By the 1950s, the Dodgers were the most prosperous team in Major League baseball, but their golden era would end at their peak of success. While they finally beat the Yankees in the 1955 World Series, Dodger president Walter O'Malley was worried about the team's future in Brooklyn. Ebbets Field, now old and outdated, had been planned before the age of the automobile. It had good mass transit connections, but inadequate parking spaces and no room for expansion in its now built-up surroundings. O'Malley was interested in another site in Brooklyn but the city would only offer Queens. Most importantly, California was beckoning with a package of financial benefits that the city did not match. In September 1957, the team played its last game at Ebbets Field and the next year became the Los Angeles Dodgers. In 1960, Ebbets Field was demolished to make way for a massive housing project. Murals of the Dodgers were painted on the walls, but they were an empty gesture. It was the end of an era both for the Dodgers and for Brooklyn. Their fans were the children of immigrants who had grown up with the team, learning how to become Americans as fans of this most American game. In the 1960s, in the wake of economic, social and racial changes that altered the entire city, thousands moved to the suburbs, leaving Brooklyn behind for future generations.

OPPOSITE PAGE *Ebbets Field was built in 1913 on an undeveloped plot of land, but over the next half century, Brooklyn grew up all around it.*

ABOVE *Fans reaching into the Dodgers dugout for an autograph from the star player, Jackie Robinson.*

RIGHT *Cars parked near Ebbets Field in 1916. Built for mass transit, not automobiles, the ballpark had little parking space.*

TOP RIGHT *Charles Ebbets' daughter, Genevieve, threw out the first ball at the park's opening on April 5, 1913.*

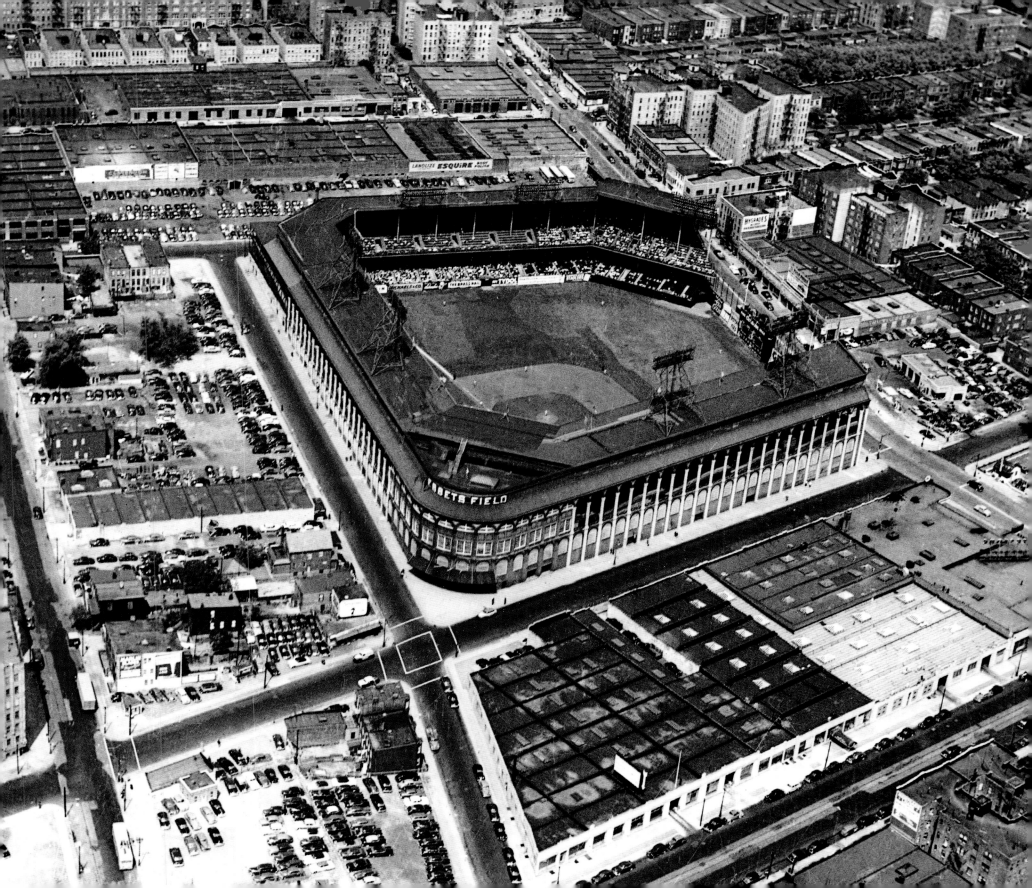

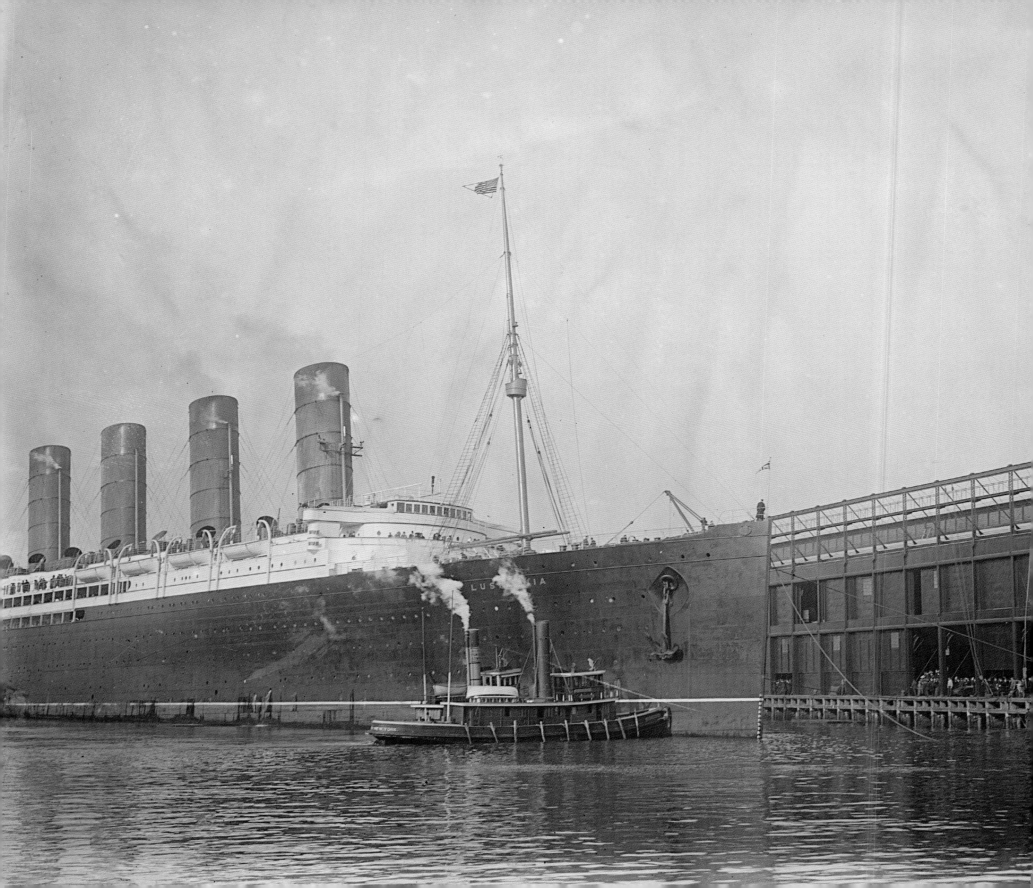

Port of New York RELOCATED 1962

By the middle of the nineteenth century the Port of New York was handling more goods and passengers than all other ports in the country combined. Manhattan alone had 126 piers on the East and Hudson River waterfronts, lined with ships, passengers, and freight haulers of every description. But the piers were sorely outdated and in serious disrepair. In 1865, a *New York Times* editorial described the city's waterfront in the worst possible terms as "a string of rotten, filthy, reeking and rickety old things which we call piers." In the past, New York had always depended upon port business interests to build and maintain the piers. In 1870, the city took matters into its own hands, creating the Department of Docks and appointing the Civil War General George McClellan to lead the charge for improving the waterfront. He was a national figure, famous for the Union victory at Antietam, but also controversial for having delayed troop movements and losing critical ground early in the war. McClellan resigned from the department after only two years, and while he was not responsible for failures that would follow over the next century, his slow-to-act reputation would define the port's pattern of doing too little too late.

Shipping companies, switching from sail to steam, were already moving from the South Street Seaport on the East River to roomier quarters on the Hudson waterfront (see pages 16–17). However, McClellan's first step was to begin construction of a massive concrete bulkhead on both sides of the river, a task that would not be completed until World War I, years after South Street's days were over. Eventually, the focus shifted to the Hudson River, where a series of new, enclosed piers were built in the early twentieth century. The most ambitious were the Chelsea Piers, a monumental complex of nine piers stretching for a dozen blocks. Completed in 1907, they would become the center of New York's glory days of ocean liner travel in the first half of the twentieth century.

The Port of New York began to lose ground in the 1960s when shipping went through radical changes in the way goods were handled. New York's problems would prove to be ingrained in the limited size of the Manhattan waterfront, and in the failure of dock officials to act on the need for change. While New York dock workers were unloading cargo bag by bag along narrow piers and trucks were fighting for space on Manhattan's crowded streets, another government agency, the Port Authority of New York and New Jersey, was building the world's first container port across the Hudson in New Jersey. Towering cranes lifted the huge containers and placed them on the backs of trucks waiting in huge parking lots. Completed in 1962, the New Jersey container port revolutionized the shipping industry and made the Hudson River piers obsolete. New York later built smaller container ports in Brooklyn and Staten Island, but the major shipping companies had already moved to New Jersey, which continued to expand. Manhattan's passenger piers were also dealt a fatal blow when jet travel replaced ocean voyages. A new passenger terminal built on the Hudson in 1972 has limited use because most travelers now fly to warmer ports for winter cruises. In the 1990s, the Chelsea Piers became a sports and entertainment center, part of the park that now stretches for five miles along Manhattan's Hudson River waterfront.

OPPOSITE PAGE *Mighty ocean liners like the* Lusitania *once docked daily along rows of piers on the Hudson River waterfront.*

ABOVE *Crowds, carriages and cars waiting for a ship to dock at the port.*

BELOW *One of many Hudson River piers abandoned after shipping relocated to New Jersey.*

Polo Grounds DEMOLISHED 1964

Not as famous as Ebbets Field or Yankee Stadium, the Polo Grounds still hold a place in the hearts of New York Giants fans. Like the Brooklyn Dodgers, the Giants broke their fans' hearts when the team left for California. Both teams left the same year—almost too much for New Yorkers to bear. It may seem as if the Giants have always been in San Francisco, but they played much longer—seventy-four years—in New York. The team started playing in 1883 on a field at Fifth Avenue between 110th and 112th streets in Manhattan. It was an actual polo ground, and although the Giants moved around to several other fields, the name would stick when they reached their final New York address in 1891 at Eighth Avenue and 159th Street in Harlem.

The Eighth Avenue site was situated below Coogan's Bluff, a ridge overlooking the ballpark and the Harlem River. Fans gathered here to watch the game for free and the name, Coogan's Bluff, became synonymous with the ballpark itself. In the

early days before bleachers enclosed the field, wealthy patrons would watch from their carriages in deep center field. The ballpark, made mostly of wood, burned in 1911. By the end of the season, the team had a new Polo Grounds on the same site. Its horseshoe-shaped, steel-and-concrete grandstand seating 34,000 people was the most ornate stadium of its day. Italian marble lined the upper deck, which was engraved with the coat of arms of each city in the National League. The stadium, expanded later to seat 56,000, was also known for its unusual bathtub shape, including the deepest center field in baseball and the shortest right-field line from home plate—a haven for left-handed sluggers. From 1913 through 1922, the Giants shared the Polo Grounds with the Yankees, and it was here, not Yankee Stadium, where Babe Ruth had his highest batting seasons. From 1925 to 1955, the New York Football Giants also played at the Polo Grounds, winning three NFL Championships. The stadium is also famous as the place where one of baseball's greatest players, Willie Mays, started his Major League career.

REQUIEM FOR A FRANCHISE

Attendance was dropping in the late 1950s, and in 1956 the Giants owner was persuaded to move the team to San Francisco. He was convinced by Brooklyn Dodger president Walter O'Malley that the two rival New York teams would draw more fans by playing each other in new ballparks in California (see page 98). The Giants played their last game in the Polo Grounds on September 29, 1957. In its last years, the dilapidated stadium was shared by the New York Mets, a new baseball team designed to replace the Dodgers, and the New York Jets football team. The Jets played the last game at the Polo Grounds on December 14, 1963, which proved to be another loss for New York. In 1964, the demolition crew arrived, wearing New York Giants T-shirts. The wrecking ball, painted to look like a baseball, was the same one used to demolish Ebbets Field four years earlier. The Polo Grounds Towers, a public housing project built in 1968, now sits below Coogan's Bluff. The only remnant of the Polo Grounds is the John T. Brush stairway down Coogan's Bluff, named for the Giants owner who built it in 1913.

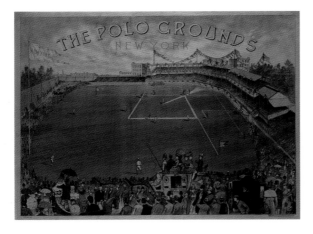

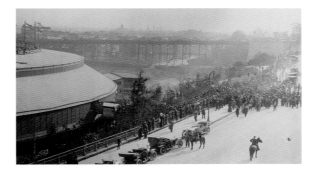

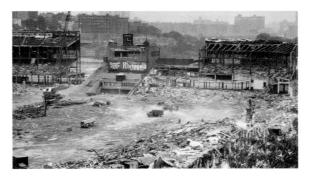

OPPOSITE PAGE *The horseshoe-shaped grandstand, built in 1911, was expanded in 1929.*

ABOVE *This drawing of the Giants' first ballpark shows an open center field where fans with horse-drawn carriages parked to watch the game.*

RIGHT *Above: The train trestle in the background brought thousands of fans to the ballpark while a few fortunate ones arrived in their early autos. Below: Wreckers demolished the famed ballpark in 1964.*

TOP RIGHT *The Giants leave the field after their last game at the Polo Grounds in 1956.*

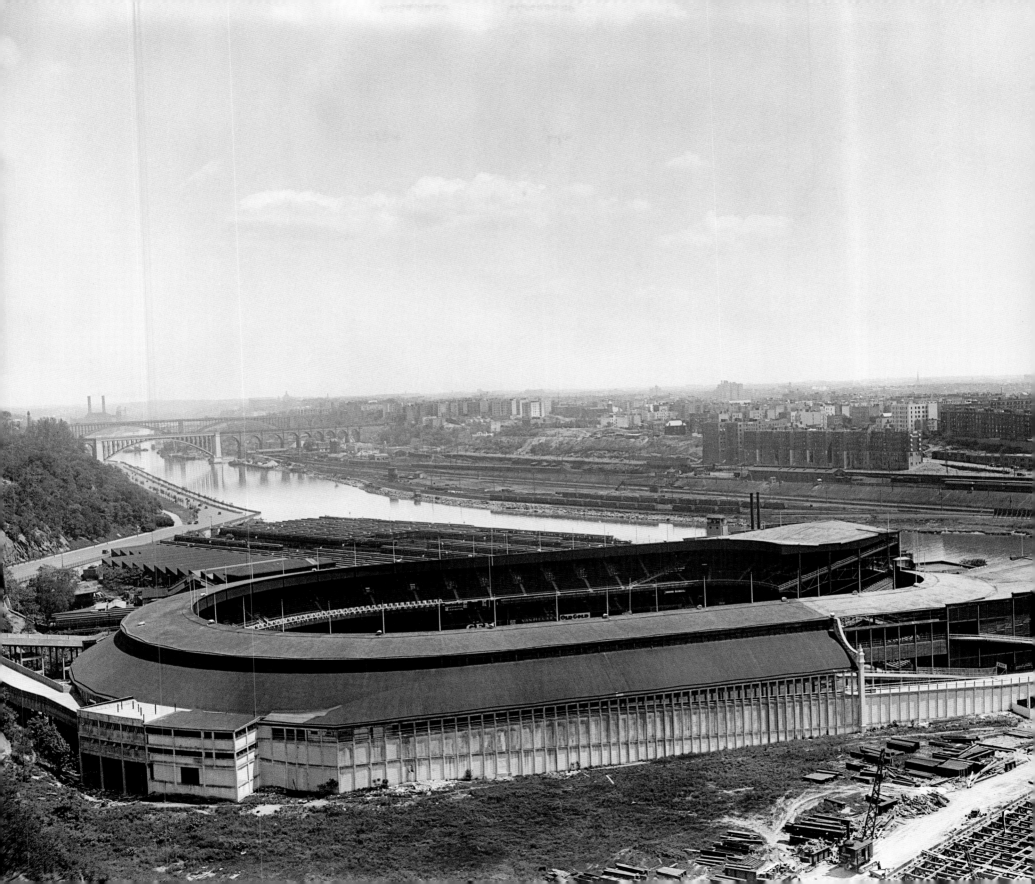

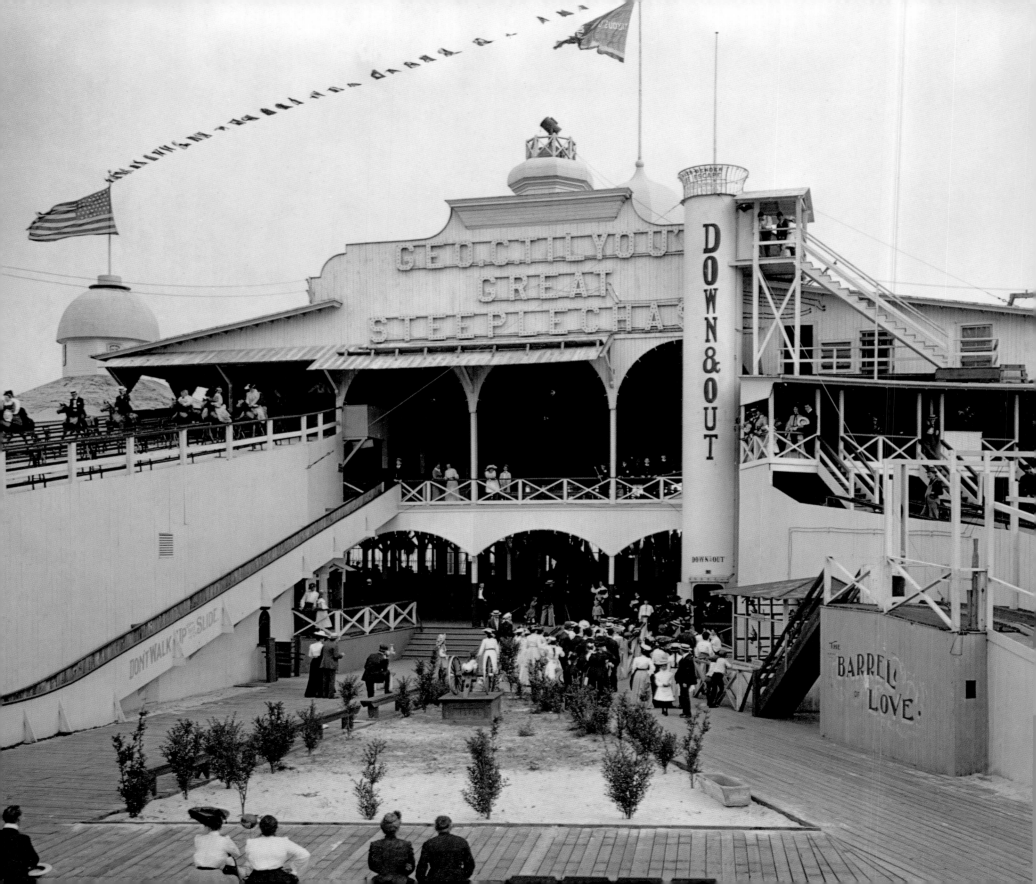

Steeplechase Park CLOSED 1964

Steeplechase Park, the first of the big amusement parks that made Coney Island famous, was the last to go. It operated continuously from 1897 to 1965, defying natural disasters and changing times. Its founder and driving force was George Tilyou, an indefatigable showman who kept the park going according to two principles: "Keep 'em laughing and never say die." After he had struggled to make the park a success in its first decade, it burned down in 1907, but Tilyou was undaunted. The very next day, he charged ten cents to see the burning ruins and put up a sign promising a "better, bigger, greater Steeplechase Park."

He had the brilliant idea to enclose the new park in a glass and cast-iron shed, calling it the Pavilion of Fun. It provided weather protection that the other Coney Island amusements lacked, and also shielded working- and middle-class families from rougher crowds around the open sideshows. Once inside, crowds had their own raucous time in the Funny Place, where jets of air ruffled skirts and petticoats, the Funny Staircase collapsed into a slide, and the Human Roulette Wheel spun people off a slippery wooden disc. Circling the pavilion was the main attraction, the Steeplechase, a ride on mechanical horses along parallel tracks that simulated an actual race. Although the gentle

slopes were not as high as an actual steeplechase, the ride was tremendously popular, particularly with young couples who could double up in an intimate grasp. A million people rode it in its third season and the numbers kept growing throughout the century as the park expanded to cover fifteen, fenced-in acres.

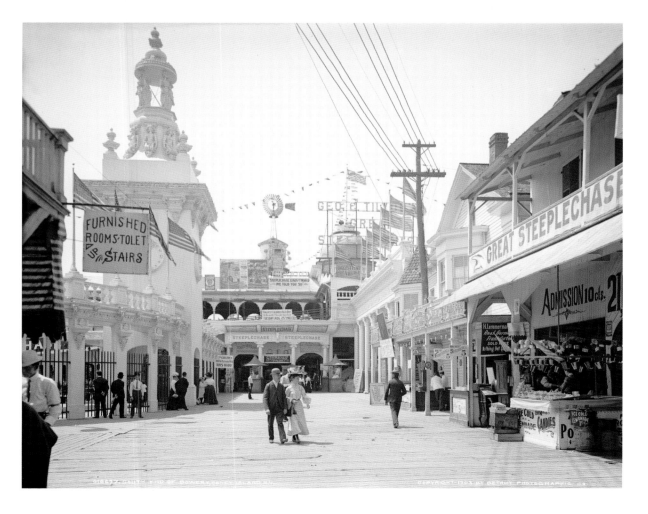

OPPOSITE PAGE *George C. Tilyou, the founder of Steeplechase Park, was Coney Island's greatest promoter. The steeplechase ride can be seen on the far left.*

LEFT *Steeplechase offered visitors countless attractions— even rooms to stay for the night.*

ABOVE *Fred Trump, relishing his planned demolition of Steeplechase Park, hands a symbolic ax to a group of bathing beauties.*

An Eye for a Ride

Ever the entrepreneur, Tilyou was always looking for new rides and attractions. Before opening Steeplechase, he had seen the first Ferris wheel at the 1893 Columbian Exposition in Chicago and wanted to buy it, but after learning that it was already booked for the St. Louis World's Fair, he put up his own smaller version—the first in Coney Island. Impressed with the Trip to the Moon ride at the 1901 Pan-American Exposition in Buffalo, he persuaded the operators to bring it to Steeplechase, and took sixty percent of the revenues until they incorporated it in their own Luna Park (see pages 78–81). After Tilyou's death, his family bought the Parachute Ride from the 1939 World's Fair. Now a landmark, the 262-foot-tall tower is the only part of Steeplechase Park still standing, although it has not operated since the 1960s.

While Tilyou's empire lasted much longer than Luna Park, Dreamland, and virtually every other

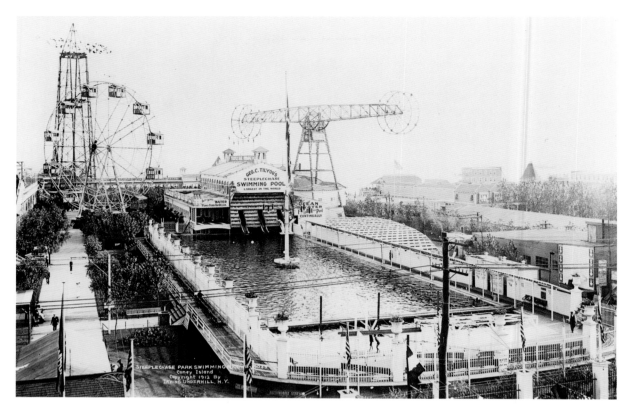

Coney Island attraction, accidents, lawsuits, family squabbles, and rising crime in the neighborhood finally shut it down in 1964. Donald Trump's father, Fred, bought the property in 1965 for housing development and destroyed the park so that it could not be protected by the city's new historic landmark law. But, the city would not agree to rezone the site for housing, maintaining that it would lead to further destruction of Coney Island's remaining amusement parks. After four decades, a minor league baseball stadium was built on the land in 2001. It is now home to the Brooklyn Cyclones, named for Coney Island's landmark roller coaster that has been operating a few blocks away since 1927.

OPPOSITE PAGE *The Steeplechase was especially popular with couples.*

LEFT *Many people thought that the cartoon face was the park's owner, George Tilyou.*

ABOVE *Tilyou packed the park with every type of ride, including Coney Island's first Ferris wheel.*

RIGHT *After the New York World's Fair closed in 1940, Tilyou's family acquired the parachute jump for their park.*

Times Tower TRANSFORMED 1965

In 1904, the *New York Times* ventured far uptown from its longtime home on Newspaper Row to a strikingly different building, the Times Tower. Rising twenty-four stories and prominently placed on a triangular site at the intersection of Broadway, 42nd Street and Seventh Avenue, the tower's height and unique site made it the focus of the area that soon would be called Times Square. The old downtown location, opposite City Hall, had been at the nerve center of the city, but *Times* publisher Adolph Ochs knew that the subway, which also reached 42nd Street in 1904, would push activity uptown. He convinced the subway company to name the 42nd Street Station after his paper, and the area became known as Times Square. The paper moved into its new quarters on New Year's Eve and celebrated the event with a fireworks display in the square. A few years later, it launched New York's most famous tradition by lowering an illuminated ball from the tower at midnight.

The original tower was a Renaissance-style building, dressed in pink granite and limestone and clearly the belle of Times Square for the first two decades of the twentieth century. The paper outgrew the tower by 1913 and moved to a nearby building just off the square on West 43rd Street. Abandoned by the *Times*, which was known as the "Gray Lady" for its serious coverage of the news, the building eventually took on the flashy personality of its surroundings. In the 1920s, when more than seventy-five Broadway theater marquees and new movie palaces were flashing in Times Square, the tower also began to sport a few neon signs. In the 1930s and 1940s, burlesque and peep shows, penny arcades, and dime-a-dance halls transformed Times Square from the Great White Way to the capital of honky-tonk.

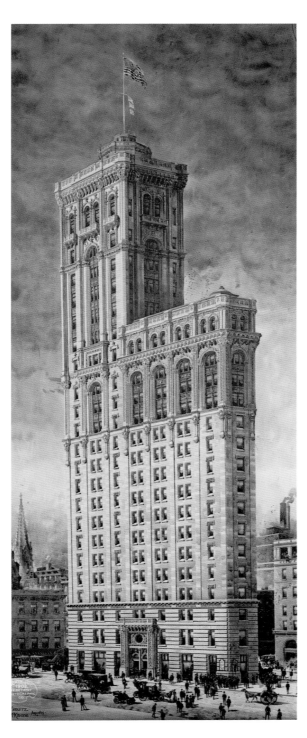

LEFT *The tower's height and location in the midst of Times Square made it the focus of the area.*

RIGHT *The Renaissance-style tower was the belle of Times Square for the first two decades of the twentieth century.*

FAR RIGHT *Seen from blocks away, the tower became the first landmark of Times Square.*

A TOWER OF SCREENS

In the 1960s, prostitutes, drug trafficking and adult movies spread throughout the area, shutting down dozens of legitimate theaters. Purchased by Allied Chemical, the tower tried to maintain its dignity with modest sixties attire, a concrete and marble sheath, belted by a moving sign of flashing headlines. But the damage had been done, forever turning the proud symbol of Times Square into just another billboard. A new owner bought the building in 1975, renamed it One Times Square, and planned to turn it into a wedge of mirrors. Fortunately, the plan was never carried out, but the building would undergo another disfiguring transformation. Although it is still commonly known as the Times Tower, its original form, covered by advertising screens, is unrecognizable. The *New York Times* moved farther away from Times Square to another new home in 2007. Once the star of the show, the tower vies for attention with the huge flashing screens on every other corner of Times Square.

Penn Station DEMOLISHED 1966

The single greatest architectural loss in New York City was the destruction of Pennsylvania Station. Other than the World Trade Center, remembered for the shocking scale of its human tragedy, it is the only building as famous for its staggering destruction as it was for its amazing construction. Penn Station was an architectural and engineering marvel that moved a complex transportation network through the city while celebrating it with civic grandeur. That such a monumental, historic building could be destroyed shook the foundation of the city's heritage. It demonstrated that no building was safe from the relentless march of real estate development.

The Pennsylvania Railroad, which joined New York City and Philadelphia in 1863, had long wanted to build a station in New York. The great obstacle was the Hudson River. Passengers and freight from points south and west had to disembark at the Hoboken, New Jersey station and ferry across the Hudson. The technology to build a bridge or tunnel across the river did not exist until the 1890s. With advances in civil engineering and electric tracks, the railroad cut a tunnel under the river by 1904, connecting the island of Manhattan to the rest of the country.

The station was completed in 1910, and like Grand Central Terminal, also in construction at this time, it became a grand entryway into New York. Designed by McKim, Mead, and White, it was a two-block-long classical temple. Modeled on the Roman Baths of Caracalla, it took the traveler through a long, modulated system of magnificent arcades and corridors to the grand waiting room— a vast space of vaulted ceilings, towering columns, and arched windows that flooded the space with light. In his 1940 novel, *You Can't Go Home Again*, Thomas Wolfe described the waiting room as an awe-inspiring place: "Great, slant beams of moted light fell ponderously athwart the station's floor and the calm voice of time hovered along the walls and ceiling of that mighty room."

"DON'T AMPUTATE, RENOVATE"

By the 1950s, the railroad, undercut by automobiles and airplanes, was in serious financial trouble. The station was neglected and became dingy and forbidding. In 1961, the railroad struck a deal with the owners of Madison Square Garden, which had been on Eighth Avenue and 50th Street since 1925 (see pages 38–39), to demolish the station, build a new Garden in its place, and a new station underground. A coalition of architects staged demonstrations in front of the station with signs reading, "Don't Amputate, Renovate," and "Don't Demolish It! Polish it!" Newspaper editorials agreed, but the city had no power to stop the demolition of a privately owned building and the destruction began in 1963. In 1965, the city finally acted to protect its architectural heritage by enacting the Landmarks Preservation Law. But it was too late for Penn Station, which was completely gone by 1966. The underground replacement, a cramped, low-ceilinged space, was fit for subways, not for the busiest railroad station in North America. The architecture critic Vincent Scully summed up the difference: Through the old station "one entered the city like a god...One scuttles in now like a rat."

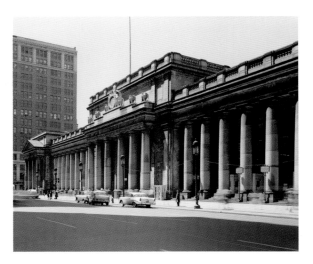

OPPOSITE PAGE *Seen here soon after its completion in 1910, the two-block-long station was an architectural and engineering marvel.*

LEFT *The monumental interior was a grand gateway into New York City.*

ABOVE *The station in the 1960s, facing destruction.*

TOP RIGHT *Demolition took three years. Only the arched skeleton still stands in this view.*

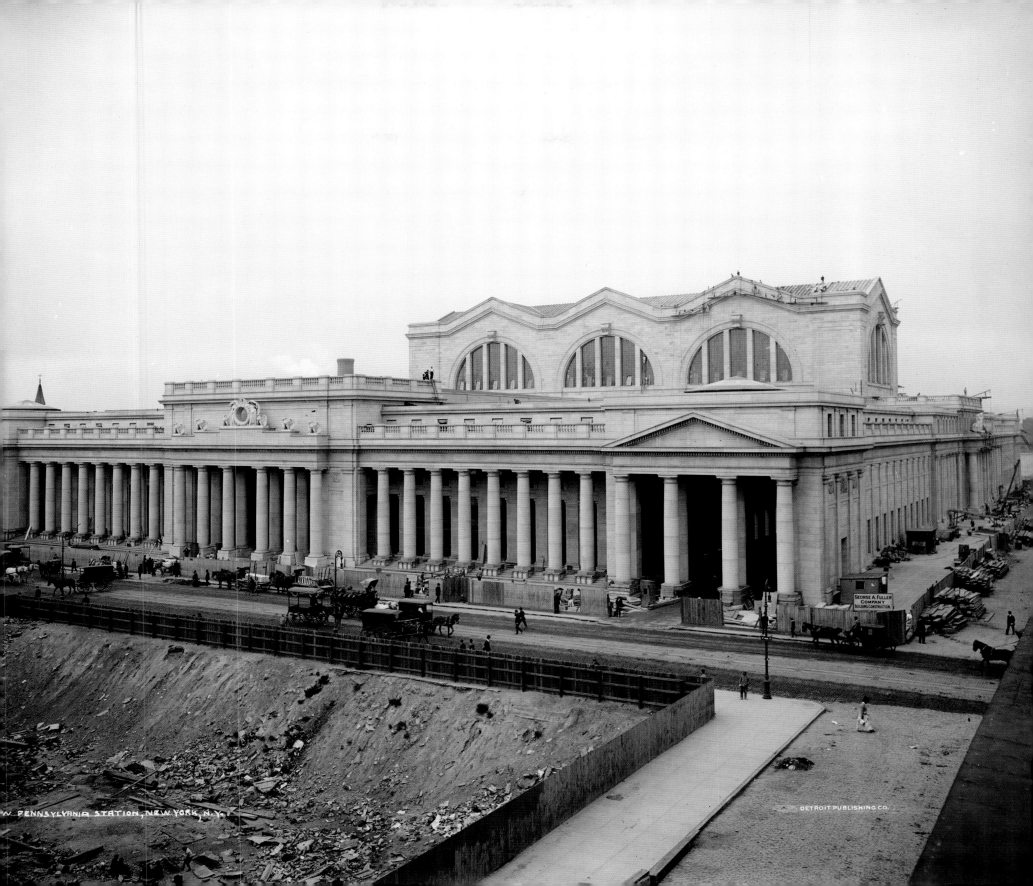

PENNSYLVANIA STATION, NEW YORK, N.Y.

DETROIT PUBLISHING CO.

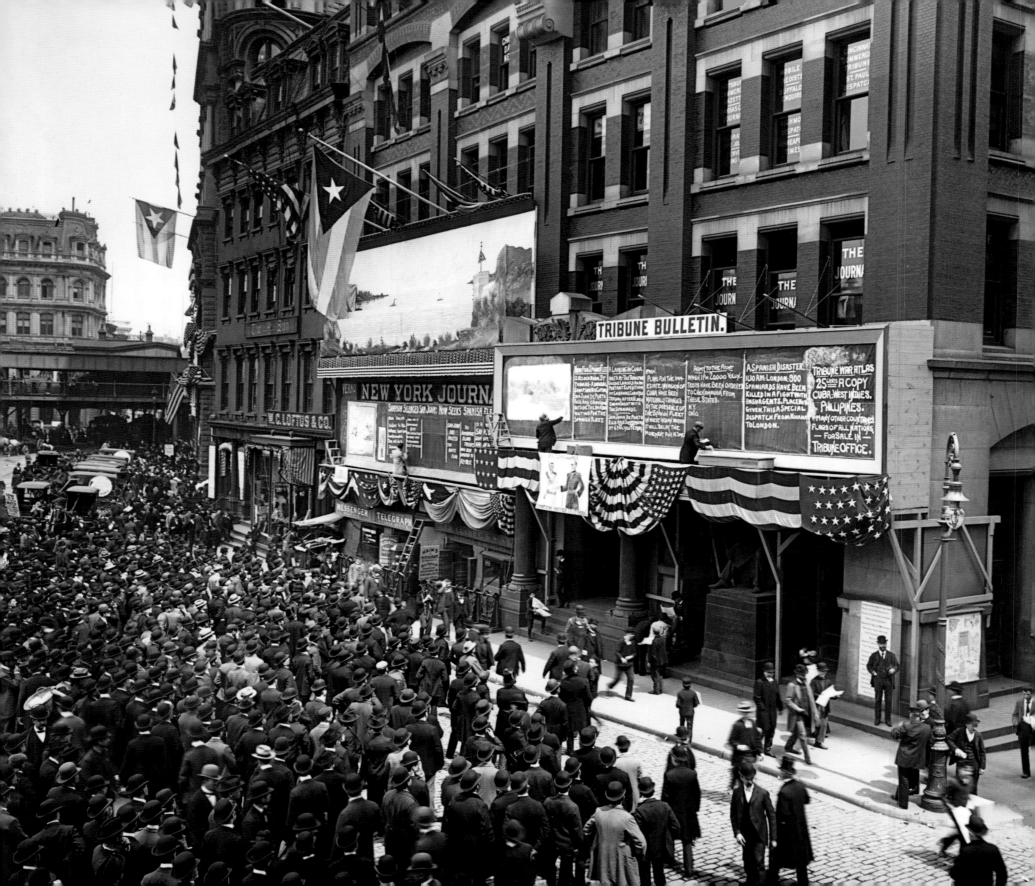

New York Tribune Building DEMOLISHED 1966

Horace Greeley, the legendary editor who founded the *New York Daily Tribune* in 1841, was a radical Republican in the days when the description meant an extreme liberal. He made the *Tribune* a leading voice for abolishing slavery long before the Civil War, and after the South seceded, he took a hard stance against the Confederacy. While many New York newspapers thrived on sensationalism in the nineteenth century, the *New York Tribune* established a reputation for good taste, high moral standards and intellectual appeal. Unlike the *New York World* (see pages 86–87) and the *New York Herald* (see pages 32–33), the *Tribune* had no place for police reports, tales of scandal, or dubious medical advertisements. Greeley had an interest in every type of reform in the nineteenth century, from utopianism, socialism, and feminism to vegetarianism. He opened his paper to serious writers and lecturers on many of these subjects—even when he disagreed with them. Karl Marx and Friedrich Engels were European correspondents for the

paper in the early 1850s. Leading writers of the day, such as William Dean Howells, Henry James, and the early women's rights advocate Margaret Fuller, also were frequent contributors.

Greeley planned to build a "new printing palace" for his paper and assembled the property next to his original headquarters on Spring and Nassau streets across from City Hall. But the project was delayed when he decided to oppose President Ulysses S. Grant in his 1872 bid for reelection. He had been a strong supporter of Grant in the election of 1868, but became a crusader against the corruption that marred Grant's administration. Unfortunately, 1872 proved to be a year of crushing defeats for Greeley. He lost the election in November, his wife died soon afterward, and by the end of the year, he was dead as well. During his campaign, he had turned over control of the paper to his young managing editor, Whitelaw Reid, who became the owner and editor-in-chief and carried out Greeley's plans for the new building.

SKYSCRAPER PIONEER

Like the paper's founder, the *Tribune*'s new headquarters reflected a forward-thinking mind. Created by the era's eminent architect, Richard Morris Hunt, the leading proponent of traditional Beaux Arts design, the building pushed its elaborate Victorian envelope and became a skyscraper pioneer. Even before steel frames were being used, the nine-story building, topped by a picturesque central tower nearly twice as tall as the base, was a powerful statement of height and one of the first high-rise elevator buildings. Completed in 1875, it was the second tallest building in New York, surpassed only by the spire of Trinity Church, and the most compelling edifice on Newspaper Row where nearly twenty other newspapers were operating.

Reid turned the paper over to his son, Ogden, in 1889. The younger man merged the *Tribune* with the *New York Herald* in the early 1920s and abandoned both the Tribune Building and the Herald Building on Herald Square. Statues of Greeley had been placed in front of both buildings. One was moved to City Hall Park and the other stands just south of Herald Square in its own Greeley Square. Long after the highly regarded *Tribune* had left, the Tribune Building also became just a memory, demolished in 1966 to make way for Pace University.

OPPOSITE PAGE *Crowds gather in front of the Tribune Building in 1898 to read handwritten bulletins about the Spanish-American War.*

LEFT *Part of the clock works salvaged from the tower in 1966.*

ABOVE *Topped by a slender tower twice as tall as its base, the Tribune's headquarters rose high above every other building on Newspaper Row.*

Brooklyn Navy Yard DECOMMISSIONED 1966

From the War of 1812 through World War II, the Brooklyn Navy Yard was the center of shipbuilding operations for the nation's defense. It began in 1801 as a forty-acre operation, fitting out ships for battles with pirates, and grew to a sprawling 300-acre complex employing more than 70,000 men and women in round-the-clock wartime shifts. The yard was located on a sheltered stretch of the East River called Wallabout Bay, Dutch for bend in the river. Just across the river from Manhattan, it was close to a ready workforce of skilled shipbuilders in both Manhattan and Brooklyn. The Navy bought the land from John Jackson, a Brooklyn shipyard owner who developed the surrounding neighborhood and marketed it to Irish immigrants. He named it Vinegar Hill, recalling the 1798 battle in a failed Irish rebellion against the British. Irish refugees arriving in New York were attracted to the familiar name, and jobs in the new yard made the neighborhood even more appealing.

During the War of 1812, the yard readied more than a hundred vessels for raids on British merchant shipping. During the Civil War, it built sixteen new ships and converted more than four hundred merchant and private vessels to naval service. Among the many ships built or outfitted at the yard were some of the nation's most famous vessels, including the *Fulton*, the first oceangoing steamship in the U.S. Navy in 1815; the steam frigate *Niagara*, which helped lay the first transatlantic cable; the ironclad *Monitor* of the Civil War; the ill-fated *Maine* of the Spanish-American War, the battleship *Arizona*, sunk at Pearl Harbor, and the *Missouri*, on whose decks Japan surrendered, officially ending World War II.

Throughout the yard's history, its workers were civilians and their jobs were highly prized, in part because the hours were relatively short, eight hours, compared to the typical twelve-hour day in nineteenth-century New York City. Local political bosses dolled out many jobs, most of which went to the Irish working class, the majority of New York's foreign-born population in the mid-nineteenth century. After the 1880s, when immigration from other European countries soared, the workforce became more diverse, with one exception—African-Americans, who were banned from working in defense plants. It was not until 1941 when civil rights leaders pressured President Roosevelt to sign the Fair Employment Practices Act that blacks were hired at the Navy Yard. With thousands of men serving in the armed forces during World War II, women also were given their chance to be mechanics and technicians. The pace at the yard was non-stop as men and women built battleships, aircraft carriers and auxiliary vessels, repaired more than 5,000 ships, and converted another 250. With six dry-docks, two building ways, eight piers, 270 buildings, nineteen miles of streets, and thirty miles of railroad tracks, the Navy Yard was the largest industrial center in the Navy and in all of New York State.

Three super aircraft carriers were built during the Korean War, but in the 1960s, shipbuilding, like so many other northeastern industrial operations, shifted to southern states. In 1966, the Navy closed the yard, eliminating 9,000 jobs. The city purchased the property the following year and in 1971 reopened it as an industrial park, an active, although much smaller operation.

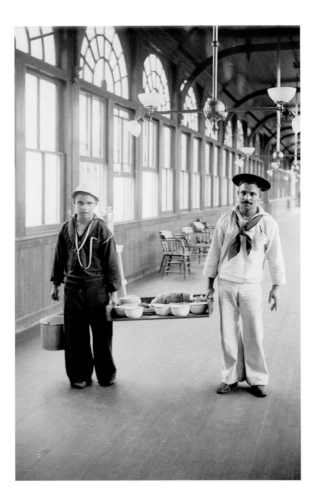

RIGHT *The USS* Kearsarge, *a 27,000-ton aircraft carrier, slid down the ways at the Brooklyn Navy Yard in May 1945, headed for the last World War II battles in the Pacific.*

LEFT *Sailors carrying food in the Navy Yard Hospital, circa 1905.*

BELOW *World War II-era sailors walking by the Navy Yard's nineteenth-century canons.*

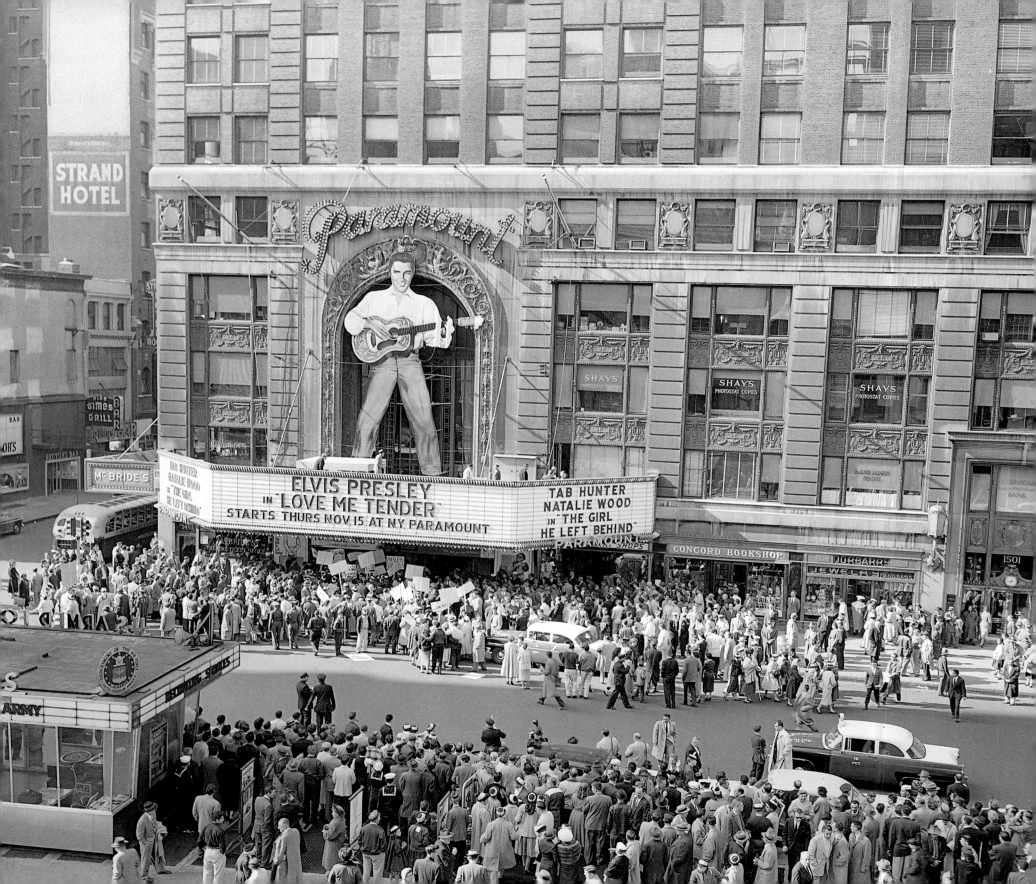

Paramount Theater GUTTED 1967

The Paramount Theater on Times Square was the apotheosis of lavish movie palaces built in the 1920s. It was Versailles and the Paris Opera House rolled into one. Every room reached a new level of size and opulence. The movie auditorium was ten stories high with three balconies instead of the usual two. The lobby was fifty feet high and 150 feet long with immense columns and a vaulted ceiling. Modeled on the chapel at Versailles, it was even more sumptuously decorated, with sweeping staircases, black and gold marble, an enormous crystal chandelier, and a ceiling mural depicting the Sun King. Even if you never watched the movie, you could be richly entertained by wandering through the labyrinth of foyers, lounges, and drawing rooms. A walnut-paneled Elizabethan lounge and a "college" room lined with famous university shields were only a few of the many period rooms. The mezzanine offered a Louis XV-style music room for small concerts or for visitors to sit and observe the crowds below.

But it would be a shame to miss the pomp inside the auditorium where theatergoers were escorted to their seats by ushers in military-like uniforms with West Point-like crisp courtesy. When prices were changed between afternoon and evening shows, a platoon of gold-braided ushers marched out in formation to switch the box-office signs. In the early days of silent films, the theater outdid the theatricality of the movies. Palaces like the Paramount were built by movie studios to showcase their own films. The escapist environment within the theater was designed to bring patrons back week after week, no matter what movie was playing. The opulent surroundings and entertainment were all available for the average admission price of fifty cents. At the Paramount, the silent films were accompanied by the biggest Wurlitzer theater organ ever built. When the top-flight Paramount Pictures premiered its talkies in the 1930s, the studio's stars, including Gary Cooper, Mae West, Bing Crosby, the Marx Brothers and many other big names, came on stage to meet the audience.

LEFT *The premiere of Elvis Presley's first film drew thousands to the Paramount Theater in November 1956.*

ABOVE *Jealous of Frank Sinatra's teenage fans, a group of sailors in 1944 pelted tomatoes at the singer's figure on the marquee.*

RIGHT *On December 28, 1956, police removed a bomb placed in the theater by "Mad Bomber" George Metesky.*

Astor Hotel DEMOLISHED 1967

The Astors liked to build grand hotels and thanks to the family patriarch, John Jacob Astor, they had lots of prime Manhattan property to do so. He started buying land in 1810 when prices were dirt cheap and made a practice of holding onto it until it was worth at least ten times what he had paid. In the meantime, he and his heirs made a fortune collecting rent. The elder Astor built the first hotel, the Astor House on Lower Broadway, in 1836 when that area was the center of the city. His grandsons built the first Waldorf-Astoria on fashionable Fifth Avenue and 34th Street in the 1890s (see pages 50–51), and at the turn of the century, they leased family property in the midst of the new Times Square Theater District for construction of the grand Astor Hotel. The block-long, corner site on Broadway between 44th and 45th streets was leased to developers who built a seven-million-dollar hotel, continuing the magic of the Astor name. Opened in 1904, the Astor Hotel became a great success and a driving force in the growth of Times Square. The result proved even more successful for the Astors, since the family owned most of the surrounding land.

By the 1900s, Times Square had become the Great White Way. Directly across the street from the Astor was Oscar Hammerstein's palatial Olympia Music Palace with a roof garden, concert hall, and theater. His lavish Victoria Theater was nearby on 42nd Street, and the Metropolitan Opera House was just a few blocks away on Broadway and 39th Street (see pages 120–121). Other theaters followed, each one more grandiose than the other. While vaudeville, cabaret, and music-hall venues also filled Times Square, the Astor Hotel always kept its high-class reputation, shining with glittering events eleven stories above Times Square. Its elaborate green-copper mansard roof, topped by a roof garden and lined with balconies below, was outlined with lights, creating an atmospheric nighttime silhouette. The huge mansard sheltered cavernous ballrooms that were filled with grand celebrations. Guests also gathered on the roof garden and balconies to watch parades and such exciting events as the New York to Paris Auto Race that took off in front of the hotel in 1908.

Inside the hotel was an extensive collection of public rooms evoking historic and exotic locales. The lobby floor contained Chinese alcoves,

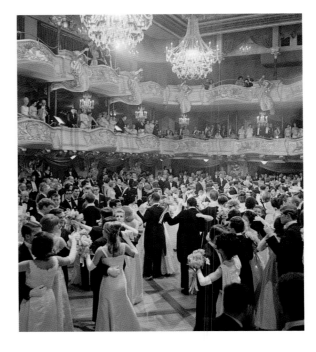

a Flemish smoking room, a Pompeian billiard room, and a Mediterranean orangerie. The Hunt Room was encircled by a frieze of hunting scenes, including deer in full relief with genuine antlers. The basement had an American Indian Grill Room decorated with Indian headdresses and bows and arrows. In the late 1950s, the hotel was managed by Serge Obolensky, a Russian prince who married into the Astor family. But all signs of royalty vanished in the 1960s when Times Square was overrun by sleaze. The hotel closed in 1967 and in 1972 was replaced by a fifty-four-story office building, One Astor Plaza. It is now occupied by contemporary royalty, the media giants, Viacom and MTV studios.

RIGHT *Cars lined up in front of the Astor Hotel for the start of the New York to Paris Auto Race in 1908.*

LEFT *The hotel was in the heart of the Times Square Theater District. Oscar Hammerstein's Music Palace was directly across the street.*

ABOVE *The International Debutante Ball, December, 1964, was held in one of several ballrooms housed within the hotel's cavernous mansard roof.*

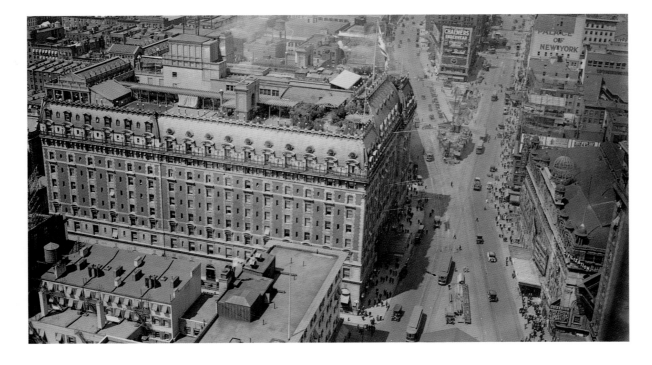

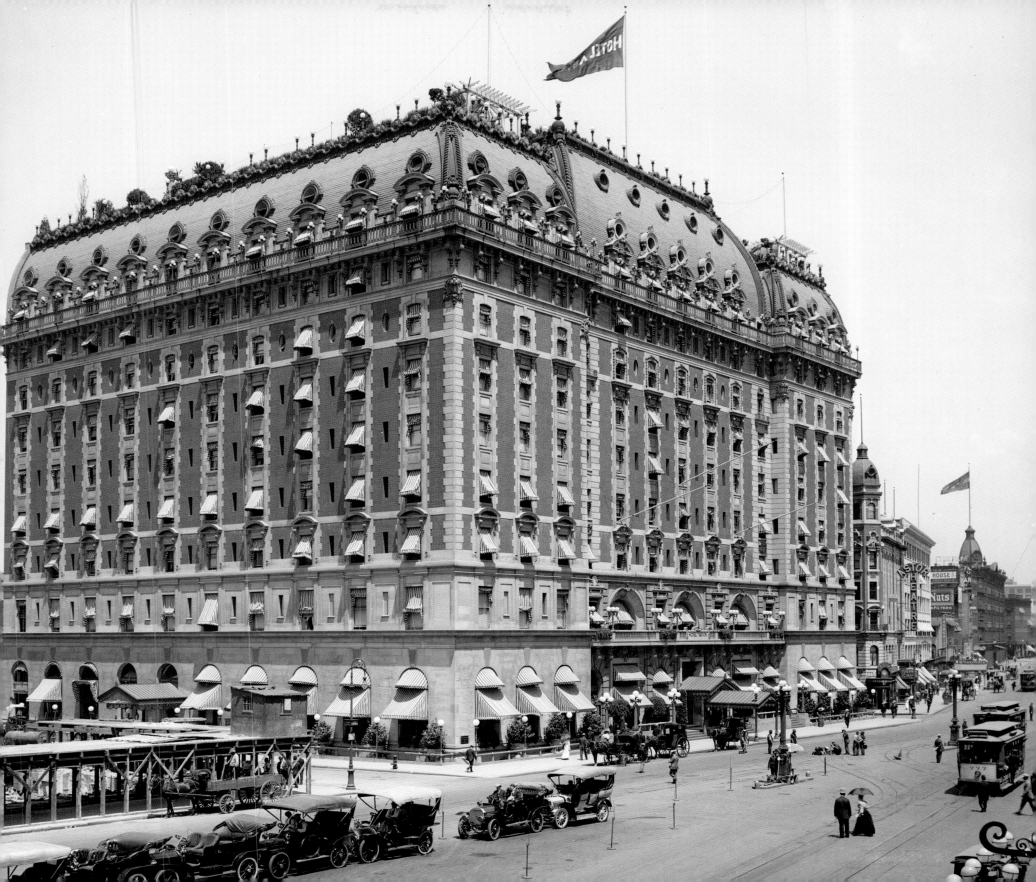

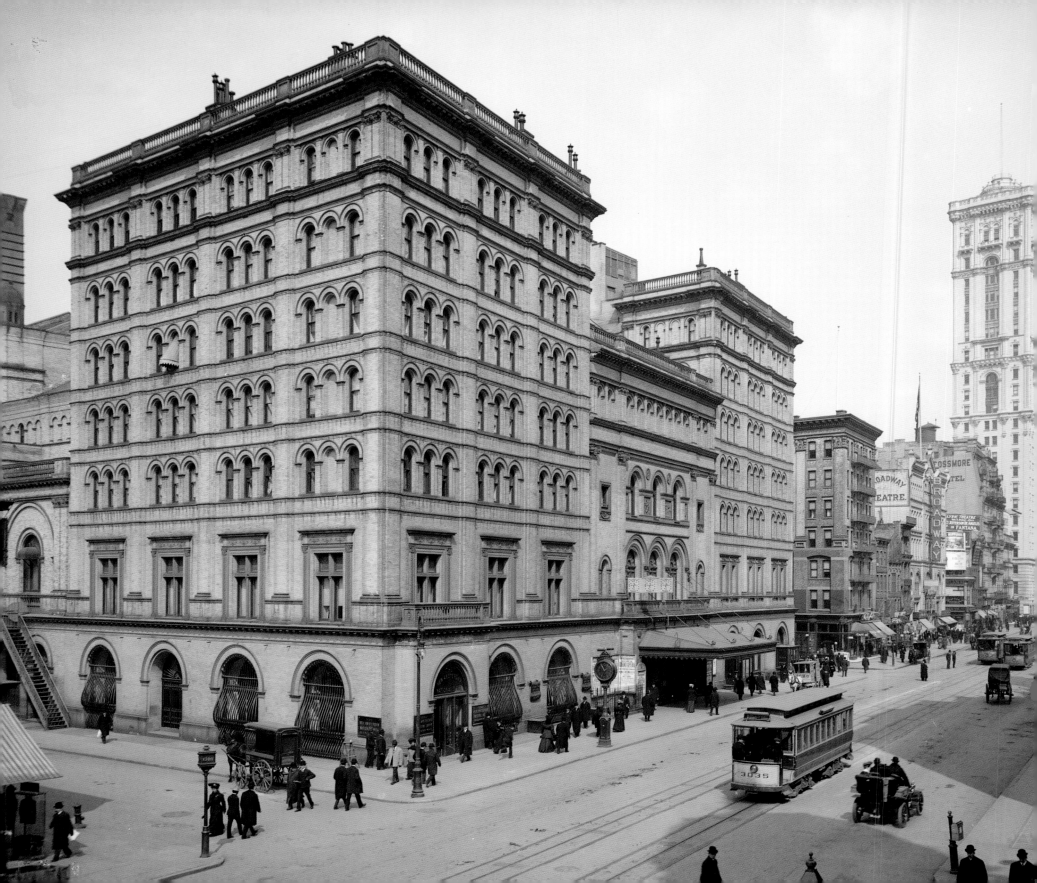

Metropolitan Opera House DEMOLISHED 1967

The first Metropolitan Opera House, the Victorian predecessor to the one at Lincoln Center, came about as the result of rivalry between the old and new crowds in New York society, a competition that turned into an outright war for prominence. Before it was built in 1882, the center of society's cultural life had been the Academy of Music on Irving Place and 14th Street in Gramercy Park where the Astors, Belmonts, and other mainstays of society had gathered for thirty years. By the 1870s, the Academy was too small to accommodate the new-money crowd, including the Vanderbilts and the Goulds, who wanted their own opera boxes. The limited space in the Academy suited the old guard, as Edith Wharton described in *The Age of Innocence*, her novel of upper-class New York life in

the 1870s. "Conservatives cherished it for being small and inconvenient, and thus keeping out the 'new people.'"

But the "new people" had enough money to have it their own way. They formed a new opera company, the Metropolitan Opera Association, and built a grandiose opera house on Broadway and 39th Street. It was bigger than anything New York or even Paris had seen before. Its auditorium accommodated more than 3,000 people, well above the 2,100 at the Paris Opera House. The Metropolitan also boasted the largest stage in the country, more than 100 feet wide and ninety feet deep with a fifty-foot rise from the stage to the roof. Flanking the immense proscenium arch were two monumental paintings, *The Chorus* and *The Ballet*. While the interior was huge and ornate, the exterior was just huge. Some compared it to a brewery. Even worse, conservatives complained, it was designed not only to make music but also to make money, with two seven-story towers, one at each Broadway corner, to be rented out for commercial use, subsidizing the opera.

At the start of the 1883–84 season, the Academy and the Metropolitan were ready for what the *New York Times* called "a social war of extermination." The Academy won the first battle as newspaper critics deemed its opening night a social and artistic triumph, and trounced the bejeweled Metropolitan crowd for its vulgarity. But the power of money won in the end. The Academy could not compete with the large investments that the Goulds and Vanderbilts were willing to make in top-flight performers. The Academy staged its last opera performance in 1885, before converting the building to a playhouse.

OPPOSITE PAGE *Just south of Times Square, the first Metropolitan Opera House was built by a new monied crowd of New Yorkers who had been shunned by old guard society. Times Tower is in the background.*

LEFT *Opera singers Enrico Caruso and Geraldine Farrar in costume for a performance of Julien at the opera house in 1914.*

RIGHT *A 1902 poster for a "Gala Performance of Grand Opera" held in honor of Prince Henry of Prussia.*

"STUPID BEYOND MEASURE"

Eighty years later, the tables would turn as the "old Met" was undone by a modern marble opera house at Lincoln Center and a new Metropolitan Opera Association that wanted to earn revenue by leasing the old property. The old Met's supporters, no longer the wealthy families of the Gilded Age, were preservationists, joined by celebrities such as the conductors Leonard Bernstein and Leopold Stokowski, who wanted to save the building for other musical performances. After a bitter public battle, the opera association, fearing competition, convinced the Landmarks Preservation Commission not to protect the building, allowing it to be destroyed in 1967. The site was sold in the depressed economic market of the 1970s for far less than it would prove to be worth. Twenty years later, according to the *New York Times* architectural historian Christopher Gray, the former manager of the Met admitted that selling the property in the 1970s had been "stupid beyond measure." An office building now occupies the site.

Singer Building DEMOLISHED 1968

The Singer Building, an architectural gem built in 1908, holds a dubious distinction. Until the destruction of the World Trade Center, it was the tallest building ever demolished. Ironically, the construction of the twin towers next door would indirectly seal the Singer Building's fate. By sending property values soaring in the 1960s, the huge project made the Singer's real estate on Lower Broadway more valuable than the distinctive building itself.

The Singer Building was part of the first boom of New York skyscrapers in the early 1900s. As buildings began to soar, many people feared that they would overwhelm the city. Ernest Flagg, the eminent architect of the Singer Building, had a practical solution. He proposed that towers could rise to any height if they covered no more than one quarter of their sites. He argued that this regulation would ensure open ground and adequate light around the building, essential qualities both for people on the street and inside the towers. The result would be a skyline made up of a "tiara of proud towers." He created such a tower on top of the Singer Building, one that was a crowning jewel of the Manhattan skyline for sixty years.

His first design for the Singer Building, the headquarters of the Singer Sewing Machine Company, was a ten-story building on Lower Broadway. Soon after it was built, the City Investing Company made plans to build a massive, thirty-two-story building next door. Sewing machines were big business in the early 1900s and the company could afford to make its headquarters a proud monument to its success. In 1902, Singer commissioned Flagg to design a tower rising above the base of the first building (and the encroaching City Investing Company building). He created one with a slender form, just sixty-five feet square, strikingly clad in iron and glass, with brick and limestone corners that matched the base. It was topped by a mansard roof and a giant lantern. When it was completed in 1908, the tower made the Singer Building forty-one stories tall, the city's tallest, but only until the fifty-story Metropolitan Life Insurance tower was built overlooking Madison Square Park less than a year later. Nonetheless, the Singer Tower would remain the most distinctive silhouette on the city skyline. The building also had an opulent lobby, a maze of piers covered with colored marble and bronze ornaments, supporting glass saucer domes.

RIGHT *The Singer Building was an architectural jewel and testament to the success of the Singer Sewing Machine Company. In the right background is the tower of the Woolworth Building, another celebration of entrepreneurial achievement.*

LEFT *Two views of the Singer's striking tower.*

REAL ESTATE MISTAKE

Despite its beauty, the building was sold and marked for demolition in the 1960s by developers who saw a profitable opportunity for a much larger building. In 1968, after the new Landmarks Preservation Commission failed to act, the Singer, along with the City Investing Building and several other neighbors, were demolished to clear a two-block site for U.S. Steel's new headquarters— a fifty-four-story glass and steel tombstone. *New York Times* architecture critic Ada Louise Huxtable described the Singer demolition site with its piles of domed vaults and marble columns as "a scene of rich, surrealist desolation." real estate profits had the last word—but, as things turned out, they had overreached the market, a mistake that would become a New York pattern. Completed in 1972, the enormous World Trade Center created a glut of office space, making it difficult to rent out the U.S. Steel building, completed in 1974 (now One Liberty Plaza), along with every other office building in the area for more than a decade.

Madison Square Garden DEMOLISHED 1968

Not as beautiful as its predecessor, nor as ugly as its successor, the Madison Square Garden that stood on Eighth Avenue and 50th Street from 1925 to 1968 was a place for momentous events. From the outside, its unremarkable architecture could not compare with the fabulous Madison Square Garden built on Madison Square in 1890 (see pages 38–39), but inside its cavernous arena, tens of thousands thrilled to many of America's most exciting sporting events, celebrations, and political rallies in the first half of the twentieth century.

It was the creation of George "Tex" Rickard, a former cowboy, Alaskan gold prospector, and saloon keeper who became a successful boxing promoter in Nevada. In 1920, the year that professional boxing became legal in New York State, he began operating the Garden on Madison Square. Five years later, backed by millionaire investors, he built the new Garden on Eighth Avenue, clearing away three old trolley barns on the site. "The House that Tex Built" would make Rickard the biggest sports mogul of the era, the man who promoted the legendary Jack Dempsey and ushered in the golden age of boxing. Rickard created the first "million-dollar-gates," raking in ticket sales of a million dollars for a single event. But boxing was not the only attraction at the Garden. As the largest indoor athletic arena in the country, with an ice floor that could be covered in a matter of hours, it hosted every type of popular sporting event, creating new teams and fans in the process. The arena's steeply pitched seats put fans right on top of the action. The New York Rangers hockey team, named after the Texas Rangers as a tribute to Tex Rickard, made its debut at the Garden, and years later the New York Knicks basketball team also was introduced.

Rickard died in 1929 and his funeral, held at the Garden, was another packed house. His partner, "Uncle Mike" Jacobs continued the Garden's success, promoting championship fights with the biggest names in boxing through the early 1960s—Sugar Ray Robinson, Kid Gavilan, Rocky Marciano, and Emile Griffith. Sell-out crowds also came year after year to see Sonia Henie's Hollywood Ice Review, Gene Autry's Rodeo, and in 1962, President John F. Kennedy's birthday party, made famous by Marilyn Monroe's sultry singing, "Happy Birthday, Mr. President." The Garden had a long tradition of hosting campaigning presidents ever since Grover Cleveland appeared at the previous Garden in 1892. The tradition continued uninterrupted at Eighth Avenue, most memorably when Democratic Presidential nominee Franklin Delano Roosevelt appeared in 1932. The tumultuous political times of the 1930s also played out at the Garden in Socialist, Communist, and pro-Nazi rallies.

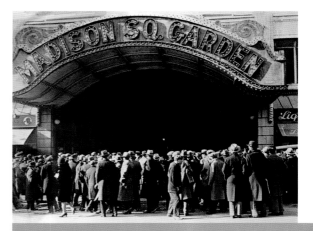

THE HATEFUL SUCCESSOR

In the search for an ever larger, more profitable facility, the Garden's owners built a new facility in 1968 on Eighth Avenue and 34th Street, replacing the grand Penn Station. Tex Rickard's creation, now known as the "Old Garden," was demolished and replaced in the 1980s by Worldwide Center, a huge office/residential complex. The new Garden, a drum-shaped structure, often appears on the top ten list of buildings New Yorkers love to hate, mostly because it caused the demolition of the historic station and led to a cramped replacement (see pages 110–111). Plans are underway to recapture Penn Station's grandeur by building a new station in a classical building across the street. Moving slowly, the project could lead to yet another Madison Square Garden at a site still undecided.

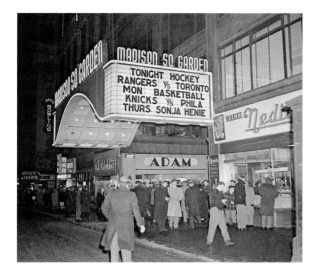

LEFT *Unremarkable from the outside, this 1925 successor was nonetheless a place of momentous events.*

ABOVE *The Garden was known for many sporting milestones, including the introduction of two legendary New York teams, the hockey Rangers and basketball Knicks.*

RIGHT *John F. Kennedy spoke at the Garden in 1962.*

TOP RIGHT *The ornate marquee was the Garden's only notable architectural feature.*

Bonwit Teller Department Store DEMOLISHED 1980

Bonwit Teller's was a Fifth Avenue fixture for fifty years, an elegant Art Deco emporium of chic women's clothes; the place where Jackie Kennedy Onassis shopped, or at least one of the places. From smart tailored suits in the 1930s to miniskirts in the 1960s and bellbottoms in the 1970s, it kept up with changing fashions and even survived a scandalous window display designed by Salvador Dalí. But it could not withstand the relentless march of real estate development, and in 1980 was done in by Donald Trump.

The Fifth Avenue site, at the corner of 56th Street, had been a fashionable address since the 1890s when William Waldorf Astor built a row of French Renaissance-style houses on the site. They were converted to commercial use in 1911 and in the 1920s were replaced by Stewart & Company,

a large store with a luxurious interior and expensive merchandise. But the timing was deadly. The store opened on October 16, 1929, thirteen days before the stock market crash, and soon became a victim of the Depression. Eight months later, it was remodeled for Bonwit Teller by the talented architect Ely Jacques Kahn and became the most sophisticated department store in the city.

Bonwit's moved into the new store in 1930. Its artistic window displays became famous and crowds would gather in front of the store on Wednesday evenings to watch the weekly changes. In 1939, Dalí was hired to design two windows. In one, according to Ronda Wist in *On Fifth Avenue*, a male figure, posed like Rodin's *The Thinker*, sat behind a female mannequin wrapped in a dark sheet on a bed. In the other, a large bathtub was filled with white hands holding mirrors above the water. About to step in, was a scantily dressed mannequin with blond waist-length hair infested with bugs. When the windows were unveiled,

women complained to the store president and the displays were removed. Dalí arrived later, stepped into the window from inside the store, and "inadvertently" pushed the bathtub through the glass. He was sued by Bonwit's and showed up in court wearing green-tinted face powder. The judge laughed and fined him $500.

RIGHT *Remodeled in 1930 as a sophisticated Art Deco emporium, Bonwit's became a Fifth Avenue fixture for fifty years.*

FAR LEFT *During the Christmas season in 1962, Bonwit's treated male shoppers to fashion shows.*

LEFT *Salavador Dalí was fined $500 for "inadvertently" smashing Bonwit's window. His storefront display had been promptly removed following customer complaints.*

TRUMPED BY DONALD

The store maintained its fashionable reputation, particularly once Tiffany's moved in next door in 1940. But after it was purchased by a large chain in 1965, it began to lose its cachet. In 1980, the property was purchased by a young Donald Trump planning to build his first Manhattan tower. Critics attacked his plan for a glass-faced skyscraper in the midst of Fifth Avenue's low-rise limestone stores. He did not gain any fans when he reneged on his promise to save the Art Deco ornaments on the façade, including two fifteen-foot-high figures pledged to the Metropolitan Museum of Art. The entire building was demolished, ornaments and all. Trump also apparently lost track of another detail promised to the museum, the twenty-by-thirty-foot bronze grille that had adorned Bonwit's entrance. Once removed, it was never seen again.

Biltmore Hotel GUTTED 1981

Built right next door to the "new" Grand Central Terminal in 1913, the Biltmore was a convenient and brilliantly designed hotel that whisked guests smoothly from arriving trains to their accommodations. Erected above the underground tracks, the hotel had its own arrival station, nicknamed "the kissing room." Overnight guests were not bothered by the noise of the trains since the hotel's first seven stories, filled with shops, public rooms, and restaurants, buffered the eighteen-story twin towers of guest rooms above. The Biltmore lobby clock in the Palm Court, the grand public lounge, became Manhattan's most famous meeting place. "Meet me under the clock"

needed no further description. The busy lobby was also the place where the reclusive writer J. D. Salinger could meet *New Yorker* editor William Shawn without public notice. Politicians gathered in the grand ballroom on top of the hotel for election night results and candidates received the good or bad news in their private suites. The Men's Bar, frequented by F. Scott Fitzgerald in the 1920s and also made famous by Sloan Wilson's 1950 novel, *Man in the Grey Flannel Suit*, was forced to admit women after a successful lawsuit by feminists in 1970.

More than a popular destination, the Biltmore also was the site of historic events. In 1916, the treaty creating the U.S. Virgin Islands was signed at the hotel, transferring possession from Denmark. In the 1932 election, Franklin Delano Roosevelt received the results that would make him the nation's president for the first of his four terms in office. In 1942, Zionist groups met at the hotel and produced the Biltmore Program, a series of demands regarding Palestine. The hotel also housed the Grand Central Galleries, founded in 1922 by notables of the art world, including John Singer Sargent. Originally in the terminal, the galleries moved to the hotel's second floor in 1958 and remained there until the hotel's demise.

STRIPPED OF EVERYTHING

The hotel's multi-faceted fame came to an ignominious end in 1981 when the owners redeveloped the hotel and stripped it down to its steel skeleton, defying last-minute efforts to salvage its elaborate interiors. In July, the hotel owners, Seymour and Paul Milstein, announced their intention to convert it to a glass and granite office building. Just a month later, while the city landmark commission was considering the designation of several of the Biltmore's interiors, the brothers suddenly closed the hotel and moved out the surprised guests and employees. Demolition began soon after, and despite temporary restraining orders brought by preservation organizations, all of the decorative fixtures from the public rooms, including the Palm Court, were removed. The Millsteins claimed that their lease with the new tenant, the Bank of America, left no alternative, and agreed to work with one of the preservationist groups to restore the Palm Court within the new office building. After the organization's architects discovered that nothing was left to restore, the Millsteins gave the group $500,000. One item would find its way to the new office lobby, the Biltmore clock, which rests over the concierge's desk, according to critic Paul Goldberger, "looking altogether lost."

AT GRAND CENTRAL TERMINAL

LET'S MEET UNDER THE CLOCK AT *The* BILTMORE NEW YORK

OPPOSITE PAGE *"Miss Skyway" contestants on the Biltmore's roof, 1956.*

FAR LEFT *The hotel rose above the train tracks at Grand Central Terminal.*

LEFT *A Biltmore matchbook advertising the hotel's famous meeting place.*

Lüchow's Restaurant BURNED 1982

Known for its hearty German food, flowing beer, and oompah band, Lüchow's Restaurant was in business for an entire century. The atmospheric restaurant had two incarnations, the first beginning with its founding in 1882, and the second starting in 1950 when it was rescued from decline. Surviving anti-German sentiment during two world wars, the restaurant, like its food, was full of robust flavor.

It was located in the midst of a musical and artistic Mecca in the late nineteenth century, operating on East 14th Street, a few steps away from the Academy of Music, the elite opera house later turned playhouse (see pages 120–121), and Steinway Hall, a popular concert hall started by the German manufacturer of Steinway pianos. August Lüchow, a German immigrant who worked as a waiter in the earlier restaurant and beer garden on the site, bought the place with a $1,500 loan from the piano magnate William Steinway, a regular customer. Musicians, actors, artists, and

the occasional anarchist and millionaire playboy ate at Lüchow's, not to mention the city's large German population who also took delight in the Wiener schnitzel and sauerbraten. The composer Victor Herbert ate there regularly and also wrote some of his compositions at his usual corner table. Live music, talk of the latest progressive ideas, and general high spirits filled the dining rooms, which were decorated with hunting trophies and murals depicting scenes from Wagner operas in the Nibelungen Room.

OPPOSITE PAGE *Behind its simple façade, Lüchow's was one of the city's most famous restaurants, a destination for tourists and celebrities alike.*

BELOW *Demonstrators tried in vain to preserve the building before its demolition.*

"NO EGG ROLLS IN THE NIBELUNGEN ROOM"

The restaurant began to decline after Lüchow's death in 1923, limping along until Jan Mitchell, a Latvian immigrant turned restaurateur, revived it in 1950. Mitchell had eaten at the restaurant in his first days in New York and always loved the food. He brought back the classic German dishes that had been dropped from the menu and reinstated the weeklong bock beer and venison festivals. He also put the umlaut back in the name, which the former owner had dropped in 1917 in response to anti-German feelings. Without it, new customers in the 1950s often mistook Lüchow's for a Chinese restaurant. According to the *New York Times* food critic William Grimes, Mitchell "was tired of explaining that no egg rolls were served in the Nibelungen Room." Although the theaters had moved uptown, the restaurant kept its celebrity appeal. Judy Garland held her post-concert party there after her famous Carnegie Hall performance in 1961. Ingrid Bergman, Lauren Bacall, Mickey Rooney, and other stars also came to Lüchow's for after-theater events.

Mitchell sold the restaurant in the 1970s, and while the quality of the food and the neighborhood declined, it remained a tourist attraction until a fire in 1982 closed its doors. The restaurant operation moved uptown but, out of its famous surroundings, it survived only until 1986. The abandoned 14th Street building was taken over by drug dealers and prostitutes, and after unsuccessful attempts to landmark the building, it was torn down. The site is now occupied by a New York University dormitory, one of many within a once-again thriving neighborhood.

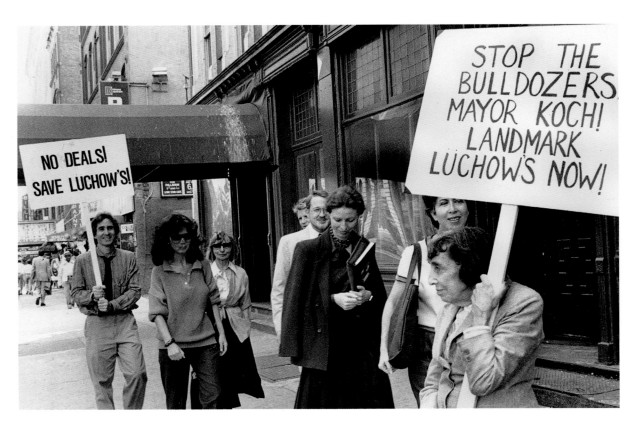

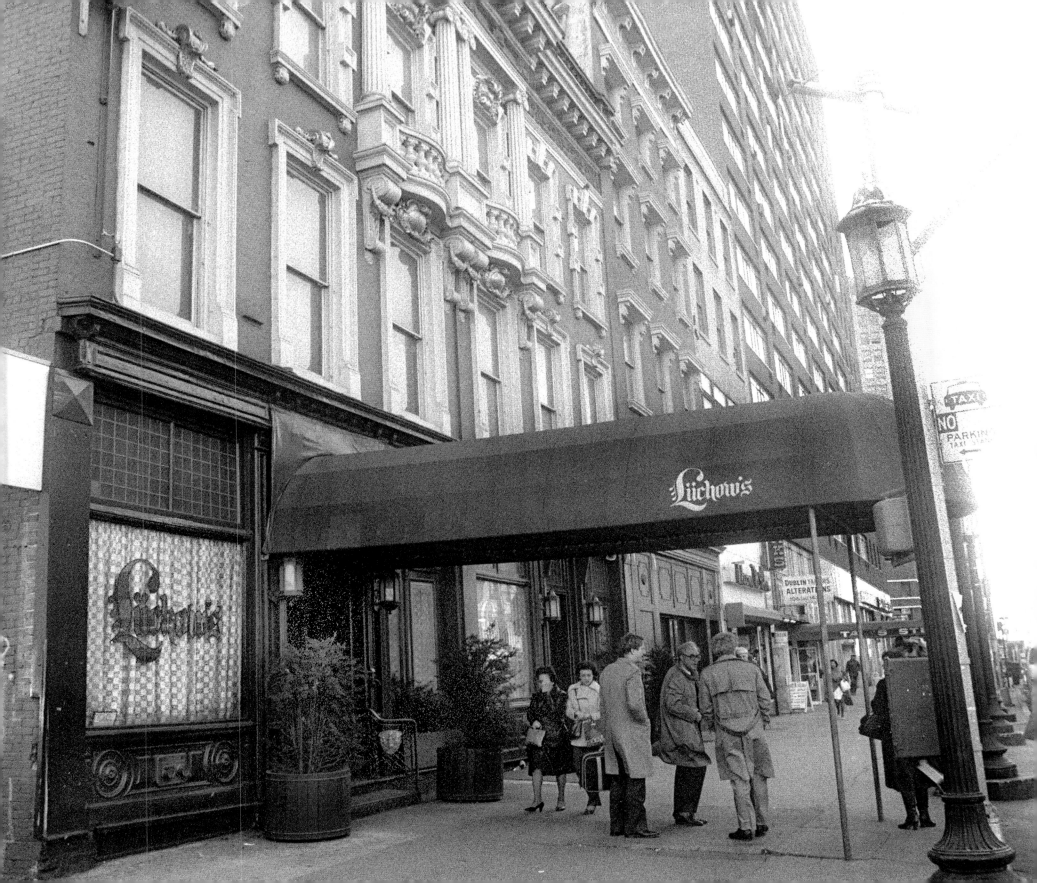

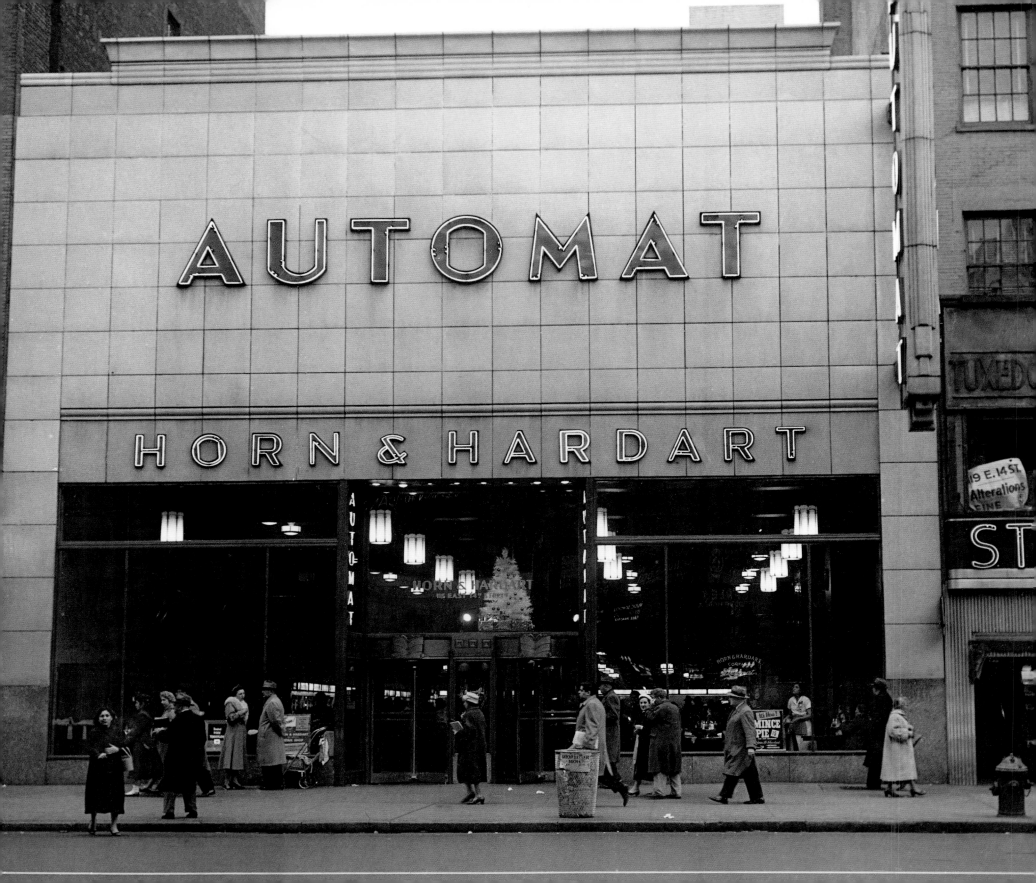

Horn & Hardart Automats CLOSED 1991

A New York institution since 1912, Horn & Hardart automats were once as iconic as the Statue of Liberty, a quintessential New York experience, but not just for tourists. At their peak in the 1930s and 1940s, forty of these restaurants were serving inexpensive food in "automatic" dispensers. The gleaming chrome and glass dispensers held a bounteous display of comfort food. A few coins in the slot, a turn of the knob, and a compartment would open with a revolving tray serving up your heart's delight—steaming macaroni and cheese, turkey and gravy, or warm apple pie. Unlike today's vending machines, the food was fresh, prepared on the premises and quickly replenished in the dispensers.

New Yorkers may not admit it, but the Horn & Hardart automats began in Philadelphia. The first one, operated by Joseph Horn and Frank Hardart, opened in 1902, the same year that James Harcombe opened an automat in New York at 530 Broadway, near Union Square. In both locations, the dispensers and the name "automat" were imported from Germany. The New York operation was a fancier affair, decorated with inlaid mirrors and richly colored woods. Along with sandwiches and soups, it served lobster Newburg and beer, cocktails and cordials from its faucets. The staff had to keep a sharp eye for boys dropping coins into the liquor slots. Harcombe's automat lasted only a few years, replaced by Horn & Hardart in 1912. The new operators brought their own, newly manufactured dispensers—but no alcoholic drinks—to Broadway and 46th Street in Times Square. As the theater district blossomed, actors, songwriters, and other entertainers made the automat their home away from home. Just a nickel would open most of the dispensers, and customers could sit all day at the lacquered tables in the large room. It was a boon to budding performers, writers, and musicians. Playwright Neil Simon called it the "Maxim's of the disenfranchised." But celebrities, including Irving Berlin, the columnist Walter Winchell, and even socialites ate there too. Jack Benny hosted a black-tie dinner in a New York automat. In 1933, H & H hired the French chef from the elegant Sherry Netherland Hotel to develop recipes. Other chefs joked that he was "L'Escoffier des Automats." His recipes, protected in a safe, told the company's cooks not only how to make the food, but where to position it on the plate. The automats spread throughout the city, patronized by a cross-section of New Yorkers. Children also loved them, more for the chance to place a nickel in the slot than for the food. The *Horn & Hardart Children's Radio Hour*, a variety show of the 1940s and 1950s, helped to encourage the young patrons.

LAST PIECE OF PIE

Famous for their pies, H & H automats served 72,000 slices a day in their busiest years. They did their best business during the Depression, despite many customers sneaking slugs instead of nickels into the dispensers. Over time, it took several nickels to open a single dispenser, and eventually only tokens, worth a dollar each. By the 1970s, the food had lost its flavor and the restaurants were often dreary. Several were converted to Burger Kings. The last survivor was on the ground floor of a building at 200 East 42nd Street, near Third Avenue. Automat aficionados felt it was not authentic since it had opened in 1958, long after the golden years. In April 1991, it served up its last piece of pie.

HOW AN AUTOMAT WORKS

FIRST DROP YOUR NICKELS IN THE SLOT

THEN TURN THE KNOB THE GLASS DOOR CLICKS OPEN

LIFT THE DOOR AND HELP YOURSELF

HORN & HARDART

Interior of One of the Fifty Automat-Cafeterias in Philadelphia and New York

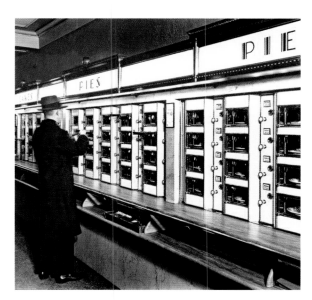

OPPOSITE PAGE *A classic Horn & Hardart Automat advertising a seasonal special, mince pies, just fifteen cents a slice. During their heyday in the 1930s, the automats served 72,000 slices of pie a day.*

FAR LEFT *A few coins in a slot and a turn of the knob would yield a wide selection of comfort dishes.*

LEFT *The last automat on 42nd Street.*

ABOVE *A postcard explaining how to use the "automatic" food dispensers.*

Central Park Children's Zoo **REPLACED 1997**

In 1961, a fairyland of fiberglass and real animals opened next to the larger Central Park Zoo. The star of the new children's zoo was a whimsical whale, affectionately known as Whaleamena. Pint-size Jonahs and Joans stepped into her fiberglass mouth without fear of being swallowed. They also boarded Noah's Ark for a stationary sail, wandered through Hansel and Gretel's Candy Cane Cottage and visited the Three Little Pigs in each of their houses, all under lights shaped like giant daffodils and tulips. This nursery-rhyme vision of animal life, also populated by a few actual pigs, chickens, and ducks, was enormously popular. Thousands of baby boomers grew up visiting the zoo, dressed in white shirts and starched dresses, a gratifying scene to its donors, former Governor Herbert Lehman and his wife, who lived nearby.

By the 1990s, the zoo was in need of repair and significant infusions of cash. Without additional donations available, the city shut down the facility, and it deteriorated into a candy-colored slum. In 1995, an anonymous donor said to live in a Fifth Avenue apartment overlooking the zoo, offered to pay for its reconstruction, but in a totally new, naturalistic setting. When the city announced plans for the transformation, the storyland zoo became a cultural war zone. Nostalgic baby boomers, along with Governor Lehman's granddaughter, protested the demolition, while others derided it as kitsch. The battle even divided preservationists. Architect Robert Stern embraced the kitschy figures as valid examples of an earlier style and compared those who wanted to destroy it to previous generations who had dismissed the city's Victorian heritage.

But Margot Gayle, a pillar of the Victorian Society of America, said the old zoo was "vulgar, ugly and Disneyland-like." The new design was an environmentally conscious enchanted forest, albeit one with plastic trees. Karrie Jacobs, a critic for *New York Magazine*, said the choice was between "faux 1961 and faux nature."

RIGHT *"Whalemena" was the zoo's star attraction, where little Jonahs and Joans could enter without fear of being swallowed. A stationary sail on Noah's Ark was another landlubber's delight.*

LEFT *Baby boomers grew up visiting the whimsical zoo, and many later tried to save it.*

GOODBYE TO OLD FRIENDS

In the end faux nature won, as the city Art Commission unanimously approved the new design. On the day of demolition, in August 1996, hundreds of New Yorkers came to say goodbye to the old zoo. The faded and chipped statues were encircled by yellow police tape normally used to rope off a crime scene. The crowd groaned as sledge hammers struck, but some of the figures, including the giant White Rabbit of *Alice in Wonderland* fame, were saved for museums and other city parks. Whaleamena, her dented head resting on a guard rail, was shipped off to Rockaway Beach in Queens. Her upright tail was sliced off to fit in the delivery truck and she lay in ignominy for a year awaiting funds for repairs. In 1997, the same year that the new zoo opened to the delight of a new generation, a Parks Department employee finally undertook the repair job for free, installing the restored Whalemena on the ocean boardwalk.

World Trade Center Towers DESTROYED 2001

Completed on the anniversary of the nation's bicentennial in 1976, the twin towers would become a world symbol of America's power and, ultimately, of its vulnerability.

The sudden destruction of the towers became an unprecedented American tragedy that shook America's confidence, put it on the defensive, and changed world politics. During the quarter century of their existence, the towers themselves had brought New York a mixture of good and bad results.

The towers were part of a seven-building World Trade Center complex that was conceived during a time of different thinking about urban vitality. It was built by the Port Authority of New York and New Jersey as a massive urban renewal project, a planning doctrine of the 1960s that believed in clearing away old buildings and replacing them with towers within open plazas. It wiped away Radio Row, several blocks of low-rise buildings in Lower Manhattan—not a major loss, except to the

shopkeepers. The Port Authority began building the project just as it was shifting New York's port operations to New Jersey (see pages 100–101). It took seven years and a billion dollars to build the World Trade Center, but upon completion it provided little financial consolation to New York. The flood of huge, new buildings created a glut of office space that nearly bankrupted existing office buildings in the area and made the twin towers a white elephant, filled only when New York Governor Nelson Rockefeller transferred state workers from other buildings. Ironically, they reached their highest value when they were leased to a private consortium for three billion dollars—in early 2001.

The excavation for the towers produced an enormous volume of landfill, adding ninety-two acres to the adjacent Hudson River shoreline and a new neighborhood, Battery Park City. But the Trade Center itself never came together as a neighborhood. Its super blocks interrupted the flow of streets and its windy, austere plaza did not invite

pedestrians. It was an isolated city within a city with all of its shops and restaurants underground. Despite its height, views from the inside were limited by the narrow windows sliced by the exterior skin of steel piers. Office workers joked that the windows were designed for shooting arrows. Only in the observatory and the famous restaurant, Windows on the World, did one appreciate being within the world's tallest buildings. Their huge size was a marvel in a country that had always been obsessed with size. While the rest of the world saw the towers as a symbol of New York, most New Yorkers did not see them that way, until they were gone.

OPPOSITE PAGE *At 110 stories, the twin towers were the world's tallest buildings.*

LEFT *Soon after the terrorist attacks, this simple monument was erected to acknowledge the outpouring of national grief.*

SKYLINE EXCLAMATION POINTS ERASED

Unlike the Chrysler and Empire State Buildings, the twin towers were not beloved icons. Architectural critics complained that their boxy shape and flat tops did not add much to the skyline. Their double exclamation points at the southern tip of Manhattan were not universally appreciated—until they were erased. It is taking a long time to create something meaningful in their place. The gaping hole was fenced off for a decade. Surprisingly, New Yorkers started coming back to live and work all around it within a few years of the disaster, a testimony to the city's resilient vitality. While a new tower is rising and a memorial is under construction, it is too soon to measure their immediate effect. But in time, the terrible gash will be healed, bringing the pieces of the city back together.

Fulton Fish Market ABANDONED 2005

One of the world's largest wholesale markets, the Fulton Fish Market had a long history in Manhattan, always colorful and often crime-ridden. It sold fish for 183 years in basically the same spot on the East River near the Brooklyn Bridge, preceding the bridge by sixty-one years. It was the last major part of Manhattan's working waterfront that had anything to do with the water. Although the fishing boats were all replaced by truck deliveries by 1970, it kept its authentic atmosphere and traditions. It was a place where men with names like Iceberg Tommy, Shrimp Sammy and Porgy Joe hung on to their slippery surroundings for decades until the city finally succeeded in pushing the market up to the Bronx.

The Fish Market began in 1822 as part of the new Fulton Market, located near the Fulton Ferry dock on South Street. It also sold meats, dairy products, and produce brought by farmers on the ferry from Brooklyn. By 1831, the other merchants got tired of the fishy smell and forced the fishmongers to move to a shed on the waterfront, replaced by a new building in 1869. Fishing boats would pull up behind the building, squeezed so closely together that the fishmongers and shoppers could jump from boat to boat. The catch was kept in "fish-cars," shallow cages that allowed the river water to flow in and out. Al Smith, who would become Governor of New York State in 1918, grew up in a tenement near the market and, like many local boys, learned to swim in the fish-cars. By the 1890s, meat and dairy shops had opened in local neighborhoods and ice was delivered to many homes. Going to the market daily was no longer necessary—except to buy fish, the most perishable item. Business was down at the main Fulton Market and the remaining merchants begged the fishmongers to return. Some did, eventually filling up the building. Others stayed at the waterfront fish market, which expanded to several buildings, including the largest, opened in 1939 and still called the "new building." No longer a retail market, it served a wholesale clientele of restaurants and fish stores, operating at night under the glare of harsh overhead lights.

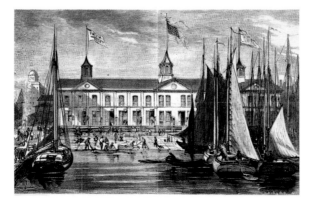

MOB RULE AND THE FINAL MOVE

The trucks arrived at midnight when hundreds of men sprung into action, jostling for space with hand trucks and forklifts or wielding grappling hooks to unload the ice-packed cartons. Sales began at three o'clock in the morning, and by nine the buildings were hosed down and shut for the day. The fishmongers, mostly Italian, Jewish, and later Korean, passed their businesses from father to son. They were a closely knit group that came under the tight control of organized crime in the early 1900s and kept its code of silence. The first mob boss was Joseph "Socks" Lanza who formed the United Seafood Workers' Union in 1919. He earned his nickname, not from the socks on his feet but from the punches he threw at people unwilling to pay him for the right to sell their fish. Although he went to prison in 1941, mob extortion continued as authorities turned a blind eye. In the 1990s, Mayor Rudolph Giuliani placed the market under surveillance and shut down a few businesses. After years of resistance, the entire operation and its 650 workers moved in 2005 to a new facility in the Bronx, now second in volume only to the world's largest in Tokyo. Except for the original Fulton Market that was rebuilt with restaurants and shops in the 1980s, the old fish market buildings remain empty.

RIGHT *A fishing boat unloading its catch at the market in 1939, a practice that switched to truck deliveries in 1970.*

FAR LEFT *Shoppers and fishmongers at the market in the late nineteenth century.*

LEFT *An 1869 engraving of the first market building.*

ABOVE *Market workers do the twist with a fish to a tune played by the "Filet Harmonicats," 1962.*

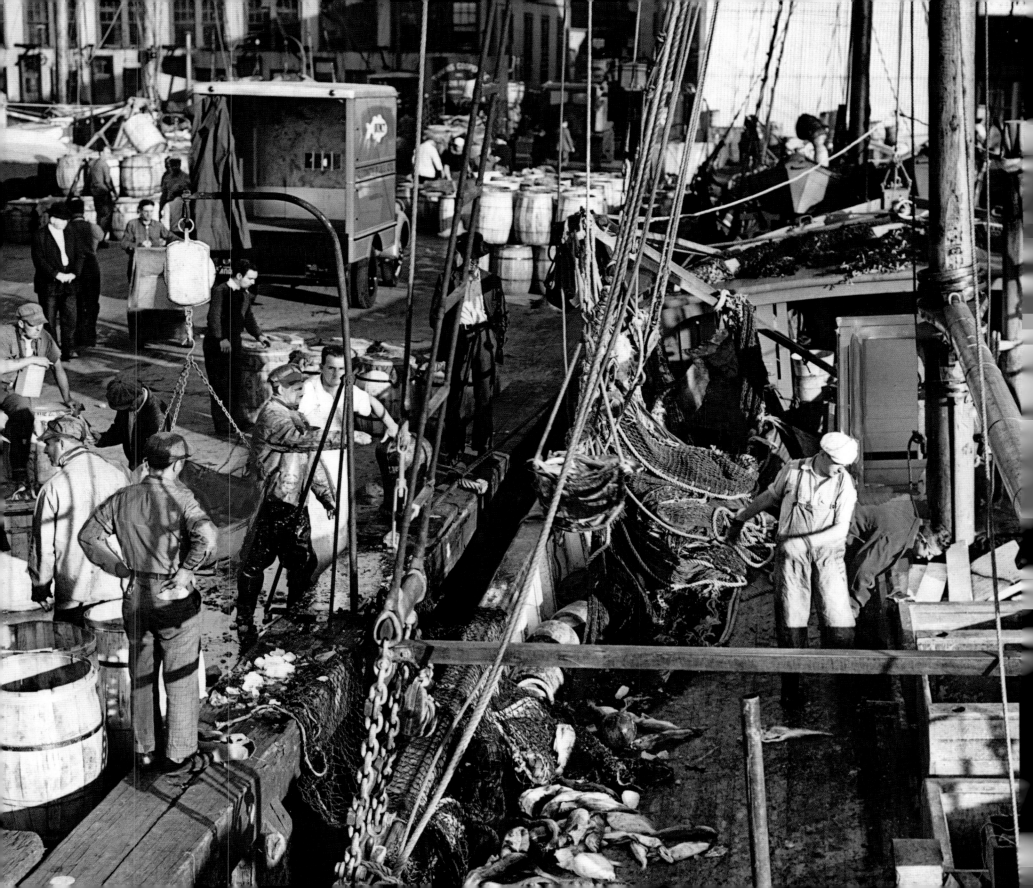

Moondance Diner MOVED TO WYOMING 2007

Many diners have come and gone in New York City, but few have traveled as far or suffered as much as the Moondance Diner, an Art Deco original that made a 2,100-mile trek to its new home in Wyoming. Opened in 1933, it was just another New York diner on a gritty corner near the Holland Tunnel. The Moondance, not its original name—it used to be the Holland Tunnel Diner—served hamburgers to local workers and late-night coffee to weary truckers driving between Manhattan and New Jersey. In the 1960s, the old industrial buildings in the area became a destination for artists, eventually known as the trendy neighborhood of SoHo. After a while, the old diner also got some attention for its unique charm. In the 1980s, it got a makeover with a bright yellow, revolving moon sign and its new name in glittering script. And in the 1990s, it became a star. In the television sitcom *Friends*, it was the place where the character Monica Geller, played by actress Courteney Cox, worked as a waitress. However, things were not as they seemed, since the show was filmed in Los Angeles and the actual diner was only in exterior shots. But more roles came its way: scenes in the television series *Sex and the City*, in the 2002 film *Spiderman*, and in a few music videos.

But living in a trendy neighborhood would prove to be its undoing. Even sites near the Holland Tunnel became prime SoHo real estate, and in 2007 the diner's spot on Grand Street and Sixth Avenue was sold for development of a luxury condominium. The diner's operator wanted to move it to another New York location, taking hope from a 2005-move by the Munson, a 1945 diner, from Eleventh Avenue and 49th Street to an upstate home in Liberty, New York. But patrons and preservationists tried without success to raise enough money to move the Moondance. As the demolition date drew close, the development company offered it to the American Diner Museum in Providence, Rhode Island. The museum listed it for sale on its website, and in one of those wished-for online dating moments, a Wyoming couple fell in love. Cheryl and Vince Pierce bought the Moondance for $7,500, drove to SoHo in a tractor trailer, packed the diner up on the flatbed, and drove it to their hometown of LaBarge, Wyoming.

OPPOSITE PAGE *Built in 1933, the diner got a makeover in the 1980s and became a trendy SoHo destination, until it was displaced by real estate development.*

BELOW *The diner was a setting for several television shows and music videos in the 1990s, and for scenes in the 2002 film* Spiderman.

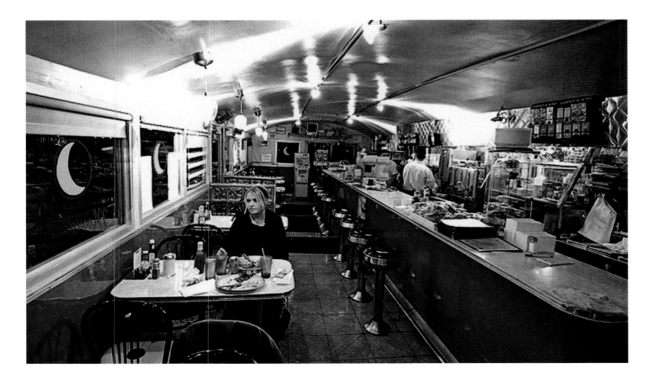

RESURRECTION IN WYOMING

After surviving that perilous trip, the Moondance did not make it through its first Wyoming winter in 2008. The snow and ice were too much for its seventy-five-year-old barrel roof, which caved in and buckled the fragile walls. Fortunately, the famous revolving sign had been placed in storage and the Pierces were able to put the diner back together. It reopened in 2009, serving breakfast, lunch, and dinner six days a week. While LaBarge has only 600 residents, the diner is located on a major highway and at last report was doing a brisk business. Its famous sign has been braced against the fierce Wyoming winds, and *USA Today* recently voted the Moondance hamburger one of the top fifty in the country. Ironically, the 2008 recession stopped the luxury condo, but just like the diner, the developers found a happy ending, building a new hotel on the site in 2010.

Yankee Stadium and Shea Stadium

DEMOLISHED 2008

The old Yankee Stadium, built in 1923, was regarded as one of the best baseball parks of its era. Shea Stadium, built in 1964 as the home of the New York Mets, was considered one of the worst. Both were demolished in 2008 for modern replacements and both were mourned for lost memories of some of the best moments in New York baseball history.

Yankee Stadium was the first Major League Baseball stadium to be called a stadium. The others were just ballparks. Built on the site of a Bronx lumber yard owned by William Waldorf Astor, it was a colossal structure unlike anything baseball fans of the day had ever seen. Completely enclosed, it had three tiers of seats and a decorative copper frieze circling the top of the grandstand. It contained 58,000 seats at a time when other parks had no more than 34,000, but as the Yankees' popularity soared, more than 80,000 fans often crowded into the stadium. The biggest draw was Babe Ruth who had joined the team in 1919 when the Yankees were still sharing the Polo Grounds with the New York Giants (see pages 102–103). The Yankees' owners were betting on Ruth's home-run hitting prowess when they built the huge stadium, which immediately became known as the "House that Ruth Built." From the 1920s through the 1960s, it was also home to other great players, Lou Gehrig, Joe DiMaggio, Mickey Mantle, and Yogi Berra, the legendary "Bronx Bombers." After the stadium received a major modernization in the 1970s, many fans believed that it had lost much of its character, but the indomitable Yankees continued to enjoy success on the field and at the box office, piling up a record-breaking twenty-seven World Series Championships in forty contests.

Lack of character was the defining architectural feature of many stadiums built in the 1960s and 1970s, and Shea was no different. Built for football as well as baseball, its configuration never satisfied fans of either sport. But despite its remote location in Queens and the Mets disappointing performances, it opened with a bang in its first two years of operation, drawing patrons from the adjacent World's Fair in 1964 and a full-house of screaming Beatles fans for the group's famous concert in 1965. Its namesake, William Shea, was honored for his role in creating the Mets in 1962, a new team designed to replace the Brooklyn Dodgers. While Shea Stadium never garnered the same affection as the Dodgers' beloved Ebbets Field (see pages 98–99), the Mets embodied the Dodgers' underdog spirit and worked their way into the hearts of thousands of fans, winning the 1969 World Series. They would win only one more championship at Shea, a dramatic victory over the Boston Red Sox in 1986, and finally made it to a "subway series" with the Yankees in 2000, a loss for the Mets but a riveting battle for fans throughout the city.

For years, the Yankees' truculent owner, George Steinbrenner, had threatened to move the team to New Jersey if New York did not build a new stadium. Before the end of his term in 2001, Mayor Rudolph Giuliani, a devoted Yankees fan, committed city funds for a substantial part of the new stadium's controversial $1.3 billion cost. To be fair, the city had to build a new one for the Mets as well and paid a large share of the $850 million cost for Citi Field, named for Citigroup, which bought the naming rights. The new stadiums opened in 2009, both right next door to the old ones. Before the old stadiums came down in 2008, fans purchased the seats and even packages of frieze-dried sod from the fields, hoping to preserve the memories.

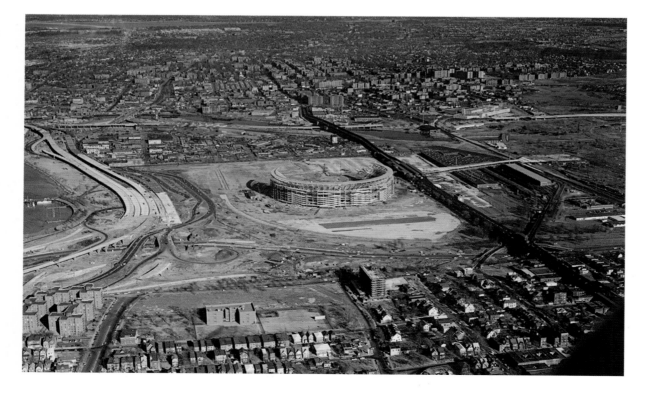

RIGHT *Side by side are the new Yankee Stadium, completed in 2009, foreground, and the old stadium, demolished in 2008.*

LEFT *Shea Stadium in construction. It opened in 1964, along with the walkway (right) that led from the stadium to the grounds of the 1964–1965 New York World's Fair.*

INDEX

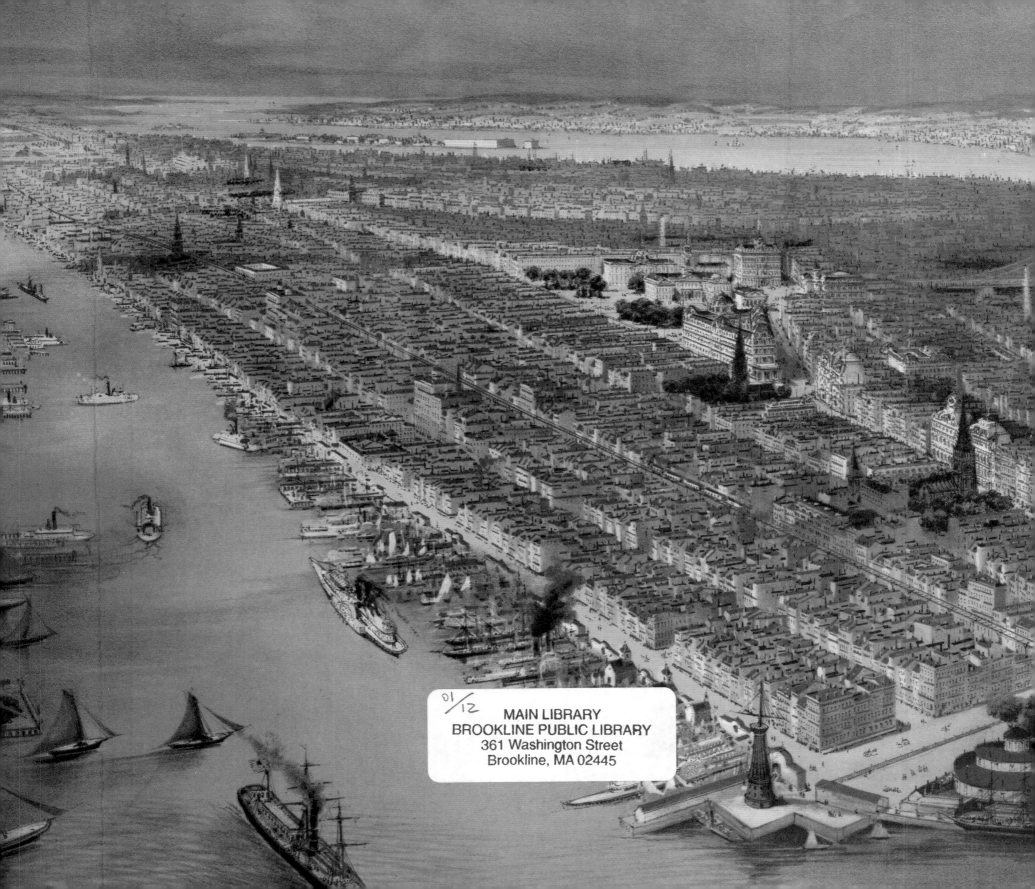